nextbook

We are always looking for the book
it is necessary to read next.
SAUL BELLOW

DONATED BY NEXTBOOK

Rembrandt's Jews

Rembrandt's Jews

STEVEN NADLER

The University of Chicago Press
Chicago & London

STEVEN NADLER
is professor of philosophy and director of the Mosse/Weinstein Center
for Jewish Studies at the University of Wisconsin–Madison. He is the author, most
recently, of *Spinoza: A Life* (which won the 2000 Koret Jewish Book Award for biography)
and *Spinoza's Heresy: Immortality and the Jewish Mind.*

The University of Chicago Press, Chicago 60637
The University of Chicago Press, Ltd. London
© 2003 by Steven Nadler
All rights reserved. Published 2003
Printed in the United States of America

12 11 10 09 08 07 06 05 04 2 3 4 5

ISBN: 0-226-56736-2 (cloth)

Library of Congress Cataloging-in-Publication Data

Nadler, Steven M., 1958–
Rembrandt's Jews / Steven Nadler.
p. cm.
Includes bibliographical references and index.
ISBN 0-226-56736-2 (cloth: alk. paper)
1. Rembrandt Harmenszoon van Rijn, 1606–1669—Relations with Jews. 2. Jews—
Netherlands—Amsterdam—History—17th century. 3. Jews in art. I. Title.

N6953 .R4 N33 2003
759 .9492—dc21 2003004088

♾ The paper used in this publication meets the minimum requirements
of the American National Standard for Information Sciences—
Permanence of Paper for Printed Library Materials,
ANSI Z39.48-1992.

Contents

Illustrations

Acknowledgments

I am extraordinarily grateful to a number of people for the help they provided me as I worked on this book. Robert Bernstein, Miriam Bodian, Marc Kornblatt, Tim Osswald, Bella Pomer, Shifra Sharlin, Larry Silver, David Sorkin, and Red Watson all read early drafts and offered extensive and valuable suggestions for improvement. Mirjam Alexander-Knotter and her colleagues graciously shared with me the results of their research into Jewish art patronage in seventeenth-century Amsterdam. I especially want to express my gratitude to Shelley Perlove and Michael Zell, who took time away from their own research into Rembrandt and seventeenth-century Dutch art to go through the manuscript and make important corrections and useful comments; I appreciate their generosity, not to mention their forbearance with an art history amateur. In Amsterdam, Henriette Reerink proved herself to

be, once again, a true and patient friend; and I am indebted to the curators of the Museum het Rembrandthuis for allowing me to view the renovated house in the off hours. At the University of Chicago Press, I thank Alan Thomas and Susan Bielstein, whose enthusiasm and encouragement for this project are just what an author needs; I also appreciate the help of Anthony Burton and Drusilla Moorhouse. And finally, all my love, as ever, to Jane, Rose, and Ben.

On the Breestraat

IT IS THE SUMMER OF 1653, *midweek in early August. The afternoon is warm and humid, as these months tend to be in Amsterdam, even in this century of intensely cold winters. There is a bustle on the avenue along the canal called the Houtgracht, where the floral and vegetable markets overflow with shoppers trying to complete their daily errands. Some people congregate in small groups to catch up on local gossip or trade rumors about the war with England, where things are not going well for the Dutch. Off to the side, just before the little drawbridge over the canal, a number of well-dressed men conversing in Portuguese file into a house. They gather to conclude a deal or settle some pressing legal matter. A few doors down, children tumble out of a school. They run helter-skelter over the cobblestones and skip stones across the canal. A shout goes up whenever a stone reaches the other side.*

One must wait to cross the canal. After a masted boat has passed through, the drawbridge comes down very slowly. On the other side of the

narrow waterway, the street continues straight ahead, where more flower stalls offer fragrant enticements. Just one block down is Sint-Anthonisbreestraat—Saint Anthony's Broad Street. A neat row of houses, all with similar redbrick facades and steeply pitched gables, lines each side of the street. Breestraat, as it is called, is wider than the thoroughfare that leads over the canal, with more pedestrians, horse-drawn carts, and well-apportioned carriages stationed in front of houses. To walk safely down the street at this time of day, one must stay close to the side and out of the way of the traffic.

At the end of the block, on the corner on the left and just back from the row of trees that line the lock on the canal, stand two large houses. Like many of the other dwellings, they are attached to each other by a common wall. The second house from the corner, the left one of the pair, is No. 4; it is the home of a prominent painter of portraits and histories.

It is an impressive house—not a true mansion, like the one Isaac de Pinto built for himself across the street, but even so it is a stately place. The three-story facade is made of brick with inlaid stone. It is quite wide, thirty-two feet across. Its tall front windows are topped by half-moon arcs of brick and stone. Above the roofline rise two thin dormer windows, each with a beam and pulley-hook sticking straight out into the street. The only way to move things to the upper floors of these narrow Dutch houses is to hoist them up and through the windows. In the center above the uppermost row of windows, crowning it all, is a decorative stone relief.

There is a tumult in front of the two houses. The street has been turned into a construction site. Building materials are strewn about—lumber, bricks, sand, mortar—and workers tramp in and out of both homes. Most of the work is going on in No. 2, on the right, the corner house, but repairs are also being made to the foundation of its companion.

Two wide steps lead up the stoop of No. 4. The front door, its threshold caked with dried mud, is propped open. The house is filthy. There is dust everywhere: plaster dust, sand dust, dust from the stones, and dust from the wood. It comes floating in from the worksite on the street through the open windows. It is tracked in on shoes and it falls off the shaken walls. Dust covers the floors and carpets, the windowsills, the sheets on the bed, the table, the food. Dust coats every surface of the house. It is even in the stu-

dio, complains the owner. The bare canvases are covered by a thin layer, enough to interfere with their priming; all of them will need to be cleaned. The paintings that were still wet—works in progress and recently finished pieces—are ruined. The dust that worked its way onto them is there for good. It is of no use to sweep up at the end of the day, he complains; by the time the air settles in the night, everything is covered again. The place is a goddamn mess, he sighs, and there is no end in sight.

Then there is the rattling. The house shakes with every swing of a sledgehammer, with each attempt to ram a beam into place; the windows chatter every time a nail is driven into lumber, and whenever a new brick is tapped into line. The construction required in No. 4 is in the basement, but it makes the upper floors reverberate. There is no escaping the tremors. They reach right down into a man's soul.

Worst of all is the noise: the incessant banging and cutting and hammering and chopping and knocking, the shouting and the yelling, the sharp cracking sound of wood thrown on top of wood, and the ringing of stones tossed from a wagon onto the street. It is enough to drive one mad.

—⟨∞⟩—

It took the contractor Pieter Swense six months—six bone-jarring, nerve-shattering months—to jack up the house of Rembrandt's neighbor in No. 2 Breestraat, the Jewish merchant Daniel Pinto. The house had to be raised by "three feet and two thumbs" (about eighty-six centimeters). One reason the project took so long was the shortened workweek. The Dutch contractor and his men certainly would not have worked on Sunday, God's day; and Pinto must have stipulated that they could not labor between sundown Friday and sundown Saturday, the Jewish Sabbath, either. There may have been other factors, too. In addition to paying Swense thirty-three guilders, Pinto agreed to throw in "half a keg of good quality beer [that can be] consumed on the job." This was presumably a daily ration. The workmen were free to imbibe "more frequently" if they wished, but it is explicitly stated in the agreement that this additional refreshment "will be at the expense of the contractor."[1] As the days grew warm, half a keg of beer would not have gone very far.

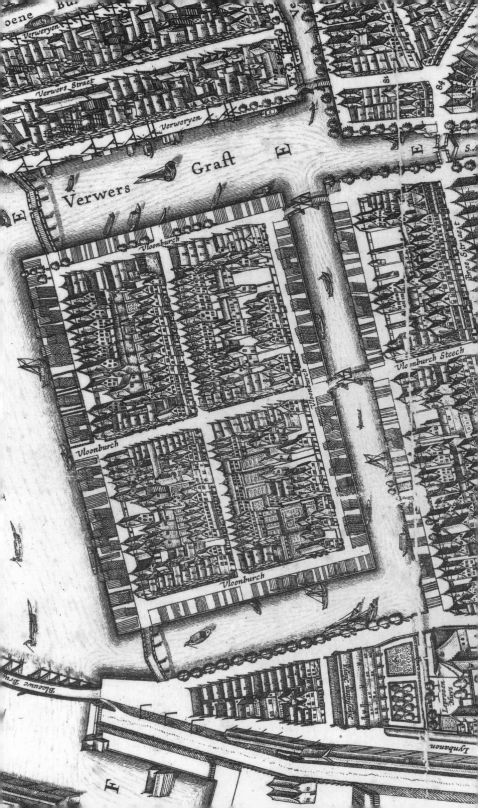

Swense died before he could complete the job. The master bricklayer Arent Reyessen and the carpenter Jan Janszoon were brought in to shore up the foundations and finish the repairs. Maybe it was more complicated than they originally thought, or perhaps there were many delays. Whatever the cause, the work went well past deadline. The project took over a year in the end. By that time, Rembrandt's patience was gone and his concentration shot. From the time construction began in early 1653 to its completion in May 1654, he had been unable to work with any consistency. The extant records indicate only one dated painting from that year, the *Aristotle Contemplating the Bust of Homer*, now in the Metropolitan Museum of Art. Rembrandt's living area, his work space, his art—they were all a wreck.

So were his finances. That is why it must have been particularly galling when Pinto started complaining that Rembrandt was not bearing enough of the cost of the restoration work. It was not an unreasonable objection. After all, Rembrandt benefited from the project. Their attached houses shared a wall, and extensive rebuilding of that joint property was required. Pieter Pieterssen, a local lumber merchant, had been directed to keep track of whether the wood he delivered to the job site was for the supports and beams of Pinto's side of the wall or Rembrandt's, "so he could charge each of them separately." Instead, he gave a single bill to Pinto. When asked by an irritated Pinto "why he [Pinto] had been charged on the same bill for lumber rented and bought for Rembrandt, and why not each of them had been charged separately, as agreed," Pieterssen replied—according to the witnesses who testified to the notary Benedict Baddel, recorder of the dispute—"that it was none of his business and that he knew of no one but Pinto and had no desire to claim any money from Rembrandt."[2] It seems that Rembrandt's reputation as a delinquent debtor was well known. Pietersson was a smart businessman.

(Facing) Amsterdam's Jewish Quarter, detail from a map of Amsterdam by Balthasar Florisz. van Berckenrode, 1625, Municipal Archives, Amsterdam.

I doubt that Pinto ever received any money from Rembrandt for the wood. He could have pressed the matter, but, like the lumber merchant, he probably had no desire to add his name to the ever-expanding list of the painter's creditors. There were other, long-standing members of that club with higher priority. What Pinto could do, however, was try to get some relief from the rent he was paying to Rembrandt for the use of the artist's cellar. Pinto had been storing rolls of tobacco, one of the goods in which he dealt, in half of the basement of No. 4. (Rembrandt seems not to have had much use for this part of his house, for the rest of the cellar was being rented by other Jewish merchants, the brothers Jacob and Samuel Pereira.) But with all the work being done on the house, and especially on the supporting wall in the basement, it was impossible to keep anything down there, much less use it as a base for business. By withholding the rent, Pinto could make up what Rembrandt owed him for the restoration work. Or at least he could escrow the money and use it as leverage to get Rembrandt to pay up his share. The notary, Baddel—who was one of the notaries of choice among Amsterdam's Portuguese-speaking Jews because he had an assistant who knew their language—reports that two witnesses came forward on behalf of Pinto. One was the mason Reyessen, who was intimately acquainted with the condition of Rembrandt's cellar. The other was Mordechai d'Andrade, a fellow Portuguese Jew who worked for Pinto and who "was always present during the renovations and therefore had seen everything." Reyessen and d'Andrade testified that Rembrandt's basement "was so noisy because of masons and carpenters that the requirant [Pinto] was unable to use it during that period of time."[3] Why should he pay rent for a cellar he could not use? Of course there is no mention of the fact that Pinto could not use it because of the renovations he himself had undertaken.

Pinto's house had been sinking. It had been built, perhaps hastily, on saturated landfill almost fifty years earlier. It rested on ground reclaimed from water and marshes in the city's 1593 expansion project. This substantial urban annex was constructed because municipal leaders had recognized that old Amsterdam could

no longer contain its rapidly expanding population. As the Dutch Republic's war for independence from Spain wore on toward the end of the sixteenth century, more and more immigrants—many of them fleeing the Inquisition—were arriving in the cities of the Protestant north from the Catholic provinces of the southern Netherlands that remained loyal to their Spanish rulers. The refugees came from all over those Hapsburg territories, but especially from Antwerp—once the shining commercial center of northern Europe but now worn down by blockades and eclipsed by the new glory of Amsterdam.

The influx did wonders for the new nation's economy and culture by creating fabulous wealth and ushering in its renowned golden age. But it was difficult for Amsterdam to accommodate all these newcomers. The buildings of the city, wedged between the canals and the river, were already packed in tightly. A metropolis surrounded by water can usually build only upward; thus, the great towers of Manhattan, once known as New Amsterdam. But skyscrapers and high-rises were not an option in seventeenth-century Amsterdam. The only solution was to create more land.

The Dutch were brilliant at this. In fact, compared to the great land reclamation projects on the North Sea, the Amsterdam expansion would be simple. Within a few years, where once there had been waterways, wetlands, and grazing fields outside the city limits, now there were neighborhoods, with wood and brick houses, wide streets and narrow alleyways, market squares and wharfs. What had been Sint-Anthonisdijk (St. Anthony's Dike) that directed the flow of the Amstel River along the east side of the city, was, by 1600, Sint-Anthonisbreestraat, the central avenue of the city's newest quarter. The neighborhood itself was called Vlooienburg, from the Dutch word for flood, *vloed*.

The landfill was soft, mostly sand and sod. As the waterlogged material shifted and settled, so did the pilings that had been driven into it and on which everything rested. Crooked houses were the result. These are charming to the twentieth-century tourist but were a nightmare to the seventeenth-century homeowner. Plaster cracked, doors did not close properly, paintings hung askew. When

the houses sank and went cockeyed, they needed to be raised and leveled. Pinto's house was certainly not three feet off kilter. More likely, he had decided that as long as the house had to be straightened up, a major job in its own right, he might as well have it raised substantially to increase the storage space in the basement for his tobacco. A successful businessman, Pinto had the resources for such a major project. So in early 1653, he decided to take care of the problem, whatever the inconvenience to Rembrandt. The homeowner behind them raised his house five years later, in 1658. Rembrandt, however, could not afford to do so. He could barely afford the house itself. No. 4 Breestraat was not resettled until 1661, several years after Rembrandt had moved his family to less expensive quarters in another part of the city.

Things were not supposed to turn out this way. It had all looked so promising twenty years earlier. The house seemed just the right place. It was perfectly situated at the heart of Amsterdam's art world, a neighborhood that was also home to many of the city's social and political elite—including well-connected members of regent families. If you were an artist in seventeenth-century Amsterdam who wanted to be surrounded by galleries, dealers, and other artists, not to mention wealthy patrons who desired—even needed—portraits and "history" (including biblical- and religious-themed) paintings to adorn their walls, you could pick no better place to live. Vlooienburg and its environs were where much of the city's art was commissioned, made, displayed, and sold. Just across the street from Rembrandt lived the painter Adriaen van Nieulandt, at No. 5 Breestraat. Two doors from van Nieulandt (at No. 1 Breestraat) was a house built around 1605 for another painter, Pieter Issacszoon. By the time Rembrandt moved in, however, Issacszoon was living farther down Breestraat, just across the Sint-Anthonissluis, or Saint Anthony's Lock, on a block that included the painters Dirck Santvoort, David Vinckboons, and Roelandt Savery. Down the street from Rembrandt in the other direction, toward the new Saint Anthony's Gate, lived the painter

Paulus Potter, with yet another artist, Thomas de Keyser, right next door. The house where Daniel Pinto now lived, at No. 2, had once belonged to the art dealer Hendrick Uylenburgh, who still lived on Breestraat but closer now to Santvoort and the others. Pinto himself had bought the place from the painter Nicolaas Eliaszoon Pickenoy.

The Vlooienburg quarter did not have the cachet of the older, more established parts of town. The wealthiest of the wealthy in Amsterdam tended to live on the upscale canals that form the concentric half-rings of the city center. Such people as the van Beuningens and the fabulously rich Trips lived on the Old Singel. Addresses on the Prinsengracht and in districts like the Jordaan carried even more prestige. But that did not stop Pieter Codde, a member of one of the city's leading families, from living on Breestraat. And one of the dwellings across the street from Rembrandt's No. 4 was owned by Joan Huydecouper, a most distinguished neighbor indeed and who is on record as having bought "a head by Rembrandt" in 1628. That house was now rented to Jan Cocq, the father of Captain Frans Banning Cocq, whose militia company was immortalized by Rembrandt in the painting commonly referred to as *The Night Watch*. There was certainly no lack of patrons in Rembrandt's immediate neighborhood.[4]

The house that Rembrandt bought in 1639 from Christoffel Thijs for the exorbitant sum of thirteen thousand guilders was built together with Pinto's in 1606. It was being rented at the time of Rembrandt's purchase by Balthasar Visscher, a merchant. The elegant home came with a garden in the back, a real premium in a crowded, watery city like Amsterdam. This was a stunning purchase for a painter of Rembrandt's means to make. It was eventually his undoing.[5]

This was not Rembrandt's first residency on Breestraat. In 1624, he had come from his hometown, Leiden, to Amsterdam to work in the studio of the history painter Pieter Lastman. Lastman was living on Breestraat at the time, but on the far side of the Sint-Anthonissluis, closer to the Zuiderkerk and just beyond the vague and unofficial boundaries of the Vlooienburg quarter. Rembrandt

stayed with Lastman for six months, before returning to Leiden to begin his career as a master painter. He encountered serious competition in Leiden, however—the talented and popular Jan Lievens. Lievens, too, had studied with Lastman, and excelled in just the kind of history painting that the local patrons favored. Leiden was not big enough for both Rembrandt and Lievens. Or maybe it was just not big enough for a painter of Rembrandt's ambitions. Seven years later, Rembrandt was back in Amsterdam, living right next door to the house he would later buy—living in the same house, in fact, that would be raised "three feet and two thumbs" by Daniel Pinto in 1653.

In the early 1630s, No. 2 Sint-Anthonisbreestraat was the home and business address of Hendrick Uylenburgh, an important art dealer in the city. Perhaps Rembrandt had met Uylenburgh through his teacher Lastman, during his earlier stay in Amsterdam. Or maybe the gallery owner got to know the painter during a buying trip to Leiden. Uylenburgh may even have played a role in bringing Rembrandt to Amsterdam. What we do know for certain is that by late 1631 Rembrandt was living in Uylenburgh's house and working in his studio. Rembrandt received portrait commissions through Uylenburgh and made extensive use of the dealer's network. He also taught painting to some of the other artists associated with the business, such as Govaert Flinck, Ferdinand Bol, and Isack Jouderville. In the middle of Amsterdam's newest neighborhood was one of the city's most productive and profitable art establishments, with one of history's greatest artists as its rising star.

Rembrandt gained more from his association with Uylenburgh than simply entree into the city's lucrative system of patronage and lessons running an art studio. In June 1633, Rembrandt and Uylenburgh's cousin Saskia, who was also living in the house, announced their engagement. The nuptials brought the painter not only a wife but also a favorite model; for many years Saskia posed for numerous portraits and narrative scenes. During the first two years of their marriage, the couple continued to live with Uylenburgh in No. 2 Breestraat. Then sometime in 1635, they moved

out to the Nieuwe Doelenstraat, where they rented a house on the Amstel River from Jannetge Martensdochter. By 1637, however, they were back in Vlooienburg—not on Breestraat, but on the more crowded (and less affluent) island from which the neighborhood got its name. It was an undeniable but, fortunately, only temporary step down the social ladder. For two years they lived in a house that faced the wharfs of Binnen-Amstel. This was, for the most part, a business district. Ships and barges put into this side of the island to unload their goods, and much of the area contained warehouses and lumberyards in which raw and processed timber and other merchandise was stored before sale or further transit. In addition to being the home of the Amsterdam art market, Vlooienburg was also the center of the city's wood trade. Much of the lumber that made possible the republic's great and frequently engaged maritime fleet was brought, prepared, and sold here. Daily, Rembrandt strolled down Nieuwe Houtmarkt (New Wood Market) to Lange Houtstraat (Long Wood Street) to get to the Houtgracht (the boulevard along the Wood Canal). He crossed over to Breestraat—and Uylenburgh's gallery—by way of Korte Houtstraat (Short Wood Street) and the Houtkopersgracht (Woodbuyer's Canal), all within a ten-minute walking circuit.

The house that Rembrandt and Saskia rented on Binnen-Amstel was next to one called *De Suyckerbackerij*, "The Sugar Bakery." It was owned by Jan van Veldesteyn, a baker who ran an establishment named *De Vier Suyckerbrooden* ("The Four Sugarbreads"). It was not all that far from the artists, galleries, and dealers of Breestraat, but it was a world away. This would not do, not if Rembrandt hoped to have his own thriving art business, such as Uylenburgh's. A proper painter needed a proper studio. It should be in a house with a sufficiently impressive facade and an anteroom in which to greet visitors—potential patrons—in the comfort to which they were accustomed. If it meant going deeply into debt, so be it. Rembrandt was getting up to five hundred guilders for a portrait. The commissions he was sure to obtain by being back in the center of things, as well as the teaching fees, would, no doubt, eventually cover the cost of the house. Or so Rembrandt hoped.

Thus, in May 1639, Rembrandt gave Christoffel Thijs twelve hundred guilders for the house attached to Uylenburgh's, No. 4 Sint-Anthonisbreestraat. He still owed him eleven thousand eight hundred guilders. It was a sum that would never be paid in full.

———⊗⊗⊗———

Today, as you approach Amsterdam from the northeast—traveling, of course, on a bicycle, perhaps riding down the polders on the Ijmeer after a visit to Alkmaar and Edam to tour the cheese markets—you pass through the newer parts of the city. Surrounded by modern office buildings and high-rise apartment complexes, you wonder (if this is your first trip) what could have happened to the quaint old city shown in tourist brochures. Small streams and drawbridges, some surrounded by lush growth, are on either side as you move briskly along the *fietspaden*, or bike paths, that are everywhere in Holland. It is a charming ride, but where are the tall, thin, steep-gabled houses and neo-Gothic churches? Where are the red, white, and blue bannered barges moored in canals along improbably narrow streets?

And then you come to the River IJ. The small harbor is the road's dead-end. There, across the water, is what you were looking for. Brick, not poured concrete; cobblestone, not asphalt; spires, not antennae. Dozens of other bicyclists—in business suits with their briefcases strapped across the center bar, with boyfriends or girlfriends sitting sideways on rear carrier racks, or with small children all but hidden in the wicker body-baskets on the racks—are waiting on the quay for the short ferry ride that will carry them across the river and into the old city. After they load and the boat pulls away, everyone stands on the open deck, holding either a book, a bicycle, or a *broodje*, the small sandwich roll that counts as Dutch fast food.

The ramp is slowly lowered as the ferry reaches the far bank, more of a sloped loading bay than a true dock. The bikers take the right-of-way, rolling as a group off the boat and straight on through the monumental Centraal Station, the rear of which looms ahead. Built in 1889, it is the central node of a city that, un-

like most other European capitals, has not completely surrendered to the automobile. Passenger trains to destinations throughout Europe share the rails with freight cars under the enormous steel roof. The station remains genteel in an Old World way. Its cafés, waiting areas, and book and newspaper kiosks invite even native Amsterdammers to linger before making their way out into the city. In addition to a clock on the front of its magnificent brick facade, there is also a gilded weather vane, a throwback, perhaps, to the days when the city depended on the sailing ships that floated into the wharfs just behind the station. On the front side of the railroad terminal is a huge plaza, with trolley lines, buses, and, above all, bicycles. Thousands of them, many squeezed in together on a three-level parking ramp. This is commuter parking, Dutch style. Some of the *fietsen* are secured with heavy chains, others with only standard-issue flip-locks. They all have handlebar chimes. In the morning and evening, the ringing of bells and the clicking whirl of bicycle gears drowns out even the motorized traffic.

The city of Amsterdam radiates outward, fanlike, from this plaza. Straight ahead, past the herring sellers and the newspaper stands, lies the Beurs, built in 1903 for the stock exchange but now used mainly for concerts. A left turn out of the station mall off the Damrak and then a right onto the Warmoestraat takes you along a canal. The red-light district begins here. Part tourist attraction, part lure for British toughs from across the North Sea, the neighborhood's seediness has been relieved somewhat in recent years by the city's attempts to clean up its image. There are still many sex shops along these narrow streets. The bright and hip-looking Condomerie caters to the needs of the district's visitors. Even to a well-traveled American, the sight of a lingerie-clad woman standing in a street-level window is still something of a shock.

A left turn ahead leads to the Oudezijds Voorburgwal. On the right is the imposing Oude Kerk, built in 1306 but already too small for its growing congregation by that century's end. Its High Gothic nave—brick, not stone—lines up just behind the spire that contains a forty-seven-bell carillon. The basilica is surrounded by

chapels, annex buildings, and even houses added over the centuries. Rembrandt's Saskia is buried here.

Another left turn just past the church takes you over a bridge to the Oudezijds Achterburgwal. The Cannabis Museum is just a block away, a stone's throw from the old headquarters of the Dutch East Indies Company, now a part of the University of Amsterdam. As you continue along on Zeedijk, once a part of the city's original fortifications, you pass through Amsterdam's small Chinatown and enter the Nieuwmarkt. The market plaza is dominated by the castle-like, fifteenth-century Waag (weigh-house). When the weather is decent, the yard in front of the Waag is filled with fishmongers, cheese sellers, vegetable stands, flower stalls, even bakers. This was the scene of fierce rioting in 1975, when the city started demolishing old homes in the neighborhood—including parts of the Jewish Quarter—to make way for a new subway. In the face of such protest, the municipal authorities wisely revised their plans and began serious renovation efforts. Photographs of the demonstrations are on display in the Nieuwmarkt metro station.

The avenue splinters into smaller streets here, and it is easy to get lost as you leave the plaza. If you continue straight through the Nieuwmarkt and out the opposite side, however, you arrive, finally, on Sint-Anthonisbreestraat. In fewer than one hundred meters, the name of the street changes. Beyond the well-preserved Italianate home that belonged to Isaac de Pinto on the left and the simple but stately Zuiderkerk on the right, over the small bridge where the Sint-Anthonisluis still controls the water level of the canal, Saint Anthony's Broad Street becomes Jews' Broad Street, Jodenbreestraat. At a steady pedal, the trip since debarkation at Centraal Station takes no more than ten minutes.

───❧───

Had Rembrandt moved into any other neighborhood of the city, he would have been surrounded by neighbors with such names as de Witt, Graaf, Van den Berg, and Janszoon. As it was, the occupants of the houses around No. 4 Breestraat had names that were,

to the Dutch ear, of a somewhat more exotic timbre: Rodrigues, da Costa, Bueno, Nunes, Osario. Rembrandt's block was the home of Manuel Lopes de Leon, Henrico d'Azevedo, and David Abendana. Daniel Pinto was right next door. On the other side of Rembrandt, at No. 6, lived Salvatore Rodrigues, also a merchant. Across the street lived Salvatore's brother, Bartolemeo Rodrigues, in No. 3. In Breestraat No. 1, on the corner and opposite Pinto, in the house once occupied by the painter Pieter Isaacszoon, was Isaac Montalto, the son of the late Elias Montalto, who had served as court physician to Maria de Medici, Queen Mother of France. The wealthy Isaac de Pinto owned a large house on the block, taking up Nos. 7 and 9. He lived there until 1651, when he bought an even bigger home, also on Breestraat but on the other side of the lock. Next to him was Abraham Aboab. In No. 23, in a house owned by their father Abraham, resided the brothers Samuel and Jacob Pereira, the same merchants who were renting part of Rembrandt's basement. At the end of the block was yet another merchant, Bento (or Baruch) Osorio. With over fifty thousand guilders to his account at the Bank of Amsterdam, he was one of Vlooienburg's richest residents. Across from Osorio, on Rembrandt's side of the street, was Antonio da Costa Cortissor. In 1639, Cortissor generously (but, no doubt, profitably) sold a piece of his garden so that a synagogue could be built in the neighborhood.[6]

Saul Levi Mortera, a learned rabbi and formerly a secretary to Isaac Montalto's father, lived just across the Sint-Anthonisluis from Daniel Pinto's house. Menasseh ben Israel, also a rabbi and possibly the most famous Jew in Europe, lived on Nieuwe Houtmarkt, on the Vlooienburg island. Between them, on the Houtgracht itself and one block from Rembrandt's house, lived Miguel d'Espinoza (or de Spinoza). His son, Baruch, would become one of the most radical and vilified philosophers of all time, but only after being permanently expelled—with great prejudice—from the Amsterdam Jewish community for his "abominable heresies" and "monstrous deeds."

All these people, with the exception of Rabbi Mortera, were Sephardim: Jews of Iberian extraction. The Spanish and Por-

tuguese names were, to their gentile neighbors, a dead giveaway. The men may have dressed like the Dutch, trimmed their hair and beards like the Dutch, and assumed Dutch aliases for business purposes outside of Holland—thus, Josef de los Rios (Joseph "of the River") became Michel van der Riveren, while Luis de Mercado (Louis "of the Market") was known to some of his associates as Louis van der Markt—to protect them from harassment. Their houses were done up in the Dutch style, and they prided themselves on their ability to pass as typical burghers in their new homeland. But there was no mistaking the distinctly foreign cultural flavor they brought to Breestraat.

Vlooienburg was, then, not only the center of Amsterdam's art market and lumber trade. It was also the heart of Amsterdam's Jewish world. And Rembrandt settled right at its center. Every house immediately contiguous with or facing his own was owned or occupied by a Jew. And an overwhelming majority of the households on his block, on both sides of the street, were Jewish. From his front stoop he could see into Rabbi Mortera's windows; from his top floor he had a view of the community's synagogue. He could not help but hear the sons of Jewish families chattering in Portuguese on their way to school in the morning. On Friday afternoon, he could smell the slow-cooking Iberian foods they prepared for the Sabbath.

Before the Lower East Side of New York, before the Marais district in Paris, even before London's Park Lane, there was Vlooienburg. And much of what we think about Rembrandt and his art stems, ultimately, from his decision to live there.

Just a few decades earlier, Rembrandt could not have moved into a Jewish neighborhood in Amsterdam. Not because of any residency restrictions, but simply because there were no Jews in Amsterdam at the turn of the century—at least, not officially. Jews had been forbidden in all the Low Countries by the mid–sixteenth century by proclamation of its lord and owner, Holy Roman Emperor Charles V. Some of the residents of Vlooienburg circa 1600 had

the Mediterranean complexions—so strikingly different from the pale, blond Dutch—of the Sephardim. They spoke to one another in Portuguese and read classic works of Spanish literature to their children. They might also have known some Hebrew. But these were, according to official documents, "Portuguese merchants," and, at least in the eyes of the municipal authorities, Christians. Or so everyone pretended.

Many of the Portuguese in Amsterdam at the turn of the century had moved north from Antwerp, when the city held out much brighter economic prospects than its decimated Catholic cousin. Some, however, had fled directly from Spain and Portugal to escape the Inquisition in those countries. The Church's officers of the faith were ever-vigilant against insincere "New Christians": erstwhile Jews or individuals of Jewish descent who were suspected, despite generations of forced conversions, of continuing to practice Judaism in secret. By 1610, two hundred Portuguese lived in Amsterdam, slightly more than one quarter of one percent of the city's total population of seventy thousand. By the time Rembrandt moved into his own house on Breestraat in 1639, the Portuguese numbered over a thousand. And now they were—openly and proudly—Jews.

Toleration, through a kind of willful and self-serving ignorance, came fairly quickly after the initial settlement of Portuguese and Spanish *conversos* in Holland. A somewhat more grudging formal acceptance took a bit longer; and full emancipation required almost two more centuries.

The regents of the city of Amsterdam knew, as early as 1606, that they had practicing Jews in their midst. That was the year that an organized Jewish community first asked the municipality for permission to purchase a burial ground within the city limits. The request was denied. Apparently Jews were permitted to live in Amsterdam but had to leave when they died.

By 1614, there were two well-attended congregations in Amsterdam, Beth Jacob (House of Jacob) and Neve Shalom (Dwelling of Peace), as well as a number of smaller communities elsewhere. The question of their legal status could be ignored no longer. The

following year, the States General of the United Provinces of the Netherlands, the republic's central governing body, took the initiative and removed all barriers to Jews practicing their religion openly. It was a magnanimous gesture, but of questionable efficacy. The Netherlands was a highly decentralized federation of provinces, ministates that were themselves decentralized federations of cities and towns. Local regents tended to resent any attempts to usurp their authority, and their laws—both at the municipal and provincial levels—usually trumped decisions from above. Despite the States General's ruling, Amsterdam (at least for the public record) was adamantly opposed to Jews openly practicing their religion. Obviously, the city's authorities could do nothing about what went on behind closed doors in private homes. But, at least on the books, the regents continued to forbid Jews living within its limits to worship publicly.

Not that things were particularly unpleasant for the Amsterdam-based members of the "Portuguese Nation," or *La Nação*, as they liked to call themselves. While they may not have yet enjoyed legal protection and official acceptance, they were allowed to go about their business unmolested, and even to hold services "in private," with a considerable wink from the authorities. Rabbi Isaac Uziel, for one, felt that things were free enough in the city. Impressed by the level of toleration he finds there, he writes in 1616 that "people live peaceably in Amsterdam. The inhabitants of this city, mindful of the increase in population, make laws and ordinances whereby the freedom of religions may be upheld. . . . Each may follow his own belief, but may not openly show that he is a different faith from the inhabitants of the city."[7] Worship your God in your own way; just do not flaunt it.

Amsterdam's policy of "don't ask, don't tell" may have been a fine compromise for the time being, but everyone realized that eventually the issue would have to be confronted, especially because many of the more conservative and intolerant leaders of the Dutch Reformed Church were widening the scope of their concern beyond the ever-despised Catholics and starting to look menacingly at the Jews. They demanded the expulsion of both groups. The province within which Amsterdam lay, Holland—the richest

and most powerful province in the republic—ignored these prejudiced fulminations and took the first steps toward official acceptance. In 1616, the States of Holland set up a commission to advise them on the problem of Jewish residency and worship. One of the members of the commission was Hugo Grotius (Hugo de Groot), a highly regarded jurist and one of the most important political thinkers of his day. Grotius was clearly torn. On the one hand, he was reluctant to admit Jews into the volatile theological and political environment of the Netherlands. Not only was the Calvinist republic still fighting for its very life against the powerful forces of Catholic Spain, but it was also battling what was perceived as a rear-guard action from within—heretics, radicals, and rebels within the Dutch Reformed Church itself, as well as (if the demagogic preachers were to be believed) Catholic traitors. How, then, could its citizens possibly be asked to accept Jews in their midst? These are, after all, the people who deny that Jesus Christ was the Messiah, who refuse to recognize that the Law of Moses has been surpassed by a new covenant, who fail to see the salvational truth of the Christian faith. Grotius knew that even Erasmus, the great promoter of religious toleration, refused to allow Jews into his irenic circle. Judaism, the sage of Rotterdam had noted, was "the most pernicious plague and the most bitter enemy of the doctrine of Christ." Grotius believed that admitting the Jews into the republic and allowing them to practice their religion would threaten the confessional and even the political unity of the state, not to mention the devotion of those already unsteady in their religious faith. He thought it unfortunate that things had come to this point. In the famous *Remonstrance Concerning the Regulations to be Imposed Upon the Jews in Holland and West Friesland,* his final set of recommendations to Holland's leaders, he noted that

> it is a matter of bad insight that the Jews . . . were allowed to settle in this country in great numbers. It is also wrong that they were made welcome in the towns with promises of a great degree of freedom and extensive privileges, all this only with a view to private gain and trade, but not to the glory of God and the public weal.[8]

Despite all this, it is clear that Grotius was well aware of the practical—that is, economic—advantages of having a thriving Jewish population in Holland. The Portuguese were successful merchants, with wide and profitable business networks. Far be it from the Netherlands, and especially Holland, to make the same mistake that Spain made in 1492 when it expelled its Jews. Moreover, Grotius—to all appearances a pious and principled man—was not completely without compassion and even goodwill toward them. While he devotes a long chapter in his work *On the Truth of the Christian Religion* to a "refutation of Judaism," he graciously concedes that, after all, these people are not all that different from Christians. The Jews represent "a part and beginning of truth," their religion having appeared long ago "out of the thick darkness of heathenism . . . like twilight to a person advancing out of a very dark cave." They are "the stock onto which we [Christians] were grafted." God chose them to receive his Law, and "when the veil that now covers their faces is taken off, they may clearly perceive the fulfilling of the law."[9]

In the *Remonstrance*, Grotius decides that Christian charity, love, and forgiveness recommend that Christians take in the Jews and allow them to worship in their own misguided but historically venerable way. What else is there to do? "Plainly, God desires them to live somewhere. Why then not here rather than elsewhere?" There is even a benefit to be hoped for: "Besides, the scholars among them may be of some service to us by teaching us the Hebrew language." Above all, he claims, it is for their own good that the Jews be allowed to settle among the Reformed Christians of Holland, as it can only hasten their ultimate conversion. Grotius does insist, however, that certain precautions be taken to mitigate the dangers that the Jews represent to civil society: they must register with the authorities, declare their faith openly, swear an oath of allegiance to the country, and promise to live strictly by the Law of Moses. He also recommends some restrictions on their activities: they may not carry arms, intermarry with Christians, or print any editions of the Talmud, which was believed to contain blasphemies. In spite of his misgivings, how-

ever, Grotius rejected the idea of confining the Jews to a ghetto, or of compelling them to wear special clothing or marks, such as the infamous yellow badges that some European monarchs ordered the Jews in their realms to wear.[10]

The compassionate and generous jurist was already in danger of being left behind by the momentum of toleration, not to mention the practical realities in the street. In 1619, the province of Holland accepted Grotius's general recommendations in favor of public Jewish worship, and even rejected some of the restrictions he suggested placing on Jewish economic and social activities. Jews would henceforth be permitted to settle and practice their religion in the province. Holland's leaders, however, did not want to impose their will on individual cities. So they decreed that each municipality within the province was free to decide for itself whether and under what conditions Jews should be allowed to dwell within its limits. They also stipulated that while a city could compel Jews to live in a certain quarter of town, they could not order them to wear any distinguishing signs.

Amsterdam, at least in practice (if not in statute), kept pace with the provincial authorities. Perhaps the city's regents, upstanding but relatively liberal members of the Dutch Reformed Church, were moved by Calvin's own sentiments expressed a century earlier. Speaking of the Jews who lived before the Christian era, he remarked that "it ought to be known that to whatever places Jews had been expelled, there also was diffused with them some seed of piety and the odor of a purer doctrine."[11] More likely, though, Amsterdam's civic leaders were expecting something slightly more tangible to be diffused by their Jewish residents, and their motives might have had less to do with Christian charity than with the material boom the city was currently experiencing, thanks in no small part to the increased trade brought by its Portuguese merchants.

The city council never formally declared in writing that the Jews of Amsterdam were free to live openly as Jews and to practice their religion in a public manner. Its approach was more ad hoc and laissez-faire, as private services were allowed to slip into public worship without too much trouble. A number of restrictions

were imposed on Jewish life in the city, however, including occupational limitations. Jews were not permitted to engage in most of the trades that were governed by guilds; this is why Daniel Pinto had to hire Dutch contractors to raise his house. There were also strict rules governing social relationships with Christians. Mixed marriages and sexual liaisons between Jews and gentiles were forbidden. The Jews could not employ Christians as domestic servants, and their children were not permitted to attend the city's schools. Naturally, Jews were also refused many of the political prerogatives of Dutch citizens—they could not hold public office, for example—although they enjoyed some of the protections granted to all "subjects and residents" of the republic. They were allowed to purchase burgher or citizen rights (*poorterschapen*), but in their case these were of limited scope and could not be passed on to their children. The city council also demanded that the Jews keep to a strict observance of their own orthodoxy. They were ordered to adhere scrupulously to the Law of Moses and never to tolerate deviations from the belief that, as Grotius put it, there is "an omnipotent God the creator . . . [and] that Moses and the prophets revealed the truth under divine inspiration, and that there is another life after death in which good people will receive their recompense and wicked people their punishment."[12]

What seems to have worried the Dutch more than anything else, however, was the possibility that Jews might try to convert gentiles. The Jewish community, well aware of this fear, expressly forbade its members to proselytize or to circumcise "anyone not of our Hebrew Nation." Jacob Chamis fell afoul of this rule in 1640, when he circumcised a Polish man. In his defense, he claimed that he did not know that the man was not a Jew, but his judges were unmoved. Moreover, he had acted without first seeking the permission of the community's lay governing board, the all-powerful *ma'amad*. As a consequence, Chamis was put under a ban, or *cherem*, for several weeks. This punishment of ostracism was not uncommon among Amsterdam's Jews. A person under a ban was forbidden from participating in a variety of religious and social activities for a period of time, depending on the seriousness

of the offense. Someone under a *cherem*, for example, was not permitted to be called to the Torah in the synagogue, and might even be excluded from carrying on ordinary business with members of the community. A monetary penalty was also usually attached to the ban. Chamis was fined only a nominal sum of four guilders, "because he is poor."[13]

Despite vigilance on both sides, a number of incidents were very troubling to Dutch eyes—for example, the case of Jan Cardoso, himself an erstwhile Christian, and the woman who "became Jewish" so that she could marry him. The Jews feared that this was just the kind of thing that would "threaten the peace that we enjoy." The Dutch, for their part, took pains on several occasions, and in a very public manner, to remind the Jews that "nothing should be spoken or written that could be taken as expressing disdain for our Christian religion, [or] to cause anyone to convert from our Christian religion or to be circumcised."[14]

Even with the various restrictions and warnings, the Jews found in Amsterdam and other Dutch cities more freedom, peace, and security than they were granted in any other society of the time. This did not go unremarked by Jacques Basnage. In his 1716 *Histoire des Juifs depuis Jesus-Christ jusqu'à présent*, he notes that "of all the states of Europe, there is not one where the Jews live more peacefully than in Holland. They get rich there through commerce and, because of the gentle attitude of the government, they are secure in their possessions."[15] The Jews of Amsterdam enjoyed the protection of the law and religious, social, and economic autonomy—provided they adhered to Dutch standards. The city was willing to let the Jewish community set up its own regulations and codes of behavior—covering marriage and divorce, worship, education, trade, publishing, business disputes, gambling, fighting, and other matters—and deal with transgressions in their own way. In most of these domains, the community's leaders looked for their model not to Dutch law but to both Jewish law and—just as important—the community's own eclectic traditions. Naturally, they had to exercise some caution. The lay figures who represented the community before the city magistrates were responsi-

ble for ensuring that their fellow congregants observed the ordi-
nances issued by the city council. And the Dutch claimed jurisdic-
tion in criminal matters and on most legal questions that went be-
yond the management of social, liturgical and ethical mores.
Although the rabbis, for example, were free to perform marriages,
all non-Reformed nuptials had to be legalized before the munici-
pal authorities. Still, it was a remarkable degree of toleration,
practically without precedent in the history of Jewish-Christian
relations.

Of course, not everyone agreed with the official policy—or, in
some cases, with the authorities' refusal to institute an official pol-
icy. Calvinist preachers continued to rail against the Jewish threat.
The infamous firebrand Gibertus Voetius, rector of the University
of Utrecht and one of the more extreme representatives of the
Dutch Reformed Church's right wing, never let pass an opportu-
nity to inveigh against these "unbelievers." In 1636, he even
presided over a debate as to whether it would be best to deport the
Jews or simply kill them. A few cities and towns in the republic
continued to forbid Jews to settle within their domains; some even
refused to allow them to lodge in local inns or to visit for business
purposes. Haarlem would not allow a public synagogue until 1765,
despite having tried in 1605 to entice the Jews away from Amster-
dam by offering them a burial ground and even stipulating that
"Jews may go about dressed as they wish and need not wear any
external mark distinguishing them from Christians."[16]

Ordinary Dutch citizens were not usually overly concerned
about their Jewish neighbors. To be sure, toleration was not to
everyone's taste, and from certain quarters the Jews received a less
than warm welcome, if not outright hostility. But in general the
Jews were accepted. Nevertheless, it seemed to them that it would
be a good idea to keep a generally low profile in religious matters.
During weddings and funerals, members of the congregation were
asked by its leaders not to form celebratory or mournful proces-
sions, "to avoid the problems that can occur with crowds and to
avoid being noticed by the inhabitants of the city." Purim festivi-
ties, when costumes, masks, and dancing are the norm, were also

required to be muted, "since some of our enemies use this masquerading to demonstrate their ill intent toward us."

Hostile voices in the Dutch political arena, however, appear to have been a minority, and while they may have found a sympathetic hearing in some parts of the general populace, they were never of great consequence. People may have taken offense at what they considered ostentatious displays of celebration, such as the public parading of the Torah on the Simchat Torah holiday. But beyond lodging a complaint about the disturbance of the peace, there was nothing they could do about it. Even when, as happened from time to time, the power of the liberal regents was eclipsed by the politically, socially, and religiously more conservative Orangist faction—which favored a strong centralized government under the prince of Orange and well-defined limits to the autonomy of individual cities and provinces—there was never any serious consideration given to expelling or even further restricting the activities of Holland's resident Jews. It was, on the whole, a good situation, pleasant enough for Rabbi Uziel to proclaim that life for the Jews in Amsterdam was "tranquil and secure." Many years later, one of the city's Jews was moved to compose a brief *berachah*, or blessing, for the refuge that they had found on the banks of the Amstel: "Blessed art thou, O Lord our God, who has shown us your wonderful mercy in the city of Amsterdam, the praiseworthy."[17]

In Rembrandt's time, there were, in fact, two kinds of Jews in Amsterdam: us and them. Rembrandt's immediate neighbors on Breestraat were Sephardim (from the Hebrew word for Spain, *Sepharad*). These were, in addition to the refugees from the Inquisitions in Spain and Portugal and Iberian businessmen from Antwerp, émigrés of Spanish and Portuguese descent from Italy and around the Mediterranean. For a while, they were the only Jews in town. Many of them were prosperous merchants and professionals—well-dressed, highly cultured, and aristocratic in their habits if not always in their pedigrees. The occupant of No. 2

Breestraat was typical. Daniel Pinto made his money through trade in goods from colonies in the New World. Tobacco from Virginia and the Caribbean made up the bulk of his business, but sugar, spices, and fruits were popular commodities as well. He and his colleagues took advantage of their Spanish and Portuguese connections to gain access to resources and lines of supply outside the Dutch empire, and they were able to find entry into markets that were closed to ordinary Dutch merchants. Goods imported from Brazil, the Caribbean, Iberia, and the Levant brought them wealth and even some influence. They tended to invest not so much in the Dutch West and East Indies Companies (although some of their names are in the registries of those corporations) but in their own ventures. Their economic and social success was remarkable, and by midcentury they were widely recognized across Europe as a kind of Jewish elite. These Sephardim formed a very proud group of people. They were perhaps nostalgic for the life they had left behind in Iberia, but they were essentially pleased with the world they had created in Amsterdam. They saw themselves and their history as part of a larger plan, one with a divine imprimatur.

People invent myths not only to impress others—about who and what they are, where they came from, and where they are headed—but, perhaps even more important, to impress themselves. Amsterdam's Sephardim were no different in this regard. In their communal memory they preserved a number of stories about the arrival of the first Portuguese Jews in Holland. Each tale, while it may bear a kernel of truth, serves not so much as a historical record of actual events but rather as a source of inspiration, justification, and pride.

Two accounts in particular stand out. Both are focused on the singular achievements of noble and courageous individuals who, through ingenuity and commitment, paved the way for the flourishing of Amsterdam's Portuguese Jewish community. According to one story, whose events are variously dated between 1593 and 1597, the English, who were then at war with Spain, intercepted a Spanish ship heading toward the Netherlands. Aboard were a

number of New Christian refugees fleeing Portugal, including the "strikingly beautiful Maria Nuñes" and some of her relatives. The boat and its cargo were seized as enemy property and brought back to England by the British fleet. Its commander, an English duke, fell in love with Maria during the voyage. After they reached port, he asked for her hand in marriage, but she refused. Queen Elizabeth heard about these events and ordered the young woman to be brought into her presence. She, too, was struck by Maria's beauty and grace, and promenaded her about London high society. Despite generous promises and amorous entreaties, all designed to entice her to stay in England, the brave and steadfast Maria insisted on continuing her journey to the Dutch republic, beyond the reach of the Inquisition, where she intended to convert back to Judaism. The queen finally relented, and gave her and her companions safe passage to Holland. In 1598, after the arrival from Portugal of her mother, sister, and two older brothers, Maria married her cousin, Manuel Lopes Homem, in Amsterdam, thus establishing the city's first Portuguese *converso* (and possibly Jewish) household.[18]

A second tale more explicitly involves the introduction of Jewish observance in the city. It recounts the 1602 arrival in Emden (in East Friesland) of two ships bearing a number of Portuguese families and their possessions. The travelers disembarked and, after walking through the town, came upon a house with a Hebrew motto (which they could not read) written above the door: *emet veshalom yesod ha'olam* ("Truth and peace are the foundation of the world"). After some inquiring around town, they learned that this was the home of a Jew, Moses Uri Halevi. They went back to Halevi's house and tried to communicate with him in Spanish, which he did not understand. When Halevi called in his son Aaron, who knew the language, the visitors told him that they were recently arrived from Portugal and wished their men to be circumcised because "they were children of Israel." Aaron responded that he could not, without great risk, perform the ceremony in a Lutheran city such as Emden. He directed them to go to Amsterdam, where they were to rent a particular house on

Jonkerstraat. He said that he and his father would soon follow
them there. The group departed, unsure of what awaited them in
Holland. Several weeks later, Moses and Aaron Halevi found them
in Amsterdam, circumcised the men, and led the re-Judaized *con-
versos* in regular but clandestine services.[19]

The historical truth about the origins of Amsterdam's Jewish
community is in fact more mundane and complex than these
myths suggest, and involves different kinds of journeys undertaken
for a variety of reasons. But inspirational stories like these played a
very important role in the development of the community's iden-
tity and unity. They allowed its members to think of themselves,
whatever their different experiences might have been, as having a
shared history and as being engaged in a common enterprise.
They provided Amsterdam's Sephardim with a sense of belonging
to the same, sometimes embattled but always proud, collective,
much as the tales told about the heroes of the American Revolu-
tion have done for generations of citizens in the United States.

They were all Portuguese Jews. Whether or not they were ac-
tually Portuguese; whether they came directly from Iberia, the
Spanish Netherlands, or elsewhere in the Sephardic diaspora (there
were important communities in Venice, Constantinople, and Sa-
lonika); and whether Portuguese was their first language or the
one they adopted to fit into the community, they were all mem-
bers of *La Nação*. Together they worshiped (first in three separate
congregations and then, after 1639, in the Talmud Torah congre-
gation), celebrated the holidays, and buried their dead. Uniting
them was their belief in a joint heritage and a common sense of
destiny. If the Jews were God's chosen people, then these were
God's chosen Jews.

———

Then there was "them." Poor, dirty, disheveled, uncultured, beg-
ging in the streets—in sum, an embarrassment. They were differ-
ent; they stood out. Unlike the Portuguese Jews, they were unable
or just unwilling to assimilate, at least in appearance, into this cos-
mopolitan society. They were not members of the Hebrew Na-
tion; they were jews.

Until the mid-1620s, the Portuguese Jews were Amsterdam's Jews; there were no others. If one wanted to attend Jewish services, it had to be at one of the three Sephardic congregations; if kosher meat was needed, it had to be bought from a Sephardic butcher. There were a number of Jews in the city from Germanic lands, but not enough to sustain any kind of organized community; there were probably not even enough to constitute more than one regular *minyan*, or prayer quorum (ten Jewish males). They had few resources of their own, so they depended both materially and spiritually on the Sephardim. They worshiped in the Portuguese synagogues, did manual labor for Portuguese employers, relied on Portuguese charity, and were buried in the Portuguese cemetery (albeit in a separate part of the grounds). Above all, they were individuals, not a community. Some of them were refugees from pogroms in the east—especially in Frankfurt and Worms—while others may simply have wanted to make a better life for themselves in a place where they could ply their trades in peace. They were such men as Samson Boquez, who arrived in Amsterdam in 1610 from Italy and was licensed to sell kosher meat in 1623, and Reb Ephraim Ashkenazi, from Poland. Whatever the circumstances of their arrival, once in Amsterdam they were essentially guests of the Sephardim.

This situation started to change drastically in the 1630s and, especially, the 1640s. The series of hostilities and small wars collectively known as the Thirty Years' War devastated central Europe, especially the Germanic kingdoms, principalities, duchies, and minor states. Religion, politics, and economic competition contributed to a truly nasty and seemingly unending succession of battles that ravaged the land and its occupants. As bad as things were for the common people, they were often worse for the Jews. Many fled to the Netherlands not only because of the relative freedom and security there, but to escape certain death.

Ashkenazim—from the Hebrew word for Germany, *Ashkenaz*, although the term is used more generally to refer to Jews from eastern Europe as well—began arriving in Dutch cities and towns (especially Marken and Uilenburg) in the early and mid-1630s, first from the German territories, but soon thereafter from Poland

and Lithuania. By the end of the decade, these mostly Yiddish speakers constituted one-third of Amsterdam's fifteen hundred Jews, with a total city population of one hundred and twenty thousand people. The Chmielniecki massacres in 1648, in which many Jewish communities were completely destroyed, and the Russian invasion of Lithuania sent an even greater number of Polish and Lithuanian Jews westward. By 1672, two hundred thousand people lived in Amsterdam, and the Jews constituted 3.7% (seventy-four hundred) of its inhabitants. The Ashkenazim (or, as they were called by the Portuguese, *tudescos*) now outnumbered the Sephardim by two to one, with almost five thousand *Hoogduitse* Jews worshiping in their own Vlooienburg synagogues.

By the fall of 1635, the Ashkenazim were organized enough to hold their own services outside of the Portuguese halls, when they observed the Rosh Hashanah (New Year) and Yom Kippur (Day of Atonement) holy days. They did have to borrow two Torah scrolls from the Sephardic congregations for their gatherings, and the *davening*, or praying, was done in the private home of Anschel Rood, on the Breestraat. A week later, however, during the festival of Sukkot, they were back in one of the Portuguese synagogues, but only temporarily. Among the reasons for their return was that they could not obtain one of the necessary articles for the holiday: an *etrog*, a citrus fruit that plays a symbolic role in the celebration. By the end of the Jewish year the following fall, they had elected officers for a full-fledged "German" congregation, with Rood serving as *chazzan*, or cantor. Services were held in a rented apartment somewhere in Vlooienburg.

Part of the explanation for the separation of the Ashkenazim into their own congregation, in addition to whatever liturgical differences there may have been between the Ashkenazic and Sephardic services, was the fact that the Portuguese could no longer handle the overcrowding in their own houses of worship. There were just too many people trying to get into the three relatively small buildings that served the Sephardim. But that is not all. When the Portuguese began excluding nonmembers from attending services, it was not only out of a need to free up space—

there was a strong element of prejudice as well. The 1639 regulations of the united congregation explicitly restrict membership to Jews of Portuguese and Spanish descent: "This congregation was founded for Jews of the Portuguese and Spanish Nation who live in this city." Although "Jews of all other nations" might occasionally be allowed to pray in the synagogue, they could not become members.

There was no love lost between the two Jewish communities in Amsterdam. As Jacques Basnage points out in his history, "there are two kinds of Jews in Holland; some are Germans, the others come from Portugal and Spain. They are divided by their ceremonies, and hate each other so much, that it is as if [their differences] were a matter of religion itself."[20]

No matter how ragged they may have appeared, and no matter how lacking they were in what some considered the aristocratic refinements of hidalgo culture, the Ashkenazim felt superior to the Portuguese in matters of the spirit, religious observance, and Jewish knowledge. The Sephardim who first arrived in Amsterdam had lived for a long time under the oppressive domain of Iberian (or, in many cases, Flemish) Catholic society. They were raised and educated as Christians and they had acted (at least in public) like Christians. What choice did they have? In Spain, from 1492 onward (and in Portugal from 1496), the practice of Judaism was forbidden. The order from the monarchs was "convert or leave." Those who chose conversion (and many were not offered any real choice in the matter) often became sincere Christians, but a significant number did not.

Cut off from Jewish traditions, and even from Jewish texts (except the Old Testament, which they found in their Spanish and Latin Bibles), the *conversos* in sixteenth-century Spain and Portugal who did continue to practice Judaism in secret had to make do with what they may have remembered or heard about Jewish law and ritual, sometimes from many generations earlier. When they or their descendants eventually escaped from the domains of the Inquisition and returned to the Jewish fold, be it in Amsterdam or Venice or Hamburg, the transition was not a particularly easy one.

The Jews who founded Amsterdam's Portuguese-Hebrew congregations required a good deal of reeducation before they could constitute a proper Jewish community.

In this respect, the Ashkenazim held the clear advantage. The German, Polish, and Lithuanian Jews who settled in Amsterdam had not been disengaged as a group from traditional Judaism and forced to assimilate into local gentile society. On the contrary, for centuries they and their ancestors had been living the traditional life of the Jew. They knew the languages of the Torah and the Talmud and the demands of *halachah*, or Jewish law. For this reason, a number of Ashkenazim were able to achieve prominence as teachers in the Portuguese community. As a rule, they simply knew more about how to lead a properly observant Jewish life. Not a few of them carried an attitude of open disdain toward their materially more prosperous but Judaically impoverished Portuguese neighbors.

The condescension of the Ashkenazim was nothing, however, compared to the antipathy felt toward them in return by the Portuguese. The Sephardim were contemptuous of the central and eastern European Jews in their midst. They were embarrassed by them in front of their Dutch hosts. They resented their archaic habits and practices, their debased, unintelligible language, and, not least, their shabby dress. The Portuguese wore fashionable, well-tailored clothes, usually indistinguishable from the Dutch styles. From their hats and capes down to their stockings and boots, they affected the manners of Amsterdam's upper-bourgeois class. The Ashkenazim, on the other hand, stood out in their long, dark coats, untrimmed beards, and misshapen caps. Worst of all was their poverty. Those who were not able to find work as shopkeepers, craftsmen, or day laborers—all inferior occupations in the minds of the Portuguese members of Amsterdam's professional and mercantile classes—would go from door to door begging for handouts, a sure sign of idleness to the Portuguese sensibility.

The economic, cultural, and social disparities between the two groups were wide, and the Ashkenazim of seventeenth-century Amsterdam were never able to acquire, in Portuguese eyes, the

prestige or status of the Sephardim. The central and eastern European Jews tended to live not in the upscale brick homes on Breestraat but in wood houses on the more crowded streets and alleys of the Vlooienburg island. (Thus, when Rembrandt was renting a house near the "Sugar Bakery" facing the wharfs of the island, more of his neighbors would have been Ashkenazim than would be the case on Breestraat.) Even the most well-off German, Polish, and Lithuanian Jews were considered to belong to an inferior class, while the poorest of the Sephardim—and a sizable minority of them were poor—were members of a cultural elite. Portuguese Jews were forbidden by their community's regulations from buying kosher meat from Ashkenazic butchers and from joining Ashkenazic prayer services. Nor were they permitted to circumcise Jews who were not of Portuguese or Spanish descent. Needless to say, Ashkenazic-Sephardic mixed marriages were strongly discouraged.

Still, the Ashkenazim were, after all, Jews. A sense of religious solidarity continued to provide the Sephardim with some dutiful feelings toward them. The Portuguese were financially generous toward the impoverished Ashkenazim, at least in the beginning. People tended to give money out of their pockets to individuals begging in the street, and the community as a whole even earmarked a certain amount of funds from its taxes for distribution to the Ashkenazic poor. The sympathy and generosity, however, did not last long. The Portuguese quickly became impatient with their indigent Yiddish-speaking co-religionists. As early as 1632, a bylaw was passed by the Portuguese leaders to discourage handing out money to Jewish beggars. Instead, they set up two charity boxes to collect alms for the poor, "to prevent the nuisance and uproar caused by the Ashkenazim who put their hands out to beg at the gates." Eventually, all private giving to German, Polish, or Lithuanian Jews was banned. Some institutional support continued—most notably through the *Avodat Chesed* society—and the Amsterdam Portuguese congregation was generous to Jewish communities in the Germanic lands and in eastern Europe. But significant amounts of the community's revenues were specifically

allocated "for sending our poor brethren" back to their countries of origin.

———∞∞∞———

A series of thefts in the winter of 1654 probably had nothing to do with these Jewish intramural tensions; it was likely just a coincidence that the thief and his cohorts were Ashkenazim and the victim Portuguese. In any event, in January of that year—while construction was continuing in Pinto's house and Rembrandt's basement—Eleasar Swab, a member of the *Hoogduitse* community, stole from Rembrandt's cellar a large number of rolls of tobacco belonging to Jacob and Samuel Pereira. Swab, alias Eleasar Joseph, alias Lenert Swaeb (a Dutch version), was twenty-seven years old and living in the Jodenhouttuinen (Jewish lumberyard) at the time of the burglary. For a while, he had been working as a tobacco spinner, but he was now obviously seeking other ways to make a living. Swab's accomplice was Hartog Abrahams, a dealer in old clothes. Over a period of six weeks, Swab and Abrahams, abetted by Swab's wife, Judick Salomons, took sixty rolls of the Pereiras's tobacco. According to the notary record of the case, the thieves would sneak into Rembrandt's cellar sometime early in the morning, usually between four and five o'clock. The cellar had its own entrance behind the house that they could approach through a courtyard away from any major thoroughfares. Swab had borrowed a set of keys to its doors from Jacob Machorro, who worked for Jacob Pereira and who was apparently in on the game. Swab had copies made by a local smith, Abraham Hendrickszoon. The burglars were caught and arrested in February. Swab denied everything, even after Hendrickszoon was brought forward as a witness. And why shouldn't he? It was simply his word against the smith's.[21]

It was yet another annoyance for Rembrandt, and it came at a time when he could ill afford to be distracted from his work.

———∞∞∞———

In 1653, Rembrandt confronted a very bleak financial situation; in fact, he faced disaster. At the same time that Daniel Pinto was try-

ing to get him to pay for his share of the construction, Christoffel Thijs was demanding the balance that he was owed on the house— 8,470 guilders, plus another thousand guilders or so in interest. Rembrandt had promised to pay it all by 1646, so it was now seven years past due.[22] He had never been flush with cash. Despite his unquestionable success and the great reputation he enjoyed in and beyond Holland, he was still having trouble getting the lucrative commissions for which he had hoped. Perhaps he needed to do even more portraits and "history" paintings, which were the more popular genres among wealthy patrons. In order to pay off some of the principal that he owed to Thijs, Rembrandt began borrowing from friends and clients. But even these interest-free loans had to be repaid, and after a few years all of Rembrandt's creditors were running out of patience. They must have started to look longingly at his goods, both movable and immovable.

In an attempt to protect his house from seizure, Rembrandt transferred ownership of it to his son, Titus, in May 1656. The rest of his property, however, had to be sold to help pay his debts. In July, the States of Holland granted him a *cessio bonarum*, or "ceding of goods," a form of personal bankruptcy. Rembrandt had to surrender his property and belongings to the Insolvency Court, which would dispose of them through auction to raise money to satisfy his creditors. An inventory was drawn up for the sale, and it reveals the extraordinary quantity and variety of objects that the great painter had accumulated. Besides furniture and ordinary household items, there were thirteen bamboo and seven string instruments, numerous weapons and accessories (including thirty-three antique handguns, sixty "Indian guns," a catapult, and two iron helmets), miscellaneous marine and terrestrial curiosities, and statues of famous philosophers. There were also, of course, many, many paintings and prints, both by Rembrandt and by others, including Giorgione, Raphael, and Rubens. There was one Bible in the house.[23]

To protect Titus and his property from being dragged down with him, Rembrandt had the fifteen-year-old boy declared an orphan. It was not such an absurd scheme; there really was no one

who could effectively manage the young man's estate now that his father was bankrupt and his mother dead. It was also a devious means of sheltering as much of Rembrandt's own property as possible, mainly by transferring it to the "orphan" who, in turn, willed that it revert to his father in case of his dying first—which, tragically, is just how things turned out. The person eventually named by the city's orphan board to serve as Titus's guardian was Louis Crayers, the same man whom Baruch Spinoza had used some years before to shield himself from the creditors of his late father Miguel's estate by having himself declared an orphan at the age of twenty-one.

The proceeds from the sale of Rembrandt's goods were not nearly enough to cover the thousands of guilders he owed. Rembrandt started to fear for the security of his house in earnest, and with good reason. His attempt to renew the transference of the title to Titus was rejected in February 1658. Later that month, the house in which he had lived for nineteen years was sold at auction for a mere eleven thousand guilders. The buyers were two brothers-in-law, who promptly divided the dwelling into two equal halves, one for each of their families.

In March 1658, Rembrandt, Titus, and Hendrickje Stoffels, Rembrandt's onetime housekeeper and now his companion, moved into a rented apartment on the Rozengracht. After almost twenty-five years in the Vlooienburg neighborhood, Rembrandt was no longer living among Amsterdam's Jews.

One Sunday morning, during a visit to Amsterdam, I wanted some bread. With a glass of cold milk, richer than anything one can buy in an American supermarket, it is the only way to start the day in Holland. The Dutch make excellent bread, the best I have ever tasted. It comes in more varieties than someone raised on the Wonder brand would ever imagine possible, all made fresh every day in neighborhood bakeries. The trouble was, it was Sunday. I was staying in a friend's apartment on the Snoekjesgracht, in a building near the spot where Rabbi Saul Levi Mortera once lived—

beside the sluice on the canal next to Daniel Pinto's home, and just at the point where Sint-Anthonisbreestraat turns into Joden-breestraat. Nothing in the neighborhood was open. The bread shops of the city were closed. All, that is, except one.

On the Utrechtsestraat there is a Jewish bakery called Mouwes. It was a fair distance away, at least a fifteen-minute bike ride, and it would take some navigating. Fortunately, the streets at eight in the morning on a Sunday are empty even in Amsterdam. I was soon pedaling across the Amstel River. Once over the wide auto bridge, I immediately turned left and took the road along the water. I would have to make a right turn soon onto the busier Utrechtsestraat. Small pleasure boats were already chugging up the river to the country for a day's excursion, with red, white, and blue flags fluttering on their sterns. The view across the Amstel to the luxury hotels and the Royal Theater was stunning. Because it was such a pleasant ride, and despite my hunger, I intentionally went farther than necessary, turning around only after I had passed the Amsterdam Municipal Archives, where all the records of the *Portugees-Joodsche Gemeente* are now stored.

Once on the Utrechtsestraat I easily found Mouwes. It was the only center of activity on the whole street that morning. Despite harsh fluorescent lighting, the wood-paneled interior still gave off a warm, golden glow through the large window. Inside, I was carried away by the smell. Not the yeasty odor of a bread factory, but the enveloping, comforting fragrance of bread. Anyone who does not know the difference is leading a less than satisfying life.

There was a long line, and it was a good ten minutes before I reached the counter. I chose a large *vollkorn* (whole wheat) loaf, as well as a cookie. I have a weakness for *gefuldekuiken*, the soft almond biscuits made by every bakery and pastry shop in the Netherlands. The bread, wrapped in a single sheet of paper, was warm. When I tapped on the hard crust it echoed. Perfect. If I moved fast enough, the butter I planned to put on it when I got back to the apartment would still melt. I carefully counted out my guilders and left. It was only then, as I unwrapped the bread to take a small piece before putting it in my backpack, that I noticed,

on the bottom of both the loaf and the cookie, a small circular decal. It was made out of edible rice paper. On it, in fading print, was a star of David.

Having to travel so far to find a Jewish bakery, I realized what Amsterdammers have known for decades: Vlooienburg no longer exists. There is still a street called Jodenbreestraat. At its far end, just past the point where it turns into Muiderstraat, the 1675 Portuguese synagogue complex stands as glorious as ever. Services continue to be held here, although attendance is very low. On Shabbat, a decent enough crowd occasionally congregates for *shacharit*, morning devotions. The numbers swell during the summer, when there are many out-of-town visitors in attendance. There is a second, much smaller synagogue about five blocks away, down Weesperstraat.

Most of Amsterdam's Jews, however, no longer live in the immediate vicinity. They have moved to other parts of the city or out into the suburbs. Much of the change stems from the decimation of Dutch Jewry by the Nazis. The Amsterdam community suffered enormous losses. Before the war, there were one hundred and forty thousand Jews in the Netherlands, one hundred and twenty thousand of whom lived in Amsterdam. When the war was over, only around twenty thousand returned from the camps, from exile, and from hiding. But the transformation is also the result of the natural demographic processes of diffusion, dilution, and attrition that, over time, affect the character of neighborhoods in all growing cities. Like New York's Lower East Side and so many other once distinctively Jewish settlements around the world, what remains of Amsterdam's Jewish quarter is mainly a collection of landmarks and memories, a bundle of nostalgic associations and historical expectations that draws tourists.

The most significant physical change came about in 1882. That was the year the rectangular island on which Rembrandt lived for two years effectively disappeared. Two of the canals surrounding it were filled in to create one continuous plaza. Gone was the all-important Houtgracht, which had flowed out into Binnen Amstel and on which all three of the original synagogues

were located, as well as the house serving as the community's elementary school. Amsterdam's Jews did much of their shopping and their catching up on the day's news here, where outdoor markets for vegetables, flowers, and other goods lined both sides of the narrow channel. Today it is a large, open pedestrian mall called the Waterlooplein. It is still a thriving market, but it caters to a very different clientele. Clothing—new and used—is sold at cut-rates; a shirt for two euros (about two dollars), a sweater for five, or a complete athletic outfit for nine. Shoes, handbags, sports equipment, wooden clogs (for foreigners in search of that authentic Dutch look), children's toys, household utensils, Indonesian jewelry and wood carvings, army surplus clothes, electrical hardware, and computer disks are sold at the dozens of stalls and long folding tables. Street musicians and food vendors—herring, french fries, *poffertjes*, sandwiches—crowd the perimeter. On a hot day it is particularly overwhelming. Standing aloof above this acquisitive activity are the Stadhuis (City Hall) and Muziektheater. Nicknamed the Stopera, the Muziektheater is the largest auditorium in the Netherlands. It houses the Dutch national opera and ballet companies. In the early evening, while the flea market closes for the day and opera fans begin arriving for the performance, two very different kinds of crowd mingle on the Waterlooplein.

One no longer needs a bridge to walk over to Breestraat, but the central avenue is still a crowded thoroughfare. It is lined with cafés, both traditional and Dutch, which satisfy cravings for substances other than caffeine. There are book and music stores, a natural foods store, boutiques, and a bicycle shop. The shoppers are mostly young and often, especially at night, very loud. As they move with their bags and backpacks from store to store, they are oblivious to the historic interest of the corner where Daniel Pinto once knocked down a wall and tried to bill Rembrandt for the work. How many of them know that on May 9, 1945, Rabbi Justus Tal, still unaware that his own child had been killed, gathered together survivors of the *Shoah* at the end of this street and pronounced the traditional Jewish thanksgiving blessing, the *shehechiyanu*: "Blessed art Thou, O Lord our God, King of the uni-

verse, Who has kept us alive and has preserved us and enabled us to be present at this time."

The onetime Ashkenazic synagogue, the Groot Synagoge, currently houses the Joodse Historisch Museum. There, one can trace the history of the Jews in the Netherlands and view stunning examples of their material culture. Across from it stands the Mozes en Aaronkerk, a Catholic church, built over what was once a clandestine chapel. The dwelling of Isaac de Pinto at 69 Sint-Antonisbreestraat was almost demolished in the 1970s to make way for a new road. Saved by vigorous student protest, it is now a beautiful public library. Many other structures did not survive rehabilitation. The house of Miguel de Spinoza, in which the young Baruch was raised, is gone. So is the ornate mansion that served the united congregation as a synagogue from 1639 to 1675; it was torn down in the 1930s. There is a parking lot where Rabbi Menasseh ben Israel once lived, and the house of Hendrick Uylenburgh, no. 2 Breestraat, is now, as the bright red neon light informs all passersby, the "Rembrandt Corner" café.

Rembrandt's house is now "Rembrandt's House." Visitors must pay an admission fee of five euros. After the synagogue, it is by far the most popular tourist spot in the neighborhood (as well it should be, since there is so little else remaining). The house itself at No. 4 Breestraat used to be an exhibition space, especially for Rembrandt's graphic works. But renovations next door, at No. 6, have allowed the museum to move its galleries there and to try to restore No. 4 to what it must have looked like when Rembrandt lived there. They have done an impressive job. Off to the side on the ground floor, as you enter, is the anteroom, or *sydelkaemer*, that Rembrandt used for business; he would bring potential buyers here to look at paintings he was selling, his own art as well as that of others. Behind that is the printing room, where he worked on his etchings. The most remarkable rooms, however, are on the third story. At the front of the house on this floor is Rembrandt's painting studio; at the rear is his *kunstcaemer*, where he kept his collection of objects and curiosities (the curators today have assembled there a facsimile collection). Rembrandt's pupils had to make do with work space in the attic.

Residences that still house their owners' art collections—such as the Frick in New York, the Barnes outside Philadelphia, and the Musée Jacquemart-André in Paris—naturally do a much better job than museums and galleries in presenting the works within a personal and material context. Surrounded by furniture and book-filled cases, the paintings and drawings do not look so artificially displayed. They belong to their surroundings and to the lives that arranged them just so. One can see how they were intended to be viewed and appreciated, not just by their owners but also perhaps by their creators.

Rembrandt's home was, while he lived there, a showcase for his collection. His own paintings hung everywhere, but he was also an avid collector of the art of others, and his walls were covered with some of his prized possessions. The entrance hall alone had twenty-five paintings, including four paintings attributed to the genre specialist Adriaen Brouwer and three to Jan Lievens. The antechamber had thirty-nine pieces; the room behind that, seventeen, including one attributed to van Eyck. Rembrandt kept his *Figure of the Virgin* by Raphael in the room next to the parlor, while the Michelangelo (a "painting of a small child") was in the large studio. Only the kitchen, the hallway, and the laundry had no works of art hanging in them.[24] Thanks to the recent efforts of the curators, there are, once again, paintings on the walls of No. 4 Breestraat. But Rembrandt's own collection has, of course, been dispersed. If only that rich artistic setting were what the visitor today encountered when entering the Museum Het Rembrandthuis.

Even that filling in of the aesthetic context, however, would not be enough. The demographic changes in the neighborhood, most of which did not occur until the twentieth century, have ensured that the Rembrandt experience on the Jodenbreestraat can never be re-created.

Graven Images

TWO

DIEGO D'ANDRADA WAS deeply disappointed. What he had asked for was not that difficult: a simple portrait of a young girl—probably his daughter—that he could hang in his home. It would be something for him to remember her by, since she was soon to leave Amsterdam. He had paid Rembrandt seventy-five guilders up front, with the balance due when the painting was delivered. D'Andrada, a "Portuguese merchant," must have been doing quite well, since he had sought out Amsterdam's preeminent painter for the commission. A charming piece in the Dutch style was what he had in mind. At the very least, he expected the picture to bear a reasonable likeness to its model. Surely the celebrated artist was capable of this much (although it is clear, too, that d'Andrada was suspicious from the start).

In the end, what the Jewish patron got was not at all to his lik-

ing. When he lodged his complaint in February 1654, at the public notary's office, he insisted that the portrait, still unfinished, "shows no resemblance at all to the image of the head of the young girl."[1] Maybe Rembrandt's rough style, evident in some other works of this period (such as the magnificent three-quarter-length portrayal of Jan Six), distorted the contours of her face. Perhaps his growing penchant for shadow hid too many of her features. D'Andrada seems to have been familiar with the tone of Rembrandt's work, because he said in his deposition that he had given the artist "sufficient warning beforehand." No doubt he told Rembrandt to keep it simple and not lose sight of the purpose of the painting. D'Andrada now wanted Rembrandt "to alter and retouch the painting or portrait before the departure of the young girl, so that it will be her proper likeness." Otherwise, he had no interest in it. Rembrandt would have to keep the painting for himself and reimburse d'Andrada the advance.

Rembrandt refused. Not out of any sense of pride or artistic integrity, but only because he would not do a thing to the painting until "the claimant pays him the balance due or guarantees full payment by giving a security." Rembrandt would be happy to finish the work and even retouch it, but only if he was certain that he would be paid for his efforts. Besides, it was his word against d'Andrada's as to whether the portrait looked like the girl. Better to submit it to a panel of neutral observers, the board of the city's St. Luke's Guild—the painters' guild—for their judgment. He would change it if they decided there was no resemblance. Then, if d'Andrada still did not like the painting, Rembrandt would agree to keep it for auction at his next sale of paintings.

We do not know what happened to the painting.

The year 1654 was not a good one for Rembrandt in his dealings with his Jewish neighbors. But the remarkable thing about his dispute with d'Andrada is not that it occurred in exactly the same month that he was arguing with Daniel Pinto over who had to pay for the construction materials in their houses and that Eleasar

Swab was stealing things from his basement. Rather, it shows that the relationship between the owner of No. 4 Breestraat and his neighbors went beyond the usual mundane affairs that engage homeowners on the same block and entered into the domain of his art. Rembrandt did not just happen to live among (and bicker with) the Sephardim and Ashkenazim around him—renting out his cellar to them, rejecting their demands for reimbursement, and mingling among them in the casual way that neighbors are wont to do. He also painted, etched, and drew them. Sometimes they even paid him to do it. And, despite d'Andrada's decidedly negative judgment, he did it better than anyone else of his time.

One must be careful here. There is a temptation to romanticize things with Rembrandt—his genius, his passion, even his bankruptcy. It would be easy to construct a legend of Rembrandt the philo-Semite, a man so enamored of his Jewish neighbors— their ancient religion, their exotic customs, their foreign looks— that it forever changed his art. This would be Rembrandt the preeminent, even anointed, painter of Amsterdam's Jews, motivated not just out of convenience and financial gain but genuine feeling. "Rembrandt," writes H. W. Janson, whose textbook survey of the history of art has become a classic and standard fare on most college campuses, "had a special sympathy for the Jews, as the heirs of the biblical past and as the patient victims of persecution."[2] Another scholar suggests that "for Rembrandt, the Jews in their picturesque variety must have held a peculiar interest," and his paintings of them "undoubtedly reflect the spiritual disposition of the painter."[3] After all, is not the warmth of his depictions of Old Testament characters evidence of a deep rapport with the Jews of Amsterdam? It has even been claimed that Rembrandt delighted in finding on Breestraat "a naturalistic depiction of Old Testament stories in real life."[4] Rembrandt's portrayals of Jews are supposed to express an unprecedented empathy between artist and subject and a remarkable emotional tenderness. He understood these people as had no European artist before him. Their history, their legends, and especially their faces were recurring and important themes in his art. This is why he, nearly alone

among non-Jewish artists, is so often featured in illustrated sur-
veys of Jewish art.

He did, it is true, paint, etch, and draw a remarkable number
and variety of stories and figures from the Torah and other Jewish
biblical writings: Abraham, Hagar, Ishmael, Isaac, Jacob, Joseph,
Benjamin, Moses, Samson, Hannah, Samuel, Saul, David, Bath-
sheba, Mordecai, Esther, Haman, Balaam, Tobit, Daniel—the list
goes on and on.[5] He often turned to many different episodes in
the life of an individual—*David and Uriah, David at Prayer, David
Playing the Harp to Saul, David Presenting the Head of Goliath to
Saul, The Reconciliation of David and Absalom*—and some incidents
are represented several times (there are two painted versions of
Joseph accused by Potiphar's wife, as well as an etching). Many of
the paintings are moving, deeply felt works. They come across not
merely as illustrations of Old Testament scenes, but as highly hu-
manized, even personal portraits drawn from a deep familiarity
with Hebrew literature. While other artists painted the Bible,
Rembrandt painted Jewish Scripture. The faces in the paintings
are often supposed to belong to his Sephardic and Ashkenazic
neighbors, while his interpretations of some stories are said to
come from later rabbinic writings that he learned about from his
Jewish acquaintances. (Even his depictions of Jesus, it is some-
times claimed, were modeled by young members of the Portuguese
community.)

Holland's greatest painter, then, was a friend of the Jews. They
owe him "an enormous debt of gratitude," writes the Dutch-Jew-
ish historian Moses Gans, for "there has never been another non-
Jewish artist—sculptor, painter, or writer—to depict this rejected
group of people who, in his own eyes, despite everything, re-
mained God's people in exile, as truthfully as did Rembrandt."[6]
He made it possible to portray Jews as they are, and not as they
appear in the vicious and venomous sermons of their enemies.
And he did so because of a heartfelt respect for their traditions
that arose from his personal encounters along Breestraat. Rem-
brandt collaborated with the community's rabbis, sought their ad-
vice on the depiction of Hebrew inscriptions, and even owned a

copy of Josephus's *Antiquities of the Jews*. What more do we need to know?[7]

Not everyone who accepts this legend thinks it reflects well on its subject. Some of Rembrandt's contemporaries, in particular, were very critical of the attention he gave to things Jewish. The painter Gérard de Lairesse, the author of *De Groot Schilderboek* (The great book of painting) published in 1707, had a good deal of contempt for this master whose paint "runs down the surface of his canvas like shit [*drek*]"—a reference to Rembrandt's preference for thick impasto and crusty surface work. De Lairesse, according to Simon Schama, also loathed Rembrandt's taste in subjects: beggars, actors, and, worst of all, Jews, all unfit for representation in the high art of painting.[8] Compared to the elevated themes in Rubens's grand canvases and the history paintings of such Dutch competitors as Jan Lievens and his former students Govaert Flinck and Ferdinand Bol, Rembrandt was accused—like Caravaggio before him—of bringing art down into the street, if not the gutter.

One way to deflate a legend is to personalize it, to reveal the motives of its propagators. Franz Landsberger, a historian of Jewish art and, in the middle of the last century, a strong promoter of the touching picture of Rembrandt smitten by the Jewish culture around him, concedes that this particular way of looking at the artist is based entirely "upon conjecture and not upon any available evidence." And yet, writing, as he says, "in this era of European Jewish tragedy"—his book, *Rembrandt, the Jews and the Bible*, was published in 1946—he confesses that he finds great comfort in the legend. For "here was a man of Germanic ancestry who did not regard the Jews in the Holland of his day as a 'misfortune,' but approached them with friendly sentiments, dwelt in their midst, and portrayed their personalities and ways of life."[9] Perhaps, Landsberger allows, his own need for consolation in the face of the horrors of the Holocaust led him to see in Rembrandt's paintings more than the extant documentation and even the paintings themselves will support.

Or we can cast our suspicion upon the motives of Rembrandt himself. The art historian Shelley Perlove does this when she sug-

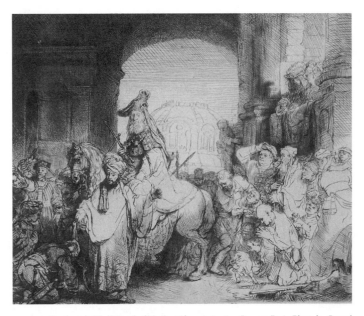

FIGURE I. Rembrandt, *The Triumph of Mordecai* (drypoint), 1641, Louvre, Paris. Photo by Gerard Blot, © Réunion de Musée Nationaux/Art Resource, New York.

gests that much of Rembrandt's interest in Jewish themes in his art arose out of a conversionist persuasion that he shared with a circle of patrons and friends—that is, out of a desire to see the Jews repent the errors of their ways, convert to Christianity and thereby hasten the return of Christ the Redeemer. A number of his paintings and prints, she insists, were directed at a Dutch Protestant audience eager to see the Millennium brought one step closer. The etching *Triumph of Mordecai* (ca. 1642; see figure 1), for example, with its hero playing the allegorical role of pious patriot, is supposed to evoke the prophesy of the restoration of the Temple in Jerusalem through the Second Coming and the establishment of "a utopia of political justice, religious unity and universal salvation."[10] Another scholar, Michael Zell, has argued that it is not just Rembrandt's depictions of Jews and Old Testament subjects that need to be considered in a "Jewish" context, but especially his later works drawn from the New Testament. Zell claims, for ex-

ample, that a number of prints from the 1650s can be understood only in the light of Rembrandt's contacts with contemporary philo-Semites and their conversionist messianism that sought a rapprochement between Jews and Christians.[11]

Finally, one can deny the legend outright. But then there is a danger of moving too far to the other extreme. Gary Schwartz, a prominent Rembrandt scholar, insists in *Rembrandt: His Life, His Paintings*—apparently with reference both to Rembrandt's personal relationships and to the themes and inspirations of his art—that "Rembrandt did not penetrate deeply into the Jewish community." Yes, he lived among them on Breestraat; and yes, there was the occasional collaboration and portrait commission. But, Schwartz implies, to move from these scattered and infrequent projects to an active engagement with Amsterdam's Jews and a deeply philo-Semitic mindset requires a wild leap of biographical imagination.[12]

The truth, as usual, lies somewhere between the extremes. It should be possible to construct a sober and realistic picture of Rembrandt and his artistic relationship with his Jewish neighbors, but this will involve reassessing a good deal of what we, through long familiarity, have come to take for granted, as well as putting some restraints on the romantic fantasy.

What makes the question so hard to resolve is that it is impossible to know whether all of those paintings and etchings by Rembrandt that are purportedly "Jewish"—whatever that might mean with respect to works of art not directly related to a liturgical purpose—really are so. Forget the Bible stories. Abraham's sacrifice of Isaac, Jacob wrestling with the angel of God, Joseph fleeing Potiphar's wife, Jacob blessing the sons of Joseph, and even Moses carrying the tablets of the Law are common themes in Western art. The number of times an artist depicts these subjects means little. Besides the obvious fact that Christians, too, lay claim to Hebrew Scripture, paintings and prints of biblical characters and stories were particularly important in the Dutch republic. Seventeenth-century Calvinist culture was, in self-conscious contrast to Catholic society, deeply oriented toward a direct, personal en-

counter with The Book. People were expected to read and know the stories themselves. And despite the general (and sometimes violent) opposition to images in places of worship, the Dutch appreciated the role that visual representations played in the edification and enjoyment of Reformed citizens. There was a demand for Bible paintings—for pictures of patriarchs and their progeny, heroes and villains—and, for the most part, their production had nothing whatsoever to do with the artist's feelings toward the latter-day representatives of the people of Israel.

Nor are details here and there of any help. Rembrandt's Moses, descending from Mount Sinai with the tablets of the Law, is carrying *two* arched pieces of stone rather than the single sculpted diptych traditional in northern European Christian art (plate 1). Separate tablets are in keeping with Jewish tradition. But did Rembrandt make this iconographical choice out of sympathy with that tradition and even acquaintance (through his scholarly Jewish friends) with a Talmudic dispute on the shape and dimensions of the two tablets?[13] Or did Rembrandt simply notice that the Book of Exodus explicitly says that God wrote the Law for Moses on two stones? Can we ever really know whether, in his unusual decision to include Joseph's Egyptian wife Asenath in his painting of Jacob blessing Ephraim and Menasseh, Rembrandt was (thanks to Rabbi Menasseh ben Israel) influenced by the medieval midrash *Pesikta Rabbati*?

> Jacob saw, in the spirit, that Jeroboam would descend from Ephraim, whereupon the holy spirit departed from him and he was unable to bless the sons of Joseph. Joseph, however, believed that his father deemed his children unworthy of the blessing. Accordingly, he began to beseech him, saying "O father, they are my children, as righteous as I myself am." Then he brought their mother, Asenath, before his father and spoke, "I pray you, father, do it for the sake of this righteous woman."[14]

And is there any definitive reason for thinking that Rembrandt's etching of a scholar in his study suddenly confronted by an ethe-

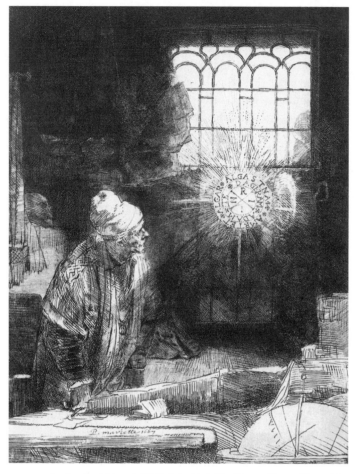

FIGURE 2. Rembrandt, *A Scholar in His Study* (etching), The Pierpont Morgan Library, New York, NY. Photo © The Pierpont Morgan Library/Art Resource, New York.

real inscription floating before his window—a work traditionally labeled *Faust in His Study* (figure 2)—was inspired by Jewish mysticism rather than alchemy and demonic deal making?[15]

Abraham Bredius, the great Rembrandt scholar and a cataloguer of his works, says that one-fifth of Rembrandt's portraits of men are of Jews. That would be an extraordinary figure, if it were

true. The trouble is, there is no way of confirming it. And then there are all those character, costume, and ethnic studies, in which Rembrandt depicts individuals in exotic dress or stylized poses. These works, called *tronies*, a major category of Dutch art that needs to be distinguished from portraiture proper, are often identified as having a Jewish theme.[16] Such an identification may seem to be supported by occasional inventory entries of the period, as in the list of goods drawn up for the 1675 bankruptcy proceedings of Gerrit van Uylenburgh, Hendrik's son. Among the paintings he owned is one by Rembrandt titled *A Jewess*, assessed at one hundred and fifty guilders.[17] But we do not know which work this is supposed to be, nor how authentic the subject identification is. In any number of studies on Rembrandt, particularly books of a certain age, many paintings, etchings, and drawings are labeled simply *Portrait of a Jew*, *Head of a Jew*, *An Old Jew at Study*, *Old Jew in Fur Cap*. But sitters are not documented for any of these works, nor is there any evidence that the subject is Jewish. The identification is almost always conjectured on the basis of the individual's face (What is it? The nose? The eyes? The beard?) or dress (a shoulder wrap taken to be a Jewish prayer shawl or *tallis*, or a head covering taken to be a Jewish skull cap, a *kippah*), or simply the way a book is lying on a table (the spine facing right and ready to be opened and read, as Hebrew is, from right to left). Even the subject of the most famous of all of Rembrandt's "Jewish" paintings, the romantic and tender portrait traditionally called *The Jewish Bride* (and sometimes asserted to be a representation of either Isaac and Rebecca or Jacob and Rachel), is doubtful. Despite the claim of one scholar that "there is no doubt that Rembrandt once again used a Jewish couple (probably Sephardim) to reconstruct a biblical scene,"[18] there are no solid grounds for thinking that either the sitters or the theme are Jewish or even Old Testament.

So much for what we do not know. Nevertheless, some works do undeniably stand out. In 1648, Rembrandt painted the head of a young man; the painting now hangs in the Staatliche Museum in Berlin (plate 2). It shows a dark-complexioned youth, probably in his early twenties. His heavy-lidded eyes are deep brown, as is his

curly hair. His beard, not particularly thick, wraps under his chin and around his face, leaving the tops of his cheeks clean. He has full lips, wide cheekbones, and a prominent, uneven nose. A brimless cap lies on top of his head. Both the cut of the cap and the way it is worn suggest a *kippah*.

A second, remarkably similar painting was done fifteen years later; it is now in the Kimbell Art Gallery in Fort Worth (plate 3). The tone is darker than the first painting, with a more striking chiaroscuro, and this time the eyes are hazel. But the visage, dress (including the skull cap), and pictorial composition are very much like the Berlin portrait. Neither of these paintings has a documented title or identified subject, and their early histories are hidden. But it is very hard to deny the common label they have long carried: *Portrait of a Young Jew*. While one should be skeptical about generalizations such as Landsberger's "Rembrandt utilizes models whose Jewishness is unmistakable," it is almost certain that the sitters for these portraits (one of which was done after Rembrandt moved off Breestraat) were among his Jewish neighbors. By the cut of their beards, they were most likely Ashkenazim.

Or consider another Rembrandt portrait, a three-quarter-length etching from around 1647. The subject has been identified as Ephraim Hezekiah Bueno van Rodrigo (figure 3). Bueno was a learned physician in the Portuguese community. He came from a wealthy and well-connected family that assimilated quickly into Holland society soon after their arrival from Bayonne, in France. (His father Joseph was also a doctor; he attended to Holland's stadholder Maurits of Nassau, prince of Orange, on his deathbed.) Bueno was a friend of Menasseh ben Israel, and he played an important role in the community's religious and intellectual life. Among his many contributions, he subsidized the printing of the first Hebrew prayer book to be published in Amsterdam, in 1627.

Rembrandt's etched portrait of Bueno—an identification suggested first in Florent le Comte's *Cabinet des singularitez d'architecture, peinture, sculpture et graveure* of 1699—shows a well-dressed man descending a staircase. This could easily be mistaken for just another portrait of a prosperous Dutch burgher: turned-back white

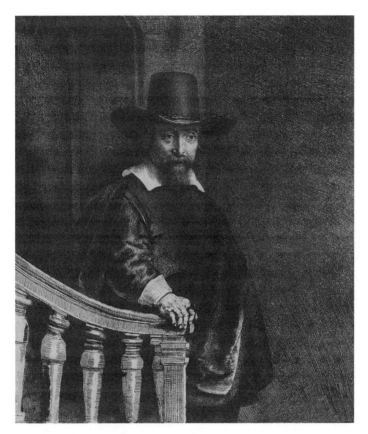

FIGURE 3. Rembrandt, *Dr. Ephraim Bueno Descending a Staircase* (etching, first state), 1647, Louvre, Paris. Photo by Gerard Blot, © Réunion de Musée Nationaux/Art Resource, New York.

cuffs, a bleached collar folded over a dark coat, the neatly trimmed vandyke, stylishly long hair, a tall black hat, even the large bejeweled ring on his right index finger. Typical urban professional, Amsterdam, circa 1650, perhaps a member of the regent class. Thus, it is initially puzzling to read the title provided by Le Comte: *Un Juif descendant un escalier* (A Jew descending a staircase). Only after one notices the strong resemblance between the man in the etching and the face of Bueno that Rembrandt roughly painted on a small panel that same year does the stairwalker's identity (and

Le Comte's label) become clear (plate 4). The painting, a preliminary study for the etched portrait, is a half-length, with only a banister visible in the lower right corner. It is painted in warm tones and captures a playful intelligence. Some have suggested a friendship between Rembrandt and Bueno, but the etching may also have been—like the painted portrait of Jan Six from this same period—nothing more than one more commission from yet another member of Amsterdam's professional class.

Finally, there is a trio of works—an etching, a painting, and an ink drawing—that, while not necessarily constituting a set, seem to be graphically and thematically linked. The painting is in the Staatliche Museum in Berlin and is sometimes given the (once again spurious) title *Old Jew Wearing a Fur Cap*. It shows an elderly man dressed in a heavy, ragged overcoat sitting with a narrow staff in his right hand (plate 5). His beard is long and unkempt, his face haggard below a tall, shapeless red cap. This could easily be a representation of some unidentified biblical character (*Moses with His Rod* might be an appropriate title), or simply a picture of an indigent Amsterdammer. Nothing about the canvas itself would lead one to suspect that it is a portrait of an anonymous local Jew or (since it is more likely a genre painting) a picture of a Jewish subject.

The face, hat, dress, and even the posture, however, are remarkably similar to that of a figure that appears in both a drawing in the Teyler Museum in Haarlem (also with a walking stick) and, even more tellingly, in a well-known etched print from 1648. In the etching, ten men (perhaps significant because of the *minyan*'s requirements) stand or walk together in small groups, with the exception of a single seated figure in the center (figure 4). Two pairs are deep in conversation. All the men are wearing long coats, some of which are fastened at the waist. Seven of them have on what appear to be turbans; one has a somewhat dated scholar's hat; and two wear the high cap seen in the painting of the old man. To all appearances, these are Jews. The etching was made in the year of the Cossack-led massacres in Poland, when Amsterdam, along with a number of other northern cities, experienced a substantial increase in eastern European Jewish immigration. These certainly

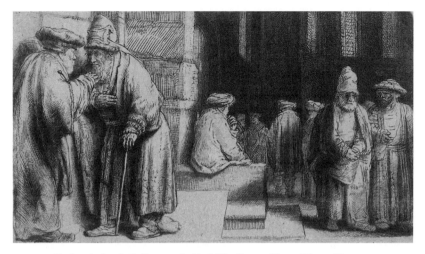

FIGURE 4. Rembrandt, *Jews in the Synagogue* (etching), The Pierpont Morgan Library, New York, NY. Photo © The Pierpont Morgan Library/Art Resource, New York.

could be members of the city's swelling Ashkenazic community; their shabby, shtetl-like clothes suggest as much. The Haarlem drawing, which seems done from life and has been plausibly identified as showing two Jews in conversation, captures a similar subject on a smaller scale (figure 5). The two figures of the drawing are very close in appearance and pose to the individuals on the right side of the etching, which suggests that the ink sketch was a preliminary study for the print.

But is the etching, as the drawing seems to be, a contemporary scene? Since the eighteenth century, when the Parisian art dealer Edmé-François Gersaint describes a print he calls *Synagogue des Juifs*, the etching has usually gone by the title *Jews in the Synagogue*.[19] A problem with this label, however, is that in 1648 no synagogue in Amsterdam even remotely approached the look or dimensions of the building depicted in the print. Rembrandt's men are clustered in a large, medieval-looking stone edifice that resembles a cathedral. The Portuguese synagogue on the Houtgracht was an impressive structure, and very nicely apportioned, but it was relatively small. It had an Italianate exterior, in front of which

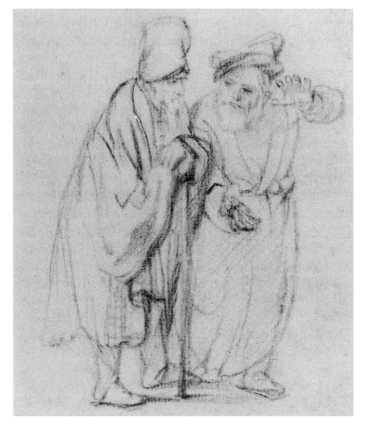

FIGURE 5. Rembrandt, *Two Men in Conversation* (drawing), Teylers Museum, Haarlem.

the well-dressed Sephardic elite would gather before services. The
inside was divided by two rows of wooden columns resting on a
wooden floor, and its windows—unlike the high, thin openings in
Rembrandt's picture—were just above the last row of benches
against the wall. The Ashkenazim, on the other hand, were still
meeting for services in private homes. They were not granted per-
mission to build a synagogue until late in 1648, and it is hard to
believe that, with their limited resources, it looked anything like
the imposing building depicted in the print. Perhaps the print is
not, after all, an etching of a scene from seventeenth-century Am-

sterdam's Jewish quarter, but a depiction of a biblical drama. Is it Jacob and his sons? Judas and his fellow apostles? The earliest extant reference to the print calls it *Pharisees in the Temple*.[20] Whatever the subject, Rembrandt may have used for it Jewish models, among whom could be the same men who appear in the painting and the drawing. And our interest in this print—as well as in the drawing and the painting—is undoubtedly enriched by knowing that Rembrandt certainly did, quite often, see such a gathering of Jewish elders. He needed only to walk out his front door and stroll down the block. It was a scene that could be regularly found in only very few major cities in Europe.

Rembrandt did paint, etch, and draw Jews and Jewish settings. There is nothing legendary about this. The faces in some, and maybe many, of his portraits and history and genre works are Jewish; several of the tableaux that he captures on canvas and paper derive from what he saw in the streets of his neighborhood. Wonderfully, few of his contemporaries found this remarkable. Nor should they have, since there was nothing remarkable about it. Rembrandt was not the only artist in town taking advantage of the opportunities offered in and around Vlooienburg.

A small number of guests were invited to the occasion. Everyone is trying to maintain the dignity and sobriety of their station, but their pride in the moment is evident on their faces and in their posture (figure 6). The men are dressed in their finest, looking to all the world like the directors of a Dutch mercantile company at the end of a very good year. They wear velvet breeches and capes, silk stockings, and fine leather shoes; their stylishly long hair is parted in the center and flows down to bright white collars; there are only a few beards and moustaches. The room reeks of success. But these gentlemen are here not to applaud another profitable quarter, nor to determine what new markets to pursue. Rather, they have gathered to witness the induction of their community's newest member into the covenant of Abraham. They crowd close in around him and prepare to begin the celebration.

FIGURE 6. Romeyn de Hooghe, *Circumcision Ceremony in an Amsterdam Sephardic Family* (drawing), Rijksmuseum, Amsterdam. Photo: Rijksmuseum, Amsterdam.

It is a *simcha*, a joyous event. One of Amsterdam's wealthier Jewish families is celebrating the *brit milah*, or *bris*, of a newborn son. The circumcision is, according to Jewish law, to take place on the eighth day of life. The *mohel* who is responsible for performing the surgery is wearing a *kippah* and stands front and center, just to the left of the boy. He reaches for the instruments and healing balms that are being handed to him on a silver platter. To his right, looking somewhat uncomfortable, is the child's father. In the center, holding the baby on his lap, is the grandfather, acting here as the *sandik* or patron. He is the only one wearing a *tallis*. Some of the guests hold goblets of wine, others have candles. The women are in the background. The mother is still in bed, resting underneath an elaborate canopy. A young girl, her daughter, sits beside her, while another child kneels with her hands in the lap of her grandmother.

We are vividly present at this important moment in the life of a Portuguese Jewish family in Amsterdam thanks to the talents of a

Dutchman, Romeyn de Hooghe. De Hooghe (1645–1708) was one of the greatest illustrators of his time. He worked in a wide variety of media—pen and ink, etching, engraving, painting, sculpture, even coinage—to produce a large number of prints, pamphlets, and book illustrations. As much an aristocrat as the people he so often portrayed—he was admitted to the nobility by the Polish king in 1673—de Hooghe found commissions in the highest circles. He was even present in 1667 to record, in a rather elaborate drawing, the signing of the Treaty of Breda, which ended the second Anglo-Dutch war. The fine detail in his handiwork is impressive; even his rough sketches capture not only the fine grades of facial expression and the texture of hanging fabrics, but also the mood of his sitters and the atmosphere of the setting.

Without de Hooghe, we would know a great deal less than we do about the world of the Jews of seventeenth-century Amsterdam. Through his etchings and drawings, we see them as they were (or at least as they wanted to be seen): their clothes, their homes, their means of conveyance, their neighborhood, even their ancient history and contemporary rituals. With a stipend provided by Jeronimo Nunes d'Acosta, the resident or commercial ambassador in Amsterdam for the king of Portugal and better known within the Jewish community as Moses Curiel, de Hooghe produced nine etchings purporting to show Solomon's Temple in Jerusalem. He also made a number of etchings of the majestic synagogue that the Talmud Torah congregation built in 1675 at the end of Breestraat. He was present during the dedication ceremonies of the building, a gala affair attended by the city's luminaries. He included his own celebratory poems among the Dutch, French, Spanish, Latin, and Hebrew inscriptions on one of the prints.

This was not de Hooghe's only foray into synagogue portraiture. Over the years, he etched multiple interior and exterior views of the city's Sephardic and Ashkenazic houses of worship. These are not just spare architectural renderings, but full portraits of buildings in use by thriving congregations, pictures that are as much about the community itself as its buildings. He also made

prints of the homes of the wealthiest Jews in town. There is the beautifully ornate dwelling of Don Emanuel Nunes, baron of Belmont and local agent for the king of Spain, which sat on a tree-lined canal on the Herengracht (also called the Joden Herengracht) and whose visitors sometimes had to run a gauntlet of aggressive beggars to get to the front door. Another de Hooghe etching depicts the splendid mansion of his sometime patron Curiel. This house is also on the Herengracht, where it towers over the more ordinary homes on either side. It is shown with its interior courtyard and fountain and sculpted shrubberies. Finally, and certainly not least, there is the house of Isaac de Pinto on Breestraat, purchased in 1651 for thirty thousand guilders. It is pictured with the fashionably dressed women of the family leaving for their social rounds accompanied by servants. De Pinto's house was attacked in 1696 by vandals resentful of the city's rich. According to the *Historie van de oproer te Amsterdam voorgevallen* (History of the uprising that occurred in Amsterdam), de Pinto— "popularly known as 'the rich Jew'"—saw his home assailed "with unabated fury." The author says, however, that "it was a mistake for the mob to attack de Pinto's house, for they ran into a trap, with the Jews giving as good as they got."[21]

De Hooghe depicted the Jews at prayer and at business, enjoying the pleasures of leisure and weeping in moments of grief. They are seen attending the community's school, walking to the *mikvah*, or ritual bath, and unloading their dead from barges after the five-mile trip up the river to the cemetery at Ouderkerk. De Hooghe shows them filing into the synagogue for worship, and he memorializes their blind old rabbi, Isaac Aboab, as he is being led by the hand to the pulpit to conduct services.

The identity of the family that posed for the celebration of a *bris* remains a mystery. We do know, however, that it was their first such festivity, because the two older children in the room are girls. It is possible that the newborn is the son of Moses Curiel and his wife Rivka, but it could just as well be one of the other well-off families of the community.[22] They obviously appreciate the finer things in life and can afford whatever they need to make their home com-

fortable. The boy was born into a world of commercial success, and he would be expected to follow in his father's footsteps.

Granted, de Hooghe was no Rembrandt. A churlish critic might even protest (and we can call this the "Norman Rockwell objection") that de Hooghe was a mere illustrator, while Rembrandt was a true artist. De Hooghe documented the world while Rembrandt created his own. De Hooghe pictures the Jews of Amsterdam; Rembrandt, although using his Sephardic and Ashkenazic neighbors as models, transcends their particularities to achieve the representation of ideal human types within biblical proportions.

But this is to miss the point of de Hooghe's art. Beyond the considerable technical skills evident in his work is a remarkable artistry and expressiveness. De Hooghe does not simply record. Whether he takes his model from life or from his own imagination, he is as much engaged in world making as any other original artist. And a lovely, well-ordered world it is, even when beggars intrude. Moreover, his manner of depicting characters and organizing even the most mundane incident (even when these are secondary to the architectural surroundings) speaks volumes about the social, political, and aesthetic values of the artist, his subjects, and his society. It is a message that is extraordinary for its ordinariness.

Christian art, from the early Middle Ages to the late Renaissance, had a distinct iconographic repertoire for dealing with outsiders. It was not just strangers or foreigners who required special attention, but, more important, the spiritual other, the individual who does not share the basic historical, moral, and religious assumptions of the faith. In paintings, prints, illuminated manuscripts, woodcuts, sculpture, mosaics, and tapestries, differences are duly (and sometimes fantastically) noted. There are particular modes of representation for Muslims, heathens, Christian heretics, criminals, and sinners. Often the distinction is indicated by way of clothing, either in style or color: heretics wear yellow crosses, frequently on a garment called the *sanbenito*, while prostitutes are

dressed in red. Sometimes the inner stain is represented on the body itself: the thief in the crowd has red hair, the mocker of the faith stands out with diseased eyes or missing teeth, criminals and witches are shown with shaved heads.

A special effort at demarcation, however, was saved for the Jew, that disbeliever of the lowest rank, the poisoner of wells, kidnapper of children, and murderer of the son of God. Jews are frequently identified in works of art by Hebrew letters (or pseudo-Hebrew writing) on their bodies or on nearby objects. Just as often, the Jew is distinguished by some article of clothing. This was not just an artistic convention. In 1215, the Fourth Lateran Council, concerned about the confusion between Jews and Christians in the Church's realm and thus the "sinful mixing" that occurs when Christians "mistakenly" have sexual intercourse with Jews, decreed that Jews "shall be publicly differentiated from the rest of the population by the quality of their garment."[23] In life and in art, this usually took the form of a badge. In many works, then, the Jew—like the leper, the prostitute, and the heretic—is easily identified by the colored patch on his clothes; for the Jew, it is typically a yellow circle, a chromatic choice reinstated by the Nazis. Frequently, a Jew will also be wearing a distinctive hat, usually red or yellow and almost always pointed, either conical like the dunce's cap or in the shape of an upside-down funnel.

Clothing and badges are marks of moral differences. They single out the wearer as evil or mendacious, a murderer or an unbeliever. The demonization of the Jew, however, went much deeper than this. The portrayals of Jews tend toward physical caricature, sometimes of a particularly nasty nature. The physiognomic exaggerations and deformities that generally characterize them in medieval and Renaissance art are all part of a worldview in which the Jew is not merely morally degenerate, but of a sinisterly different nature altogether. The bulging, heavy-lidded eyes, hooked nose, dark skin, large open mouth, and thick, fleshy lips of Jews in paintings and graphic arts make them look more like cartoon characters than natural human beings (plate 6). The mocking, repulsive faces around Jesus as he carries the cross in Hieronymus Bosch's night-

marish rendering of the Passion are only some of the more ex-
treme examples of what had became a standard artistic formula.
This is more than just ugly stereotyping. The Jew's physical
grotesqueness is a sign that he is "not one of us." At the end of the
day, a badge, a colored cloak, or a hat can be taken off, but the Jew
can never escape his true essence.

This iconographic convention is but a particular expression of
ways of thinking deeply lodged in the European consciousness of
the Middle Ages and even later. Thus, one early modern writer
complains about how difficult it is to find a Jew "without a blemish
or some repulsive feature." For, he continues,

> they are either pale or yellow, or swarthy; they have in general big
> heads and mouths, pouting lips, protruding eyes and eyelashes likes
> bristles, large ears, crooked feet, hands that hang below their knees,
> and big shapeless warts, or are otherwise asymmetrical and malpro-
> portioned in their limbs.[24]

From French psalters of the early thirteenth century, through al-
tarpieces in mid-fifteenth-century Germany, right up to Flemish
painting in the late sixteenth century, the story is pretty much the
same: the Jew's spiritual defects and moral inferiority (not to men-
tion his historical crimes) are reflected in his physical ugliness.[25]
There are exceptions, to be sure, but they are few and far between.

And then we come to seventeenth-century Dutch art, where we
find . . . nothing. Utter plainness. There is a uniformity in the de-
piction of all walks of life. Ugliness and deformity are there, but
they represent the common sins and foibles of all of humankind.
The taverns of Jan Steen and the brothels of Gerard ter Borch have
their share of caricature and lowlife. But there is no special iconog-
raphy reserved for the Jew. The depictions of Jews and their activi-
ties are generically no different from those of wealthy regents,
middle-class merchants, and indigent laborers. The naturalistic
renderings, the settings of everyday life, and the easy integration in
their dress, architecture, and habits into Dutch culture make the
Jews in the art of Holland's golden age perfectly ordinary.

Some idealism and symbolic stereotyping can be found. Jewish liturgical dress—the *tallis* and *tefillin*—is fancifully overdrawn in some renderings, the rabbinic visage a tad too Abrahamic in others. Jewish ritual can, through some artists, take on the appearance of an exotic foreign theater being acted by larger-than-life characters. Sometimes the depicted Hebrew writing is geometric gibberish. But, if anything, exaggeration in the representation of Jewish ritual, manner, and styles—such as the dramatic gestures in the 1637 drawings of Jewish ceremonies by the Haarlem artist Bartholomeus Molenaer (figure 7)—are put to work not to demonize but to ennoble a religion and a culture in the toleration of which the Dutch may take pride.

Even Rembrandt himself was not above using caricature in his depiction of Jewish figures to make a polemical religious point. In a few paintings and prints of history themes, most of them early in his career but sometimes later as well, a Jewish visage or Judaic setting—a Pharisee's posture or dress, or a ceremony in the Jerusalem Temple—is used to highlight, by contrast, a benevolent, universalist Christian message.[26] Sometimes there is a little too much intensity in a Temple priest's face as he stands before Pilate to denounce Jesus' crimes, or an unnatural look of ignorance in the Jew who fails to see that his Law has been superceded by a new covenant.

These representations of type, in the work of Rembrandt and others, are not uncommon. Jews were especially useful as foils to the message of the Gospels in Christian scenes.[27] Still, what is striking is how the celebrated Dutch artistic eye for the natural— the predilection for seeing rather than conceiving—accomplishes for Holland's Jews what it does for its domestic interiors and flower settings. Rembrandt painted, etched, and drew his Sephardic and Ashkenazic neighbors, sometimes for the sake of their biblical potential. Yet even when his compositions have their source and inspiration more in his literary imagination than on Breestraat, the faces and figures are drawn from familiar acquaintance, not prejudice. As Simon Schama puts it, "Michelangelo's Moses has horns; Rembrandt's does not."[28] Romeyn de Hooghe's drawings and

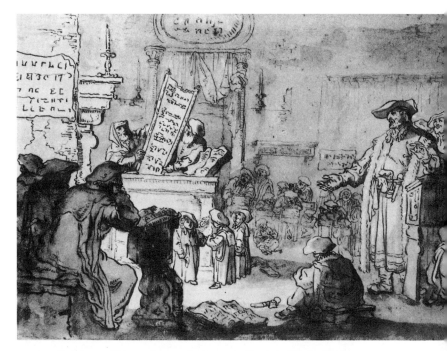

FIGURE 7. Bartholomeus Molenaer, *Synagogue Service, ca. 1637* (drawing), Albertina Museum, Vienna.

etchings are fine examples of bringing to Vlooienburg what one scholar calls "the art of describing," the creative representational impulse that made Dutch artists masters of landscape, portraiture, and still life.[29] More than a century before their political emancipation in the Netherlands, the Jews experienced there an unprecedented aesthetic liberation.[30]

As fine as de Hooghe's achievements are in depicting Amsterdam's Jewish community, he was but one of many seventeenth-century Dutch painters and draftsmen who found these "foreign residents of the Republic of the Netherlands" a source of artistic and even spiritual stimulation.

Nor was Rembrandt the only one to try his hand at a portrait of Ephraim Bueno. A likeness of the eminent doctor was also etched by Jan Lievens, Rembrandt's erstwhile rival in Leiden (fig-

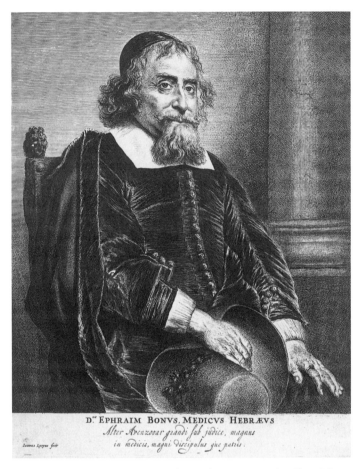

D.ᵉ EPHRAIM BONVS, MEDICVS HEBRÆVS
Alter Arenzoar grandi sub judice, magnus
in medicis, magni discipulus que patris.
Ioannes Lyvyus fecit

FIGURE 8. Jan Lievens, *Dr. Ephraim Bueno* (etching), Rijksmuseum, Amsterdam. Photo: Rijksmuseum, Amsterdam.

ure 8). The image is perfectly natural and perfectly Dutch. Its sitter is dressed just like Constantijn Huygens in the portrait that Lievens painted of this Christian scholar and secretary to the stadholder in 1628, right down to the fur-lined cape. There is one difference, though. Lievens's print, of a somewhat older man than the one descending Rembrandt's staircase, shows a seated Bueno who has removed his wide-brimmed hat to reveal on his head a

kippah. The motto at the bottom praises the subject's accomplishments not only as a medical doctor—*magnus in medicis*—but also as a scholar.

The Amsterdam painter Govaert Flinck, at one time a student in Rembrandt's studio at No. 4 Breestraat and thus not unfamiliar with the neighborhood, also produced some Jewish heads. One of his portraits, possibly a member of the Portuguese community, has often been taken (albeit mistakenly) to be of Rabbi Menasseh ben Israel (figure 9).[31] And we know with even greater confidence than in Rembrandt's case that Flinck used Jewish models for his paintings of Jesus. Here is a poem, capped with an anti-Semitic flourish, by Jan Vos about one such work painted for Joris de Wijze:

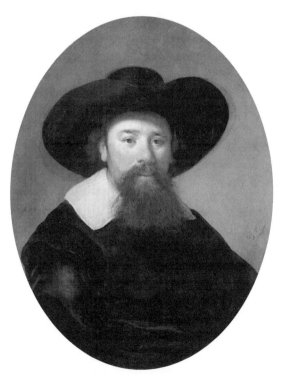

FIGURE 9. Govaert Flinck, *Menasseh ben Israel [?]* (painting), Museum Het Mauritshuis, The Hague.

All that lacks is speech, but Govert Flinck refused
To paint an open mouth despite de Wijze's plea.
For this Christ would not speak of Christ except in blasphemy.
The heart is not reflected by the face that shines at you.
You ask how come? Because the model was a Jew.[32]

Perhaps the employment of Jewish models for history paintings was something that Rembrandt encouraged among the members of his workshop. If so, Nicolaes Maes and Arent de Gelder seem to have taken the lesson to heart when they struck out on their own. Jacob Torenvliet, meanwhile, painted a contemporary-looking but no doubt fictional group of rabbis, heads covered by *tallitot*, dramatically disputing the finer points of Jewish law (figure 10). One of them holds up an open Torah scroll, while his colleagues thumb through what look to be volumes of the Talmud. Pieter van Gunst, Aernout Nagtegaal, and Jan Luttichuys, on the other hand, portrayed actual rabbis in Amsterdam. Van Gunst and Luttichuys (figures 11 and 12) etched and painted Jacob Sasportas, who, after a period in North Africa, divided his time between congregations in Amsterdam, Hamburg, and London. Nagtegaal's mezzotint of 1685 is the only known image of Isaac Aboab da Fonseca (figure 13). The eighty-year-old kabbalist had been a rabbi in Amsterdam for almost fifty years. Jan Luyken, following in the footsteps of de Hooghe, produced a number of etchings of scenes from contemporary Jewish life, including a wedding, a divorce, a man's refusal to marry his brother's childless widow (an obligation he bears by Jewish law), and a circumcision ceremony, this time with the act in progress.

FIGURE 10. (opposite, top) Jacob Torenvliet, *Rabbis Disputing the Law*, Rijksbureau voor Kunsthistorische Documentatie, Den Haag, The Netherlands.

FIGURE 11. (opposite, bottom, left) Peter van Gunst, *Rabbi Jacob Sasportas* (engraving), Bibliotheca Rosenthaliana, Universiteitsbibliotheek, Amsterdam

FIGURE 12. (opposite, bottom, right) Johannes Luttichuys, *Rabbi Jacob Sasportas* (oil on canvas), Israel Museum, Jerusalem. Gift of Friends of the Israel Museum in Holland through Mr. Bernard Houthaker, Amsterdam. Photo © The Israel Museum, Jerusalem.

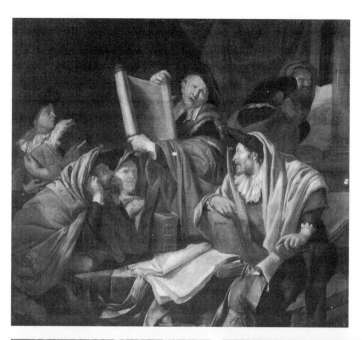

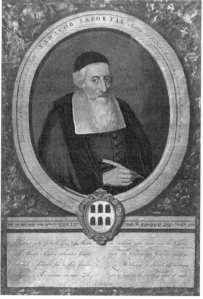

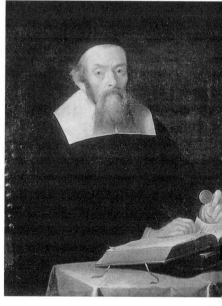

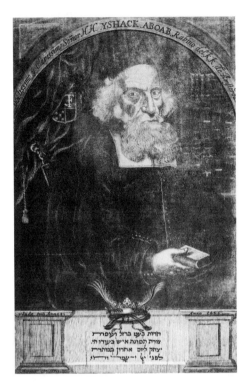

FIGURE 13.
Aernout Nagtegaal,
Rabbi Isaac Aboab da Fonseca
(mezzotint). Photo courtesy
of the Library of the Jewish
Theological Seminary,
New York.

Not everyone in the republic was able to regard the growing
and prospering Jewish population with such aesthetic detachment.
Thus, depending on the direction of the political winds, there
could be some risk for an artist who took his theme from that
community. And it was not only the reputation of one's art that
might suffer. Although de Hooghe did not live among them, he
was, like Rembrandt, close to Amsterdam's Sephardim. Perhaps
too close for some of his contemporaries. Amsterdam in the sec-
ond half of the century was not a good place to be a supporter of
William III, the stadholder of Holland from 1672 on and, after
1688, the king of England. Like many of his wealthy Portuguese
sitters, de Hooghe lent his hand to William's cause, contributing
through his prints and broadsides to the political propaganda for
the prince of Orange. The liberal, republican-minded regents of

Amsterdam, on the other hand, favored the more decentralized, stadholderless federation of provinces that constituted the Netherlands from 1650 until William's appointment. The anti-Orangists launched a pamphlet campaign against the stadholder and his supporters, explicitly including de Hooghe. Among other scurrilous charges against the artist, he was accused of being married to a woman who was having sexual relations with Portuguese Jews.[33]

Fortunately, the voices of prejudice, even after the end of the period of True Freedom in 1672, were, at least with regard to the nation's Jewish residents, of no great consequence. Amsterdam's Jews, in particular, continued to fascinate the republic's artists who pursued their visual study of Jewish accomplishment and ritual.

In a few cases, Dutch painters—some of great repute and art historical importance—went well beyond the bounds of sedate portraiture and genre works. Emanuel de Witte, known for his architectural renderings of the interiors of Dutch churches, painted a broad interior view of the Talmud Torah congregation's 1675 synagogue on Breestraat three times (plate 7). The paintings are rich with color and incident, as they capture a crowd of visitors at a moment during a prayer service. The famous landscapist Jacob van Ruisdael, on the other hand, found his inspiration upriver at Ouderkerk. He produced two fantastical paintings in the mid-1650s based on the Portuguese Jewish cemetery there (plates 8 and 9). We will return to de Witte and Ruisdael later.

Why was there all this interest among Dutch artists for Jewish themes? Why is it that here, for the first time in the history of European art, after centuries of artistic vilification, the Jews and their ways were the subject of naturalistic, even idealistic representation?

Well for one thing, the Jews themselves were paying for it.

⸺◦◦◦⸺

Let us take a moment to enter one of those fine, stately homes in Jewish Amsterdam—perhaps de Pinto's manor on Sint Anthonisbreestraat, or the Belmonte or Curiel properties on the Herengracht. To judge from the room depicted in de Hooghe's drawing

of the circumcision ceremony, it will be like walking into any other wealthy household in one of the upscale parts of the city. Fine rugs lie on the scrubbed, broad-planked wooden floors, tapestries hang over long, carved tables. The anteroom's marble floor, laid out in a pattern of black-and-white squares and instantly recognizable from interiors by Vermeer and de Hooch (if the floors in their paintings are authentic), is left uncovered. Brass chandeliers hang low to provide light when the floor-to-ceiling velvet draperies are drawn over the tall, multipaned windows. Curiosities and faux antiquities sit on the mantle above the fireplace; hanging beside them are crossed swords and a shield. If it is a particularly warm day and the windows and their half-length wooden shutters are open, the noise from the traffic in the street and the smells from the canal might be overbearing, and the company will have to retreat into one of the inner rooms, toward the courtyard, for a quieter, more serene setting.

And there, on the walls, are paintings. Large paintings and small paintings, elaborately framed canvases and simply hung panels, paintings raised high above the doorways and paintings at eye level. There are history paintings, portraits, and city views; still lifes, genre scenes, and landscapes. Works by minor, sometimes anonymous artists and by local specialists in one genre or another share the space (if our host is wealthy enough) with fabulous masterpieces. Some of the paintings were bought at the city's art markets and fairs; others were acquired through dealers or at public auction; a few were even commissioned.

Hanging behind the *bris* gathering captured by de Hooghe, high on the wall of what may be Moses Curiel's home, are two large history paintings, both of biblical scenes. On the left is *Ezekiel's Vision*, in which the prophet, who kneels in the foreground, sees an angelic creature borne on a cloud ("a vast cloud with flashes of fire and brilliant light about it") accompanied by a glittering wheel (Ezekiel 1:4–21). The other painting depicts Elijah being fed by the ravens ("The Lord said, 'Leave this place and turn eastwards; and go into hiding in the ravine of Kerith east of the Jordan. You shall drink from the stream, and I have com-

manded the ravens to feed you there'" [1 Kings 17:1–6]).[34] We have no reason to think that the Jewish owner of this house was, in his taste for art, anything but typical among his social peers. Nor should we be surprised by this.

One of the great and abiding fictions about Judaism is that it involves a wholesale rejection of the visual arts. Throughout history, it has often been said, Jews tended not to engage in the production, the sponsorship, or even the collection of artworks, and certainly not those that depict people, animals, and nature (which just about exhausts the subject matter of much of European art until the early twentieth century). From Moses' face-to-face meeting on Mount Sinai with God, whose second commandment to him was that there shall be no graven images, to the idea that the prominence of Jews among the pioneers and critical defenders of abstract modern art is the culmination of an inherited cultural resistance to figurative representation, Judaic law is believed to have discouraged Jewish patronage in painting and sculpture.

This is, however, simply not true. Indeed, if there is such a thing as a Jewish attitude toward art—and we should be skeptical that there is—it is a function not so much of some unequivocal and universal understanding of the Law but rather of changing historical, intellectual, and material circumstances. There is enormous variety in the ways in which, over the centuries, Jews have thought about art and used the arts to express themselves. The history of Jewish culture is full of joyous, sad, colorful, bleak, harmonious, disturbing, celebratory, memorial, liturgical, and just plain decorative works of art, many of them figurative or representational. Forget such an obvious counterexample to the myth of the artless Jew as Marc Chagall. Consider instead the enormously rich traditions of synagogue art (mosaic, stained glass, tapestry); manuscript illumination; ceremonial objects, especially for the home; *ketubot*, or marriage contracts; and illustrated life-cycle commemorations.

The second of the *mitzvot* communicated to Moses for the people of Israel is "You shall not make for yourselves a graven image or any likeness of anything that is in heaven above, on the

earth below, or in the water under the earth." At first glance, this looks like a blanket prohibition on artistic images. It would seem to rule out not just idols and depictions of God, but figurative representations of any kind. And yet, the history of Jewish religious and philosophical thinking on the correct interpretation of the Second Commandment is characterized by great diversity and creativity, as is the history of Jewish enforcement of restrictions on artistic imagery.

The intent of the Second Commandment is clearly to prevent the Israelites from engaging in the kind of idolatry that was common among neighboring peoples at the time and that threatened the nation's political and religious unity and uniqueness. But what this required was up for debate. A rabbinic disagreement recorded in the Mishnah is typical:

> All images are forbidden because they are worshipped once a year. So [said] Rabbi Meir. But the Sages say, only that which bears in its hand a staff or a bird or a sphere is forbidden. Rabban Simeon ben Gamaliel says: That which bears anything in its hand [is forbidden].[35]

At any given time, the position adopted by a Jewish community's leadership is usually a reflection of the relative strength of the local threats of idolatry. Taking their point of departure from Rabban Simeon, many have argued that the kinds of images that the Second Commandment forbids are only those that *explicitly* encourage idolatrous worship, such as religious icons, representations of divine or angelic beings, and ornate religious statuary. As a way of building stronger protections around the Law and forestalling even the temptation toward idolatry, however, some have broadened the scope of this injunction. Maimonides, the illustrious twelfth-century rabbi and philosopher, believed that the Second Commandment is to be understood as forbidding all three-dimensional images of human forms, either in freestanding sculpture or in relief, regardless of whether or not the image is actually for idolatrous purposes. And there are to be absolutely *no* images of heavenly bodies, because these were commonly regarded as gods by gentiles. Two-dimensional painted images of people and

other terrestrial beings, on the other hand, are allowed. "If the form is sunken, or of a medium like that of images on panels or tablets or those woven in fabrics, it is permitted."[36]

Rabbi Joseph Caro, the sixteenth-century author of the legal compendium *Shulchan Arukh* (The ordered table), is more lenient than Maimonides. He is willing to allow even three-dimensional images "made for beauty"—images of human beings, beasts, and nature—with only certain exceptions related to actual idolatrous practices. "The forms of the sun and the moon and the stars, whether in relief or sunken, are forbidden." Even these, however, are permissible if they are to be used in teaching.[37]

The Second Commandment, then, was always open to a wide array of interpretations. Rare is the Jewish authority who issues a categorical ban on all images. Only slightly less uncommon is the rabbi or community leadership that forbids all representations of people, animals, and natural objects. Even Rabbi Moses Arragel's fifteenth-century ban in Toledo on faces and other images in an illuminated Bible was more a matter of propaganda directed at Christians than a guide for practice.[38] (Arragel himself supervised the illuminations in the Alba Bible that he translated from Hebrew into Spanish.) Rabbis responded to the practices and urgencies of their times, and usually kept up with the tastes of their congregants. Compromises, inevitably, were required. Thus, in the seventeenth century, Rabbi Leon Modena of Venice noted, with an evident tone of resignation, that "there are many here who have freed themselves from this restriction [on graven images] and have paintings and portraits in their homes, although avoiding works of sculpture, both in relief and in the round."[39]

The situation in Amsterdam was complicated, especially for a Jewish community trying to navigate its way through turbulent religious and political waters. On the one hand, the strict Calvinists had nothing but contempt for image making. Preachers would fulminate against the adornment of church walls with worldly representations; that, they argued, was for idol-worshiping Catholics, but not for members of the Reformed faith. It would have been easy and expedient for the Jews to cast their lot on this matter with the social conservatives, particularly given that most of the

opposition to their residence in the Netherlands came from this quarter. The Jews could have adopted a rigorous interpretation of the Second Commandment and discouraged the making and collecting of images.

On the other hand, *everyone* was buying paintings—especially the Calvinists. Pictures hung everywhere (except, of course, in their churches): in sitting rooms, private salons, public spaces, business offices, the small shops of tradesmen, even in kitchens and taverns, as the scenes so common in Dutch genre painting show. The tailor's workshop would have a landscape on the wall; the ale house, a marine scene. Jean Nicolas de Parivel, a French visitor to the Netherlands in the period, was amazed at the ubiquity of paintings in so many different venues and among all the strata of society: "I do not believe that so many good painters can be found anywhere else; also, the houses are filled with very beautiful paintings, and there is no one so poor who does not want to be well provided with them."[40] By one estimate, there were close to five million paintings produced by thousands of painters in Holland in the seventeenth century.[41] This is an extraordinary number, especially since the total population of the republic was only around eight hundred thousand individuals.

In the end, social and aesthetic assimilation—and, perhaps, taste—won the day with Amsterdam's Jews, at least among the Sephardim. They had money to spend, and many chose to use it to acquire art. The rabbis were willing to go along. Saul Levi Mortera conceded that Jews could own works of art—both two- and three-dimensional—since they were not in and of themselves idols.[42] And in a written opinion on the question titled "On the Use of the Painters," Rabbi Moses d'Aguilar saw no reason to ban painted images in the homes of Amsterdam's Portuguese community.[43] He did, however, recommend restraint and good sense.

⸺⸺

When Lucas van Uffelen died and his estate went up for sale in 1639, art dealers and collectors throughout Amsterdam were abuzz with anticipation. The jewel of his collection was the por-

trait of Baldassare Castiglione by Raphael, a well-known painting by one of the most celebrated artists in history. For such a prize, the bidding was sure to be highly competitive. Thousands of guilders would be needed to buy a work of this caliber. When auction day arrived, there, sitting among the wealthy merchants and professionals in the room, all eagerly anticipating the moment when the painting would take its turn on the block, was Rembrandt Hermanszoon van Rijn. He had just recently announced that henceforth he, too, like Raphael—and Michelangelo and Leonardo—would go by his first name alone. Studying the treasure about to be sold, he made a rough sketch of the painting in brown ink. He certainly wondered how high a price it would fetch. Perhaps he wanted to buy it himself, and put in a bid or two. He knew, though, that he could never keep up with the rich buyers and well-supplied agents around him.

The painting, a major masterpiece (now in the Louvre), eventually went for thirty-five hundred guilders; Uffelen's whole collection netted almost sixty thousand guilders. Among the late contenders for the Raphael was the painter Joachim von Sandrart, who dropped out at thirty-four hundred.[44] The winning bid came from Alphonso Lopez, known to the city's notaries, as so many of the Sephardim were, as a "Portuguese merchant in Amsterdam."

Lopez, who was born in 1572, made his fortune in textiles and diamonds. Probably not a member in good standing of the Talmud Torah congregation, he reportedly converted to Christianity while living in France, although this may have been a ruse to help his business along in a country from which Jews were still officially banned. He was the supplier of diamonds to, among others, the stadholder, Prince Frederick Hendrik. He was also the resident in the Netherlands for the king of France and his minister, Cardinal Richelieu, for whom he bought both arms and art. His home for the few years that he was in Amsterdam was on the Singel, outside of the Breestraat district and one of the most beautiful of the city's main canals. An enthusiastic collector, Lopez probably hung his new Raphael not far from his two Titians, including the *Portrait of a Gentleman* (now in the National Gallery in London) that he had

acquired some years before. One wonders whether these were among the works sold in the auction of his painting collection that was held in 1641, just before Lopez left the republic. Two years is much too short a time to own a Raphael.[45]

While Rembrandt may have been jealous of Lopez's capacity to buy high-profile paintings, the diamond merchant was willing to share with the painter his good fortune. Lopez invited Rembrandt into his home to view his collection, and even bought a painting from him, *Balaam's Ass Admonishing its Master*, painted more than thirteen years earlier, in 1626, while Rembrandt was living in Leiden.

Jewish sales and commissions were probably not unusual for Rembrandt. Although there are few documented instances of Jewish patrons and buyers of his art, the ones we do know about are ordinary enough to suggest that it was a common transaction. They also indicate that doing business with his Breestraat neighbors was not always easy for Rembrandt. The dispute with Diego d'Andrada over the commissioned portrait of a young girl is only one instance of a deal that went sour and ended in the notary's office.

In 1637, Samuel d'Orta, "a Portuguese painter residing in this city" according to a notary document, bought from Rembrandt the etching plate that he had used that year for the print *Abraham's Dismissal of Hagar and Ishmael*. D'Orta most likely intended to make some money marketing "Rembrandt pictures." The agreement between the two artists was that d'Orta would allow Rembrandt to keep a small number of the impressions already made from the plate, "which he [Rembrandt] stated would be for his own use and curiosity." Rembrandt, however, was not permitted to sell any of them, as that would detrimentally affect the value of the plate for d'Orta. Unfortunately, Rembrandt seems not to have been able to control himself, and did exactly what he had agreed not to do. D'Orta consequently gathered a number of witnesses—all Dutch—at his house one evening and complained to Rembrandt in their presence that "he [Rembrandt] had not treated him properly." Rembrandt admitted the deed, but promised "not to

sell the three or four [prints] that he still had in his possession."
D'Orta did not have much confidence in Rembrandt's word, for
on the very next day he went around to collect those same wit-
nesses—the twenty-year-old Outger Maertszoon Groot and six-
teen-year-old Dirck Hendrickszoon—and took them in the De-
cember cold to the offices of the notary Benedict Baddel. There
they were asked to tell exactly what had happened the day before,
with Baddel duly recording their account.[46]

D'Orta was a shrewd businessman. He knew that there would
be buyers for the prints in his own community, as well as beyond.
He probably dealt in other kinds of artwork as well. Painters in
this period frequently operated as private dealers; Rembrandt did
it, so did Vermeer. From their studio/galleries, they sold their own
work as well as the works of others. As an insider, d'Orta no doubt
knew the means and tastes of his fellow Portuguese.

Major collectors in the Amsterdam Sephardic community in-
cluded Gaspar Duarte, who competed with Lopez not only in
providing diamonds to the prince of Orange but also in amassing a
sizable gallery of world-class paintings; and Isaac Orobio de Cas-
tro, a physician who immigrated to Amsterdam from Spain in 1662
after a short stay in France. Orobio quickly became one of the
leading intellectuals of the Portuguese community. (He launched
the only known written attack from within the Jewish community
on Spinoza and his heretical views.) Romeyn de Hooghe appears to
have had a special relationship not only with the d'Acosta-Curiel
family, producing etchings of their art-filled home and (in all like-
lihood) of the *bris* held there, but also with the Portuguese Jew
serving as resident in Amsterdam for the king of Poland, Francis-
cus Mollo, whose wedding to Maria Ooms he captured in an alle-
gorical print in 1673.

But art collecting was not limited—no more among the Jews
than among the Dutch—to the wealthiest few. Merchants operat-
ing on a smaller scale than the Belmontes and the de Pintos, hum-
ble shopkeepers, and even lowly tradesmen (such as the kosher
butcher) all had an ardor for paintings, prints, and drawings. Just
like the Dutch, Amsterdam's Jews, while keeping their houses of

worship free of images, indulged their aesthetic pleasure in their private homes. A survey of twenty-two estate inventories of Jewish homes from the offices of the notaries Dirck van de Groe and Adriaen Lock, who had many Sephardic clients (probably because they spoke Portuguese), turned up, among the Sabbath candelabras and Hebrew books, over four hundred and thirty paintings. Their owners ranged from rich traders to poor widows, with addresses on the affluent canals and among the humbler dwellings on the narrow streets of Vlooienburg island.[47] The walls in Jan Cardoso's home, for example, were well decorated with genre scenes (including a "pub" by Adriaen Brouwer), still lifes, portraits, military tableaux, mythological pictures, and biblical works ("Noah's ark . . . a large painting of Tobias, and a painting over the mantelpiece of the prophet Elijah"), thirty-seven paintings in all.[48] Abraham Abenjacar, as his 1648 inventory reports, owned twenty-five paintings.

A number of Amsterdam's Jews were certainly able to afford a Rembrandt oil painting (which could cost several hundreds of guilders, depending on its size) or commission a de Hooghe drawing. Others were perfectly happy with what they could find cheap at a stall in the marketplace.[49] Art was a relatively inexpensive commodity in seventeenth-century Holland. If we exclude the most expensive paintings (those selling for over one hundred guilders), then the average assessed value of a painting was, according to a survey of estate inventories, only about fifteen guilders. The average price of a picture sold at auction was even lower, around two and a half guilders—well within the means of the more modest household.[50] A small painting picked up in a shop off the street or at the fair could be cheaper still. Even the well-off did not limit themselves to high-priced, envy-generating acquisitions. Sometimes sentiment played a more important role than monetary value in Jewish art buyers' tastes. Hanging in the home of David de Abraham Cardozo on the Sint-Anthonisbreestraat was one of the paintings that Emanuel de Witte did of the interior of the new synagogue that the Portuguese community built in 1675. Cardozo belonged to the Talmud Torah congregation and no

doubt contributed to the fund for the construction of the new building. When he died and passed the work on to his "good friend," Jacob Nunes Henriques, its value was assessed at twenty-eight guilders.[51]

What did Jewish art buyers in Amsterdam like? Prints, for one thing. Not just the portraits of synagogues and scenes from contemporary life that de Hooghe, Luyken, and others specialized in, but also subjects from Jewish history and the Bible. Rembrandt's etching of Abraham and Isaac of 1645 is thought to have been done for a Portuguese-Jewish patron.[52] It shows the moment when Abraham, with his knife sheathed at his side and his son holding the bundle of wood that they have carried up to Mount Moriah, points to the sky and tells Isaac that "God will Himself provide the lamb for the sacrifice." It would not have been out of place hanging in the sitting room of a Sephardic home. Neither would any of Rembrandt's depictions of scenes from the Book of Esther. The former *conversos* who were once forced to hide their Jewishness in a Christian culture felt a particular affinity for the character they knew as St. Esther, who had to keep her own Jewish background a secret from her husband, Ahasuerus, the king of Persia.

Jewish collectors, large and small in scale, enjoyed thematically independent prints, illustrations for books, and other works on paper. Their taste also ran strongly—and expensively—toward illuminated manuscripts, especially Passover *Haggadot*, Esther scrolls, and Bibles in Hebrew, Spanish, and Latin. The Portuguese were frequent attendees at estate auctions where these more valuable items were up for sale, and it is not unusual to find in the inventory made after a wealthy Jewish collector's death a very fine selection of rare books. These were, however, usually kept within the family and passed down to the next generation. Jacob d'Acosta owned a twelfth-century manuscript of the Hebrew Bible, which he left with the rest of his collection to his son Jeronimo when he died in 1665.

Then there are the paintings of subjects from Hebrew Scripture. Among the works listed in inventories of family assets from

the community are paintings of King Ahasuerus, "The Children of Israel," the Temple of Solomon, Tobias, Noah's ark, and the dying Rachel. For all we know, a fair number of Rembrandt's Old Testament works might have been done for Jewish patrons. Unfortunately, there is no documentary evidence to support this. However much we might like to believe that Rembrandt's depiction of Moses holding *two* tablets of the Law and some of his paintings of Abraham or David were done at the request of wealthy members of the Talmud Torah congregation, the truth is that we simply have no record of who commissioned them. What we do know is that these Jews were fond of hanging paintings of stories from Hebrew Scripture in their homes. According to an inventory drawn up by the notary Lock, Aaron Querido had pictures depicting "Abraham and Hagar [two versions], Moses, Abraham and Lot, Abraham and the angels, Solomon's Judgment, King Balthasar, the meeting of Jacob and Esau, Absalom, Abigail, Abraham's sacrifice, Rebecca, the Ten Commandments and Queen Esther [two versions]."[53] Of Abraham Abenjacar's twenty-five paintings, seven were of biblical subjects, while Salvator Rodrigues's collection of twenty works contained seven whose themes came from Hebrew Scripture.[54] Alfonso Lopez, if we can count an ostensibly lapsed Jew, bought the painting of Balaam and his ass from Rembrandt. The family memorialized in de Hooghe's circumcision drawing has two Bible paintings on one wall. A preference for large, elaborately framed "religious" works, such as we find in this print, was probably as widespread among the Sephardim as it was among the Dutch. It was a taste the hidalgo members of this community founded by former *conversos* may have acquired over generations passed in Catholic high society in Spain and Portugal.

What Amsterdam's Jews seem not to have gone in for, however—at least if we judge by the evidence at hand—were portraits. In this, they could not have been more unlike the Dutch. In seventeenth-century Holland, portraiture was the third most popular genre of painting, right behind landscapes and histories, including Old and New Testament subjects, classical, literary, and mythological themes and modern historical events. This was especially true

for the moneyed class, and particularly among members of regent families, who hoped to immortalize the prestige and power that they exercised in the city's affairs through suitably imposing portraits.

The number and variety of Dutch portraits still extant is impressive. There are pictures of individuals' heads and half-length, three-quarter length, and full-length body portraits. Some of these are miniatures, others are close to life-size. There are individual portraits of lone sitters, paired portraits of husband and wife, and single portraits of married couples. Members of organized groups would commission ensemble portraits—such as the company of Frans Banning Cocq's militia shown in Rembrandt's *Night Watch* or the regents of the Old Men's Alms House painted by Frans Hals—to hang in their headquarters. Powerful political figures ordered their own portraits for commanding display in the appropriate arena. Nor was it uncommon for a family to devote an entire room of its home to creating a genealogical gallery. Even the local brothel lined its hallways with portraits of the women available to clients. Portraiture was the Dutch artist's bread and butter. Paintings and prints depicting known people were everywhere.

Except, it seems, among the Jews. There is a striking dearth of extant portraits—painted or otherwise—from the Dutch Jewish community in the seventeenth century. And to anyone familiar with that community's history, this is a highly curious detail indeed.

From Holland in this period, there are only two known portraits of Ashkenazim that are not pictures of rabbis. Both were painted in Amsterdam. One depicts an unidentified physician from Prague who was visiting the city; the other is of Susskind Stern, a local money-changer and jeweler. But this alone should not surprise us. Most of the commissioning and collecting of art by Jews in Amsterdam was done by the Sephardim, not the Ashkenazim. It was the Portuguese who had the disposable income and, just as important, the motivation to line the walls of their upper-class homes with paintings and other works. German and eastern European Jews, on the other hand, with their lower degree of assimilation to Dutch ways and more traditional Jewish observance,

might have been more scrupulous and rigorous in their interpretation of the Second Commandment.

But even Amsterdam's Portuguese appear to have shied away from traditional portraiture. We know that portraits were commissioned and collected on some scale. Pictures of the congregation's rabbis, for example, were popular. (Some of these were commissioned by the governing board to be hung in their meeting room.) And about one-eighth of the paintings in the private inventories drawn up by van de Groe and Lock are identified as "portraits." But they are greatly outnumbered by landscapes and Bible scenes. Moreover, most of them seem to have disappeared from view, possibly lost, destroyed, or kept within families and hidden away in bedrooms or attics, far from public scrutiny. From the period between 1620 and 1680, there are only seventeen known portraits of members of the community. Together they depict fifteen identifiable individuals (although some of the identifications are uncertain), and most of them are not even paintings. They run from a crude portrait that Moses Belmonte made of his mother, Simcha Vaz (one of the first Portuguese Jews to settle in Amsterdam and the wife of Jacob Israel Belmonte), to etched images of the community's rabbis, to an anonymous painting of the wealthy Don Antonio Lopes Suasso. The men captured for posterity, mostly in etchings, include the rabbis Menasseh ben Israel, Isaac Aboab, Jacob Judah Leon, Joseph Delmedigo, and Jacob Sasportas; the physicians Ephraim Bueno, Abraham Zacuto, and Samuel de Lion Benavente; the poet Daniel Levi de Barrios and his family; and the merchant Gaspar Duarte. There is, besides the picture of the de Barrios family, only one known group portrait from the period: de Hooghe's circumcision print, which is most likely of the d'Acosta-Curiel family and its guests. Several of the individual portraits come from the frontispieces of books, and so were not meant to be hung as traditional pictures.

Of course, there may be many, many more, including the richly painted pictures of these wealthy Jewish merchants and their wives that we would expect to find. Perhaps all those "portraits"—presumably Jewish portraits—listed in the inventories of Jewish

homes are right in front of our eyes and we do not know it. It is notoriously difficult to identify now the subjects of so many Dutch portraits. And given the assimilated dress and demeanor of Amsterdam's Sephardim, determining whether or not a very Dutch-looking sitter is also Jewish is, with nothing to go on but the painting itself, practically impossible. Aesthetic conformity can explain why so few portraits of Jewish sitters have been identified.

Even if we make this allowance, however, there is still something missing. Conspicuously absent are certain kinds of personal pictures of which the Dutch were so fond. Where, for example, are the group portraits of the members of important associations from the community? In their social and political organization, the Sephardim seemed a reflection of the local Dutch model. Like the city government, the Portuguese Jews were organized not as a democracy but as an oligarchy. There was the lay board of governors, the *ma'amad*, which was responsible for running the community in its social, financial, business, and even moral and religious affairs, and for representing it before the municipal authorities. Its members, the *parnassim*, drawn from the community's leading families, regulated everything from the butchering and sale of kosher meat to the assignment of seats in the synagogue and the excommunication of people for ethical and religious offenses. Even the rabbis had to abide by the judgments of the *ma'amad*, although the board was encouraged to consult them on religious issues. And like the city council, or *vroedschaap*, membership on the congregation's board was determined through selection by the sitting members. It was, in many respects and like the city's own regents, a self-perpetuating ruling clique.

There were also divers associations in the community charged with specific duties: the *Bikur Cholim* for looking after the sick and helping to prepare and transport the dead for burial; the *Honen Dolim*, a loan society; the *Talmud Torah* educational brotherhood, responsible for running the schools and distributing scholarship funds; and the *Santa Companhia de dotar orfans e donzelas pobres*, a dowry organization for orphan girls and poor brides from all over northern Europe who were members of *La Nação*. All of these

groups had their ruling councils made up of prominent citizens. It was an honor to serve on these bodies, and members of the community's elite, while they often had no choice in the matter, willingly took their turns.

Why did these Jewish communal associations, like the companies, guilds, and various boards of directors of the city, not commission their group portraits? The community even had its own artists who could do the work. Salom Italia was an accomplished etcher and engraver who was in Amsterdam for a least a decade, in the 1640s. "Italian merchant" and "Jewish by nation," according to contemporary documents, Italia lived with "a certain Portuguese female" in Vlooienburg. He did portraits of two of the community's rabbis—Menasseh ben Israel and Jacob Judah Leon —and engravings for their books, as well as illustrations for a number of *ketubot* and *megillot*. Then there was the homegrown talent, such as Samuel d'Orta, Aaron de Chaves, and Jacob Cardoso Ribeyro. All we know about d'Orta, besides the fact that Rembrandt betrayed his trust, is that he was "a Portuguese painter residing in this city." Chaves and Cardoso are somewhat more familiar. They took advantage of the great opportunities in Amsterdam to learn their craft, studying painting and drawing with Jan Lievens. Chaves, although he painted a canvas depicting Moses and Aaron for the Bevis Marks Sephardic synagogue in London, seems to have spent most of his time on works on paper. He was particularly skilled at book illustrations and illuminations for Esther scrolls. An engraving of an allegorical portrait that he drew of the community's poet-historian, Daniel Levi de Barrios, his wife, Abigael de Pina, and their two children, Rebecca and Simon, appears as the frontispiece for de Barrios's *Imperio de Dios en la Harmonia del Mundo*, published in 1673.

The poverty of extant serious portraiture among Amsterdam's Sephardim is a strange fact for which we have no explanation. We can only regret the absence of images of the people who made the community the prosperous and influential one that contributed so much to the Dutch golden age: the de Pintos, Palaches, Mendes, Farrars, Jessuruns, Pereiras, Da Silvas, Curiels, and da Costas.

Could it have been due to an overscrupulous regard for the Second Commandment? The means and the motive were all there. They had the money, the pride, and the culture. For some reason, they lacked the will.

—⚭—

The market in the Portuguese community had an impact on the production of painting and prints in Amsterdam. There is no question about it. Of course, we are not talking about enormous percentages here. Breestraat commissions and sales constituted only a minor part of what was a tremendously huge trade. Moreover, most Old Testament history paintings were intended for a gentile audience, and explicitly Jewish subjects account for only a tiny share of what was depicted on panels, canvases, and paper. Nonetheless, there is something going on in seventeenth-century Amsterdam that is unique in the history of European art and culture up until the era of emancipation. And the presence of a spiritually thriving and materially prosperous Jewish community in the heart of northern Europe's most cosmopolitan city, a community whose members emulated the unusual Dutch predilection—even obsession—for works of art, goes some way toward explaining the phenomenon.

But it is not the whole story. Jewish patronage alone does not account for the relative wealth—small as it is compared to the total market—of Judaic themes in seventeenth-century Dutch art and the number of major and minor artists who were fascinated by the Jewish society in their midst. There had to be an impetus from the Dutch side.

As a matter of fact, there was. The Dutch public definitely had a taste for things Jewish. Many of the etchings by de Hooghe, Luyken, and others were made not for Jews but for the enjoyment and edification of a Christian audience. The works often have Dutch titles or are accompanied by Dutch texts, and sometimes they appear in Dutch books. Johannes Veenhuysen's engraving of the interior of the Portuguese synagogue on the Houtgracht was made for Tobias van Domselaer's 1655 work, *Beschrijving van Am-*

sterdam (Description of Amsterdam) (figure 14). Several decades later, a guide to the city for travelers titled *Alle de voornamste gebouwen der wijdvermaarde koopstad Amsterdam* (All the most important buildings of the famous merchant city of Amsterdam) included an exterior rendering of the new synagogue at the end of Breestraat. Luyken contributed a number of etched illustrations of Jewish customs to a Dutch translation of Rabbi Leon Modena's *Religious Customs and Practices.* He also provided images of Jewish dress and religious articles for the *Mozaische Historie der Hebreeuwse Kerke.* All of these and many other items were meant to satisfy a Dutch appetite.

Was it mere idle curiosity, the allure of the exotic, or was there something deeper going on?

The Amsterdam Historical Museum is situated in an old, redbrick manor on the Nieuwezijds Voorburgwal. Originally built as the convent of St. Lucien, the building was converted into a civic orphanage after the Alteration of 1578, when the republic began its battle for independence from Spain and vestiges of the land's Catholic heritage were obliterated. The museum covers eight centuries of the city's history: its early commercial growth, the economic and cultural flourishing during the golden age, and, to a somewhat lesser extent, the decline of its glory over the past two hundred years, including the tragedy of Nazi occupation. On the ground floor of the museum, hanging among the portraits and documents commemorating Amsterdam's brilliant past, is a truly remarkable painting of the city itself. Part landscape, part map, the work by Jan Christiaenszoon Micker, after a 1538 painted woodcut by Cornelis Anthoniszoon, provides a perspective on the town and its environs like none other (plate 10).

From a bird's-eye view just below the clouds, whose shadows are cast on the land and water below, the painting takes in all of Amsterdam. The city is snuggled tightly into a bend in its namesake river. The fields beyond, on the other side of the Singel, are just beginning to show signs of urban expansion. Among the irri-

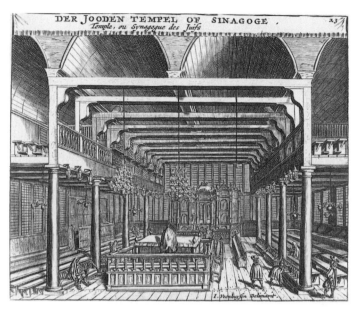

FIGURE 14. Johannes Veenhuysen, *Interior of the Portuguese Synagogue* (engraving), Jewish Historical Museum, Amsterdam.

gation canals running perpendicular into the river are scattered homes and farms; over the next hundred years or so, this would become a mass of developed and densely settled neighborhoods.

The harbor with its shimmering water is ringed with tall-masted ships and the flat barges that carry goods through the canals to the central markets. The network of buildings and streets, stretched as it is over narrow waterways, seems thin and insubstantial, like a spiderweb. Each of its long islands is linked to the others by fragile strands of bridge. One can literally count the rooftops and the gardens, alleyways, and squares among them. The major landmarks are all clearly seen from this height: Dam Square, the Waag on the Nieuwmarkt, the round Schreierstoren on the city's fortifications. Most prominent of all are the churches. With their pointed spires and gray slate roofs, they dwarf the surrounding buildings. The Oude Kerk rises alone from a sea of red-tile-roofed houses. Its basilica backs onto the Oudezijds Voor-

burgwal. Other, smaller chapels stand up here and there. Towering over everything is the Nieuwe Kerk, the High Gothic structure that was begun in 1395 but was not brought to its mature size until the 1650s. With its huge transept structure and framing courtyard, situated in the densest part of Amsterdam, it is the architectural, if not the geographical, anchor of the city. It dominates the skyline, especially when viewed from a distance, much as the Dome of the Rock stands over Jerusalem.

Or so it appeared, at least, to members of the Dutch Reformed Church. For as much as Amsterdam had become for Jews all over Europe a kind of Dutch Jerusalem, for the Dutch themselves it was "The New Jerusalem," a latter-day city of David. The result was that the citizens of the Netherlands looked at the Jews and at themselves in a way that no other European society had done before.

This is reflected in a number of different phenomena in seventeenth-century Dutch culture. Scholarship on Jewish matters was taken very seriously as an esteemed intellectual discipline in its own right, not just to support anti-Jewish polemic.[55] The study of Judaic languages and literatures was pursued to an uncommonly high degree in the Netherlands, both in the universities and within the educated class generally. This Hebraist activity was grounded in the belief that a knowledge of the language of the Old Testament was essential to a true understanding of the Bible. A familiarity with the Talmud and even the standard midrash commentaries, all of which were written in Hebrew or Aramaic, was also deemed invaluable. Petrus Cunaeus, a professor of Latin at the University of Leiden and a major jurisprudence scholar, may be atypical in his enthusiasm but not in his sentiments. He writes, in his *De Republica Hebraeorum*, that

> we had extremely great delight from the writing of this book. For we
> were taking up again those studies to which we were so exceedingly
> given over at one time during our adolescence. We had repeated
> pleasure in thinking how much enjoyment our heart derived from
> Hebraism, when we would study the volumes of the Bible [with] the

rabbinic commentaries and many other erudite works written by the Jews. We have, indeed, never regretted this effort.[56]

His colleague Johann Braun, a professor of Hebrew at the University of Groningen, even went so far as to hire a Jewish assistant to help him teach Hebrew to his students.

Philological work on Semitic languages and texts was accompanied by literary and historical research into biblical antiquity and the Hebrew commonwealth, as well as the study of Jewish belief and doctrine. In Gouda there was a priest whose duties explicitly included leading discussions on the Talmud. Especially popular among Dutch scholars was Maimonides' *Mishneh Torah*, the monumental twelfth-century compendium of Judaic law. The *Mishneh Torah* is universally considered to be the most systematic sourcebook for *halachah* because it summarizes, without all the rabbinic debates found in the Talmud, the essence of the Jewish legal code. Cunaeus was transformed by his reading of Maimonides' masterpiece: "I ran through the splendid treatises of Rabbi Maimonides with great enthusiasm in the most pleasant and leisurely fashion. . . . I was so affected that I nearly turned my pen around and erased all my previous animadversions on Jewish things."[57] It is telling that the first complete Latin translations of substantial portions of the *Mishneh Torah* were published in Amsterdam in the 1630s, almost five centuries after its original composition.

Not all Dutch Hebraism was motivated by pure academic interest or the Reformed desire for a deeper personal reading of the Bible. To many, there was something much greater at stake—the future of humankind itself. The study of Judaica was, in the minds of certain theologians, geared toward facilitating the event that would herald the Second Coming of the Messiah and the inauguration of God's kingdom on earth: the conversion of the Jews.

Millenarianism was an influential force in seventeenth-century intellectual life, and nowhere more so than in the Netherlands. The End of Days was predicted to be arriving sometime soon; favorite years included 1636, 1643, 1655, and, as might be expected, 1666. But before God could begin the process of salvation, a pro-

found transformative event was required: a supreme act of ecclesiastic unification bringing all people together into an authentic, universal Christian church. Most important, because they were further removed from the *via vera* than the members of dissident Protestant sects and even Catholics, a special effort was needed to make Jews aware of their errors and to turn them toward the truth. In short, the Jews had to be converted to Christianity before the Millennium, the thousand-year reign of Jesus Christ, could come. Moreover, violent means and forced conversions would not do. Millenarians generally rejected the Inquisition's methods. Conversions had to come about as a result of the Jews seeing the light and freely acknowledging that without the New Testament the old one remains unfulfilled. The appropriate means were *benignitas* and *tutela*, kindness and care. "Oh, let the blind see the true light uncovered!" wrote the reverend Johannes Coch (or Coccejus), professor of theology at Leiden.[58]

Thus the imperative to engage Jews in dialogue and disputation. They were to be converted by argument, not arms. They had to been shown the Gospel truth in Hebrew Scripture and the Christian completion of rabbinic texts. To this end, the University of Leiden even appointed a Professor Controversiarum Judaicarum to take up the debate with Jews and to train others to do so. The preferred approach was written, but verbal jousting viva voce was not uncommon. The contests took place in churches, synagogues, and private homes. The disputants were preachers, rabbis, scholars, and laypeople. They included David Farrar of the Beth Jacob congregation, who clashed with the Middelburg pastor Hugh Broughton in Amsterdam in the early 1600s, despite the city's regulation against Jews "speaking or writing ill about the Christian religion"; and Constantijn L'Empereur, who held the chair at Leiden and, in keeping with his job description, was a frequent instigator of these debates.

This attempt at persuasion, if it was to be done right, demanded a knowledge of Hebrew and a familiarity with Jewish literature. "Study your opponent, acquaint yourself with his ways." Conversionists needed to learn the Jewish sources firsthand. Many

prospective Calvinist missionaries studied Hebrew and other Eastern languages in Dutch universities before they set off to convert the Jews and other heathens. The celebrated Joseph Scaliger of the University of Leiden made the point directly for his contemporaries: "One who wishes to refute and confute a Jew must be very expert in Judaism. . . . The Jews are learned and subtle; they must have demonstrations made out of the Talmud, not out of the New Testament, [which they will] ridicule."[59]

Of course, this kind of philo-Semitic interest in Jewish literature and concern for the universal fate of the Jewish people should not be confused with a benevolent and sympathetic or even tolerant attitude toward Jewish individuals and communities. A reverence for Judaism as a religion, a body of texts, and a historical tradition is certainly compatible with a hostility toward actual Jews, particularly when they insist on living at the heart of a Christian society. And yet—in contrast to what was happening in some German Lutheran lands during that period—the conversionist urge in the Netherlands was indeed tempered by an equally strong tolerant, sometimes paternalistic strain. As Grotius puts it, "we have to practice natural love to every person without excluding anybody."[60] Dutch millenarians, such as Pieter Serrarius and the Remonstrant scholar Gerard Vossius, had great respect, even affection, for their adversaries—perhaps because some of them, like Menasseh ben Israel, were their neighbors and friends.

Hebrew scholarship in the service of millenarian aims, however, does not do much to help us understand de Hooghe's works on paper or de Witte's synagogue paintings. Conversionism was too common and, at the same time, too isolated a phenomenon to explain the Dutch cultural fascination with the actual Jews in their midst—a fascination manifested not only in a predilection for painted and printed images of Jewish themes and in a prominent academic Hebraism, but also in frequent visits to the synagogues to watch the Jews in prayer and day trips up the Amstel to tour the Jewish cemetery at Ouderkerk. On the one hand, a conversionist passion was not peculiar to the Dutch; it was found wherever mil-

lenarians and messianists were present—that is to say, all over Protestant Europe. On the other hand, most members of the Dutch Reformed Church were *not* conversionist millenarians. Ordinary citizens lacked the apocalyptical passions of some of their more enthusiastic theologians.

What these citizens did have, though, was a certain image of themselves that informed even the simple faith of the rank and file. The Dutch liked to see something special in the Jews that, as in a mirror, reflected back their own sense of who they were and what they stood for. This notion was not just religious but political and historical as well.

Some scholars suggest that this special attitude to the Jews had something to do with the Reformed attitude toward Scripture. Dutch Calvinists were devoted (at least in theory) to the reading of the Bible, to a direct, personal encounter with the text, and not to the slavish obedience to priestly and papal authority that they saw in Catholics. Perhaps it was just this dedication to Scripture that made them take so great an interest in the descendants of the ancient Israelites dwelling among them. After all, right there in Amsterdam was the living embodiment of the Law of Moses, the Portuguese- and Yiddish-speaking remnants of God's chosen people. This may be what Grotius originally envisioned when, in his argument for the admission of the Jews to Holland, he noted that they are "the children of Abraham, Isaac and Jacob, the Israelites who have received the pledge to be accepted as children and are to partake in the glory, the covenants, the laws, the religion and the promises. . . . They are the ones to whom God's oracles have been entrusted." The Jews, he suggests, may "serve us as an example and as evidence of the truth of the Holy Scriptures of the Old Testament."[61]

Still, this too does not quite seem to answer the question. The Dutch interest in the Jews is not really the expression of some naive, antiquarian delight in the descendants of Abraham, Isaac, and Jacob. The burghers of Amsterdam did not regard Vlooienburg as a kind of Old Testament theme park; nor were they under the illusion that Jewish religious practice in the seventeenth cen-

tury was a pure, contemporary personification of ancient Israelite worship, unchanged from biblical times by centuries of rabbinic and other influences. The story of the Dutch-Jewish rapport is more complicated—and more interesting—than that. It goes right to the heart of Dutch identity in the seventeenth century, particularly as this evolved through the struggle for independence from Spain and the political, social, and artistic forces unleashed by that crusade.

In September 1574, the citizens of Leiden were starving. After months of siege by Spanish forces, supplies had finally run out. Their crops and fields were ravaged, their livestock destroyed. Some of the hardest battles in what would prove to be a long and costly war were pitched around Leiden, and its residents bore the brunt of the devastation. The city was defended not by professional soldiers but by its civilian militias. They were weak from the lack of sustenance and exhausted from the fighting. According to one contemporary report, the men and women of Leiden could scarcely stand on their own feet.[62]

There had been a brief respite for two months in the early spring, when the Spaniards were distracted by a rebel army coming from the east to relieve the city. But by May those forces were repulsed and the siege resumed. William of Orange—William the Silent, the great military hero of Dutch independence—sent word by carrier pigeon that help was on its way and that the Leideners should hold on. Even if William showed up with his army, though, it would be a difficult struggle. The Dutch were outnumbered and outclassed by the highly trained forces of imperial Spain.

William made a bold decision. He gathered a large naval contingent in the Maas River, south of Leiden. Then he opened the dikes along the river to flood the land to the north, in order to trap the Spanish army between the city and the river and allow the ships to sail in to the rescue. Unfortunately, the water did not rise high enough; the fleet was able to travel only as far as Delft. With the Spaniards still in charge of the open country, the Dutch troops

could not even disembark for a land campaign. Hope in Leiden fell. The quest for freedom appeared to be over.

And then a great miracle happened. Just when it seemed that all was lost, the wind changed direction and rain started to fall. And fall. And fall. It rained for days on end. The river's waters rose, the Spanish army was backed into a corner, and the Dutch fleet brought relief to the desperate city.

The Dutch instantly recognized the biblical dimensions of their salvation. The story of the flood that delivered Leiden became legendary. The revolt was saved by divine intervention. It was an event endlessly celebrated in art, poetry, and song. The Spaniards attacking the Dutch were forced back by the water inundating the plain above the Maas, just as the Egyptians who were pursuing the Israelites were drowned when the Red Sea crashed in upon them. Paintings and prints depicting the seminal event in the Exodus story became very popular in the Netherlands in the late sixteenth and early seventeenth centuries. The Leiden artist Isaac Claeszoon van Swanenburg's painting *Pharaoh Drowning in the Red Sea* was hung with great pride in Leiden's new town hall. Its allegorical significance was clear to everyone. Abraham Bloemart produced a number of engravings of the Egyptians being swallowed up by the waters. And in the series of prints portraying the siege of Leiden made in the late 1570s by Hendrick Goltzius, William is depicted as Moses.

The Dutch believed themselves to be the descendants of the ancient Batavians, the heroic people described by Tacitus who struggled mightily to win their independence from the Romans and who, the Dutch insisted, were the original inhabitants of the northern Netherlands. It was one of the unifying myths that sustained them in their revolt against Hapsburg domination. But this historical self-portrait coexisted with another story, one that extended their lineage back even further in time. If the Jews were the first to be elected by God and promised pride of place in His plan for human history, the Dutch were now the distinguished holders of that honor. The Netherlands was the modern Israel; its citizens, the new chosen people, bound to their Creator by a new

covenant. They saw their own recent history—their campaign for political sovereignty, liberated from Spain, and for religious freedom from Catholic oppression—reflected in the biblical story of the Israelite struggle for emancipation from bondage in Egypt and the subsequent fight to claim the lands that God had promised them. "God gave [us] this land and this city of Amsterdam through difficult and hard wars," writes one contemporary pamphleteer, "[just as] the children of Israel had obtained the land of Canaan."[63] If William was Moses (and, like Moses, William did not live to see the promise fulfilled; he was assassinated in 1584), then his son, Prince Maurits, a brilliant military leader, was Joshua. The playwright Joost van den Vondel, for his part, compares Philip II of Spain with Pharaoh:

> The one bowed down Jacob's house with slavery
> The other, the Netherlands, with tyranny oppressed.[64]

By 1648, with the Dutch victory over Spain finalized with the Peace of Westphalia, an equally apt, and equally overplayed, biblical image was available: David vanquishing Goliath.

This brilliant vision went beyond the military struggle and colored the internal politics of the new nation. The Dutch found in Hebrew Scripture a rich source of models for both martial and civic virtues: courage, temperance, fortitude, wisdom, and justice. The republic was often likened to the Israelite commonwealth, and its rulers to the Hebrew judges and kings. Sometimes they drew on a later period of Jewish history, the Macabees and their valiant struggle in the second century B.C.E. to maintain religious and cultural integrity in the face of foreign occupation.

This Judaistic self-image was not always a source of unity; opposing political factions put it to work for their own devices. Conservative Calvinists used it to argue for a strong central (and theologically orthodox) government and to remind Dutch leaders of their obligation to root out heresy and religious nonconformity: "The ruler is to do the will of God in the same way as the kings of Israel had served the Lord, by preventing heresy and punishing

idolatry."[65] On the other side of the spectrum there was Jacob Cats, the grand pensionary of the province of Holland and one of the republic's leading literary figures. Cats argued at the Great Assembly—called in 1651, after the sudden death of Stadholder William II, to debate what form of government would best suit the Netherlands—that the position of stadholder should be eliminated. He exhorted his fellow citizens to

> look to the example of the oldest republic the world has ever known, namely that of the Hebrews, that is to say, God's own people, who from the time they were led out of Egypt until the time of the kings, being about four hundred and fifty years, never appointed a regular Captain-General, not withstanding that they were continually engaged in warfare, but chose a head or general for each separate campaign.[66]

The Dutch identification with ancient Israel in their own fight for freedom from Spanish tyranny and Catholic persecution found a particularly original expression in the popularity of the Esther story. According to the biblical narrative, Hadassah—"Esther" is the Persian version of the Hebrew name meaning "myrtle"—lived with her cousin (and foster parent), Mordecai, in Shushan (Susa), the capital of the Persian empire. The king of Persia at the time was a man named Ahasuerus (most likely Xerxes I, who ruled between 485 and 464 B.C.E.). Having ostracized his wife, Vashti, for insubordination, the king was in want of a new queen. He fell in love with Esther and married her, unaware that she was Jewish. One day, Mordecai performed a great service for Ahasuerus by turning in some men he had overheard plotting to murder the king. At the same time, Mordecai was despised by the king's prime minister, Haman, because he would not bow down to him "or do obeisance." When asked why he refused to show honor to the king's minister, Mordecai, faithful to God's prohibition against idolatry, replied that he was a Jew. The spiteful Haman therefore conceived a plan to "destroy, slay and exterminate" all the Jews in the kingdom, and persuaded the king to go along with it. "The

money and the people are yours," the clueless king replied, "deal with them as you wish" (Esther 3:6–11). Mordecai learned of the plot, and told Esther. He bid her to go to the king with the information, but she was reluctant to do so, for no one was supposed to enter the king's presence without being summoned. Mordecai, however, reminded Esther of her duty to her people, as well as the danger she herself was in: "Do not imagine that you alone of all the Jews will escape because you are in the royal palace. If you remain silent at such a time as this, relief and deliverance for the Jews will appear from another quarter, but you and your father's family will perish." Esther summoned her courage. "I will go to the king, although it is against the law; and if I perish, I perish" (Esther 4:12–17). At great risk to her own life she went before her husband and invited him and Haman to a banquet. At the meal, she asked them if they would do her the favor of coming to another banquet on the next day. It is at this second feast that she reveals to the king her own Jewishness and Haman's plot against her people.

> If I have found favor with your majesty, and if it please your majesty, my request and petition is that my own life and the lives of my people may be spared. For we have been sold, I and my people, to be destroyed, slain and exterminated. (Esther 7:3–4)

The king was enraged. He ordered that Haman be hung on the gallows he had been preparing for Mordecai. Esther's heroism and the salvation of the Jews is celebrated annually on the holiday of Purim, when Jews gather at the synagogue to hear the reading of the *megillah* of Esther. All in attendance, adults and children, many dressed in costume, boo and make loud noises every time Haman's name is uttered.

The Esther story was very important to the Sephardic Jews of Amsterdam. It resonated deeply in the communal psyche, and they put a special effort into their Purim festivities. At one point, the leaders of the community had to demand that they be toned down, as the Dutch were annoyed by the disturbance. (Also, the

cross-dressing and female impersonation often involved was, the rabbis argued, contrary to Torah.) The Portuguese Jews saw in Esther's own *marrano* experience of being forced to hide her Jewishness as she passes in a gentile society a distant echo of their own crypto-Jewish history as *conversos* in Spain and Portugal. The more prosperous among them spent a good deal of money on expensive illuminated *megillot;* they were treasured items in many personal collections of rare books and manuscripts.

Christianity, of course, has its own interpretation of the biblical story. Esther's courage in interceding with the king on behalf of the Jews is usually seen as a prefiguration of the Virgin's intercession with God for the salvation of humankind. In medieval and Renaissance European art, where there was generally limited interest in the Book of Esther, most of the works that do draw from the tale focus on the moment when Esther prostrates herself before Ahasueris. In Italian, Flemish, and French art, in paintings by Tintoretto, Veronese, Michelangelo, Rubens, and others, an inherited set of artistic conventions and devices—including crowns, scepters, and kneeling queens—are used to make the religious message clear. But things were different in Holland. The Calvinists did not see the moral of the tale in the same terms as the Catholics did. In Dutch culture, the tale of Esther looms large and assumes great significance. It appears as a theme in the literature and visual arts of the Netherlands in the seventeenth century more often than anywhere else at any other time in history.

The Dutch were as fond of Purim plays as were the Jews. The Sephardim often kept to a relatively faithful if joyously creative reenactment of the Bible story. Their productions were in Spanish and sometimes Hebrew, and bore such titles as the *Comedia Famosa de Aman y Mordochay* (but not Esther!). The Dutch, on the other hand, often went out of their way to make sure that no one missed the contemporary political relevance of the drama. In plays such as *Esther,* by Jacob van Zevencote; Jacob Revius's *Haman: A Tragedy;* the Amsterdam production of Nicolas Fonteyne's *Esther, or the Picture of Obedience;* and Johannes Serwouter's *Hester, or the Deliverance of the Jews,* the audience would easily recognize the figure of

Haman, with his idolatrous demands, as a representation of Spain. Esther and Mordecai, on the other hand, were clearly personifications of the virtuous, pious Dutch. For those who wanted a deeper understanding of what they were seeing on the stage, there was Jacob Cats's poem "Vashti," and Johannes de Saef's 1636 prose work, published in Amsterdam, whose title sums up the point nicely: *Mordechai, ofte Christelijcken Patriot* (Mordecai, or the Christian patriot).

Along with their literary colleagues, Dutch artists strove to keep the Esther story alive in the public consciousness. They took great interest in moments of the story that their counterparts in Italy and other Catholic lands ignored, such as when Mordecai overhears the plot against the king, Esther's preparation for her appearance before Ahasuerus, and especially the feast at which she triumphs over Haman. They paid careful attention to material and emotional detail, and often dressed the characters in contemporary garb, lest the viewer miss the scene's moral and civic lesson.

Even before the Dutch revolt reached its full flowering, the sixteenth-century artist Maarten van Heemskerck was producing a series of drawings illustrating different episodes from the book. Rembrandt himself devoted numerous drawings and at least four paintings to Esther scenes. This is, in fact, a surprisingly small number, given his passion for picturesque Bible narratives and propensity for repeatedly returning to the same story. *Haman and Ahasuerus at the Feast of Esther* (in the Pushkin Museum in Moscow) and two paintings of *The Condemnation of Haman* (now in Bucharest and Leningrad) all date from the 1660s. A fourth painting, once identified as *The Toilet of Bathsheba* (National Gallery of Canada, Ottawa), is now (with good reason) thought to be *Esther Preparing to Intercede with Ahasuerus.*[67] There are also two etchings: a quiet, portrait-like *Esther with Haman's Decree* and, most interesting of all, *The Triumph of Mordecai* from 1642, in which a shamed Haman is forced to honor Mordecai by leading him on a horse before a city crowd (figure 1). One night, Ahasueris, reminded of the favor that Mordecai had done for him, asks his minister, "What ought to be done to the man whom the king delights to honor?" Haman,

thinking that he is the one to be so graced, replies, "He should be arrayed in royal robes with a crown upon his head, set upon the king's horse and led through the city by the first of the king's princes who shall proclaim, 'Thus it shall be done to the man whom the king delights to honor'" (Esther 6:1–9). The king then reveals that the honor is to be given to Mordecai, the man who had saved his life from the conspiracy, and orders Haman to carry it out. Mortified after being so publicly humiliated, the minister hurries home with his head bowed.

Rembrandt's etching owes much to a painting done in 1617 by his teacher, Pieter Lastman, also called *The Triumph of Mordecai*. This was not Lastman's only rendering of an Esther subject; one year later he painted the melodramatic *Haman Pleads to Esther for Mercy*. Jan Lievens, also a Lastman protégé and not to be outdone, tried his hand at the story. He painted the *Feast of Esther* (once thought to be a Rembrandt) in 1625. Jan Victors painted his own version of Esther's banquet, while Arnold Houbraken painted *Haman Begging for His Life*. Arent de Gelder produced so many works from the story that, had he been an anonymous painter working in the Middle Ages, he would surely be known to us now as "The Master of the Book of Esther." Even the Catholic Jan Steen, famous for his boisterous tavern settings and messy home interiors, with grownups and children wreaking every kind of havoc and broken pipes and egg shells trampled underfoot, found inspiration in the *megillah*. He devoted five paintings to events from the story. Twice he painted *The Wrath of Ahasuerus*, in 1668 and then again in 1671–1673. The later version is a very large canvas filled with histrionic gesture. It shows the moment when the king learns from Esther of Haman's plot to kill her people. Rising angrily from the table, he upsets its contents—a vase lies, very Steen-like, broken on the floor in the foreground—and forces the pale, evil-looking Haman into a cower (plate 11).

Tellingly, the great and prolific Rubens, a Fleming from the southern Low Countries, court painter to the Hapsburgs and Catholic artist par excellence, painted only one scene from the Book of Esther: *Esther Before Ahasuerus*.

Jewish history and Jewish legend, even Jewish belief and cere-
mony, held great allure for the Dutch in the seventeenth century.
They succumbed to the temptation to picture themselves as the
new Israelites. It was a flattering image, one that did much to bol-
ster their morale during a tumultuous century during which they
fought off Spanish domination and repelled an invasion by the
French. It also goes a long way toward explaining the paintings,
prints, and poetry that they so avidly consumed. The Dutch
needed these images of Judaism. It fed their sense of self and their
sense of mission. It clarified for all their place in history: their past
and, especially, their future.

When a son—the future William II, the next prince of Orange
and eventual stadholder in the provinces of Holland, Zeeland,
Utrecht, Overijssel, Gelderland, Groningen, Drenthe, and West-
erwolde—was born in 1626 to Stadholder Frederick Hendrik and
his wife Amalia van Solms, the Orangist faction in the republic
was elated. The continuation of the family line, and its possession
of the major stadholderships, was now assured. The infant's bap-
tism was well attended by the most eminent families in the land. It
was a proper Calvinist ceremony. Deference was made to Batavian
tradition, and the political importance of the occasion was lost on
no one. Nor did they forget the larger scheme of things. When it
was time for the presiding minister to address the stadholder's
wife, the first lady of the republic, he turned to her and declared,
with all due solemnity, "I think that I see standing before me the
Great Queen Esther . . . O fortunate princess, O second Esther."[68]

The Unhappy Rabbi

THREE

POOR MENASSEH BEN ISRAEL. He was one of the most accomplished and cosmopolitan rabbis of his time. A true renaissance man, whose erudition and achievements were renowned, nobody did more in the seventeenth century to advance the Jewish cause, whether in learning or in politics. Scholar, philosopher, diplomat, teacher, editor, translator, printer—no activity seems to have been outside his considerable talents. His network of friends and admirers stretched across the continent; his contacts in both the Jewish and gentile worlds ran deep. He was perhaps the most famous Jew in all of Europe. And yet he felt that, somehow, he did not get from his own community the respect he deserved.

He was right.

He was born in 1604 as Manoel Diaz Soeiro in Madeira, a Portuguese colony off the coast of Africa, not far from the Canary Is-

lands. To a *converso* clan suspected of Judaizing, this was still too close to the Inquisition's grasp. So the family moved first to La Rochelle, in southwestern France, and then, sometime around 1610, to Amsterdam. They were not just fleeing some abstract and general threat against New Christians: the lives of particular family members were in danger. Manoel's father, while living in Spain, had been seriously injured by the Inquisitors' methods, and there was reason to believe that he would soon be arrested once again. The authorities' suspicions of secret Judaizing were probably well grounded. For when the family reached Holland, the men were all circumcised and took the name "ben Israel," son of Israel.

They joined the Beth Jacob congregation, the oldest in the community. Manoel, now Menasseh, was taught in the community's school by Rabbis Saul Levi Mortera and Isaac Uziel. He was a precocious student and had a particularly fine command of both Portuguese and Hebrew. "In my youth," he wrote, "I was so given to rhetoric and was so eloquent in the Portuguese language that, when I was fifteen years of age, my speeches were very acceptable, applauded, and well-received."[1] When Uziel died in 1622, Menasseh, who was teaching in the elementary school, was selected to replace him as rabbi or *chacham* (a Hebrew term meaning "wise man") of the Neve Shalom congregation. Menasseh soon earned a lofty reputation as a speaker. Many non-Jews came to the synagogue to hear his sermons, which were reportedly both rhetorically splendid and intellectually rich. He was also praised for his knowledge of Scripture. Some of his colleagues, however, had doubts about his skills as a Talmudist. He was never held in great esteem by the other rabbis, and he took it as a great insult when in 1639, with the merger of the community's three congregations, he was appointed to the third rank behind Mortera and Isaac Aboab da Fonseca. His relations with the congregation's leaders were rocky, and he chafed under what he believed were undignified limitations put on him, such as being required to teach in the elementary school and not being allowed to preach as often as he would have liked. The highlight of his career occurred in 1642, when he was chosen to deliver the welcoming address when the stadholder

Frederik Hendrik, accompanied by Queen Henrietta Maria of England, the wife of Charles I, visited the synagogue on the Houtgracht. It was one of the few times that he was actually given a position of honor.

In 1640, Menasseh's relationship with the community reached one of its low points when he was put under a *cherem* by the *ma'a-mad*. Someone seeking to impugn the character of some leading members of the congregation had been posting placards on the gates of the synagogue and around the community suggesting that their business practices were less than wholesome. The posters continued to appear, along with other writings, even after a ban was pronounced on their anonymous author(s). It was later discovered that they had been written by Jonas Abrabanel, Menasseh's brother-in-law, and Moses Belmonte. The offenders humbly begged forgiveness, paid a fine, and the ban was rescinded. Menasseh, however, passionately objected to the disrespectful way in which his relative had been treated. He made his case in front of the assembled congregation in the synagogue after services one day. He noted that, among other indignities, Abrabanel had been referred to in the public proclamation detailing the affair without the honorific title *senhor*. Menasseh apparently made quite a nuisance of himself. Despite the fact that two members of the *ma'amad* approached him and told him to hold his peace, and even threatened to punish him, he continued his harangue. Faced with this challenge to their authority, the *ma'amad* felt that they had no alternative but to issue a ban against the irate rabbi himself, who in turn replied: "You are putting me under a ban? It is I who can proclaim the ban upon you!" The *cherem*—which prohibited Menasseh from attending services in the synagogue and others from communicating with him—lasted only a day, but it was enough to add to Menasseh's sense of humiliation. For good measure, he was also relieved of his official rabbinical duties for a year. Throughout Menasseh's career in Amsterdam, it seemed to him that compared to the community's demonstrative appreciation for Rabbi Mortera, they went out of their way to show their lack of respect for him.

There was, in fact, no great affection between the two rabbis. They differed in their intellectual accomplishments—Menasseh would never be the scholar of rabbinics that Mortera was—and in their approaches to the faith. Menasseh, unlike the more reserved rationalist Mortera, had a particular fascination for messianic and apocalyptic themes. It was also rumored that Menasseh, with his many Christian social contacts, was less than fastidious when it came to Jewish observance. He certainly could be careless: once, while in the company of a gentile, he reportedly took up a pen in his hand and only then realized that it was the Sabbath. Menasseh and Mortera criticized each other in their sermons, and at one point it got so bad that the leaders of the community—perhaps fearing a schism—had to step in. They reprimanded both rabbis and temporarily prohibited them from preaching. The lay leaders tried to mediate the rabbis' differences and put an end to the constant antagonism, but they never succeeded in reconciling the two men. Menasseh's sense of being an underappreciated, second-class rabbi in the community, and his jealousy of Mortera's elevated status—which he believed was undeserved—rankled him to the end of his life.

Given the narrow scope of his rabbinical duties—he was allowed to give the sermon on only one Sabbath per month—as well as the meager compensation he received for them (one hundred and fifty guilders, compared to Mortera's six hundred), it is not surprising that Menasseh directed his considerable energies into many other projects. He ran one of the community's *yeshivot*, or adult study academies, and was an outstanding teacher. The yeshiva's patrons were the Pereira brothers, Abraham and Isaac, and they probably paid Menasseh well for his services. However, his work there demanded much of his time. To a correspondent he wrote:

> So that you can see that I am not exaggerating, this is how I allocate my time. Each day I devote two hours to the temple, six to the school, one and a half to the Pereira's Academy, both the public classes and individual work, of which I am president, and two to the correction of my typographical proofs, as I am alone in this work.

> From eleven o'clock until noon I receive all those who come to me
> for advice. This is all indispensable. Your Grace may be the judge of
> the amount of time I have to deal with my domestic cares, and to an-
> swer four to six letters a week.[2]

Menasseh, like the other rabbis, also engaged in some mercantile
business. With his brother and brother-in-law, he imported goods
from the West Indies and Brazil. But he felt that having to supple-
ment his salary as a rabbi in this and other ways was insulting. "At
present, in complete disregard of my personal dignity, I am en-
gaged in trade . . . What else is there for me to do?"[3]

Menasseh's real love was his printing press. He operated the
first Hebrew printing shop in Amsterdam. He became, in a short
time, an internationally known printer and bookseller. He pub-
lished several Pentateuchs, Hebrew Bibles, and prayer books (as
well as Spanish translations of these), an edition of the Mishnah,
and numerous treatises in Spanish, Portuguese, Hebrew, and
Latin. He collaborated with Ephraim Bueno on a Hebrew *siddur*
and published in Yiddish a book of Jewish customs. Because of
Menasseh ben Israel, Amsterdam was, for a time, the center of the
Jewish publishing world in Europe.

Menasseh also acquired a great reputation for his own writings,
especially among Christians, to whom some of them were directly
addressed. He was seen among non-Jews as the foremost Jewish
spokesman and apologist of his time. Gentiles sought him out as a
teacher and consultant. "[He is] a learned and pious man," wrote
Gerard Joannes Vossius, whose son Dionysius studied Hebrew
and Jewish literature with Menasseh. "If only he were a Christ-
ian."[4] No less a figure than Hugo Grotius recognized Menasseh's
immense learning, and he did not hesitate to make use of it.
Grotius's many inquiries in the 1630s on matters biblical and He-
braic testify to the great esteem in which he held the relatively
young rabbi. Writing twenty years after he had first argued that
the Jews should be permitted to settle in Holland, if only for the
sake of what they can contribute to Dutch intellectual culture,
Grotius obviously felt that his reasoning has been justified:

"Menasseh has all my good wishes. He is a man of the highest utility both to the state and to the advancement of knowledge."[5] Writing from abroad to a mutual friend, Grotius insisted that

> I have the utmost respect for Menasseh's learning and for his intellect. He follows with conspicuous success the path of Ibn Ezra, Maimonides, and Abrabanel. His books, with which I am acquainted, are much read and highly appreciated here in Paris.[6]

Menasseh, more than anyone else, assumed responsibility for explaining the doctrines and beliefs of Judaism to the gentile world. He never shied away from controversy, and he was willing to be the Jewish representative in just the kinds of polemical debates that many Christians—especially millenarians—sought. This caused the Amsterdam Sephardic community no small amount of concern, as its leaders were very cautious about crossing the line that the Dutch had drawn regarding theological debates between Jews and Christians. For some of the Portuguese, however, Menasseh's celebrity was a source of pride. Joseph Delmedigo, a fellow rabbi in the Beth Israel congregation, boasted that Menasseh had become "the ornament of scholars and the glorious diadem of our people in the eyes of the nations [goyim], who writes learned works, the likes of which have never been seen in any lands or peoples; and their theologians consult him daily to hear his learning."[7] Menasseh even earned a grudging respect among some implacable foes. Pierre Daniel Huet, bishop of Avranches and no friend of the Jews, praised Menasseh as "a Jew of the first order . . . I have had long and frequent conversations with him on religious subjects. He is an excellent man—conciliatory, moderate, sensible to reason, free from numerous Jewish superstitions and the empty dreams of the kabbalah."[8]

One of Menasseh's most well-known works was the *Conciliador*. In this book, which took almost twenty years to write (he did not complete it until 1651), Menasseh tried to reconcile the apparent inconsistencies in Hebrew Scripture. He wrote the *Conciliador* in Spanish so that *conversos*, above all, could see that the most basic text

of Judaism is not full of contradictions and perhaps be swayed to return to their ancestral faith. The *Hope of Israel* (1650), on the other hand, was published in both Spanish and Latin so it would reach as wide an audience as possible. The book caused a stir among both Jewish messianists and Christian millenarians. Menasseh composed it as a response to rumors that some of the lost tribes of Israel had been discovered in the New World. Antonio Montezinos (alias Aaron Levi) was a Portuguese New Christian who arrived in Amsterdam in 1644 after a voyage to South America. He claimed to have found there a group of "Indians" consisting of descendants of the tribe of Reuben in New Granada (now Colombia). Montezinos reported that these indigenous people recited the *shema*—the essential prayer of the Jewish faith—to him and proclaimed that "our fathers are Abraham, Isaac, Jacob and Israel, and they signified these four by the three fingers lifted up; then they joined Reuben, adding another finger to the former three."⁹ Menasseh interviewed Montezinos during his stay in Amsterdam. While Menasseh did not believe the general theory, popular among some of his contemporaries, that the native Americans *were* the Ten Lost Tribes of Israel, he was inclined to accept Montezinos's claim that the group *he* came across were truly part of one of the lost clans. And for Menasseh— as for many of his readers—the fact that there were Jews in the New World had messianic implications.

Jewish doctrine says that the coming of the Messiah, the Anointed One (and a descendant of the House of David), will mean the reestablishment of the Jews in the Holy Land and the beginning of an era of universal well-being. There was (and still is) a great deal of disagreement among Jewish authorities, however, as to what exactly the messianic period will involve. Maimonides, for example, discouraged people from hoping for an otherworldly paradise; he insisted instead that the Messiah will be a mortal human being who will restore the Kingdom of David, rebuild the sanctuary of the Temple, and gather all the dispersed of Israel under his dominion. The Messiah will bring for Jews only political independence and religious flourishing, not a sensuous heaven on earth. Quoting the Talmud, Maimonides claimed that "the only

difference between the present and the messianic days is a deliverance from servitude to foreign powers."[10]

Menasseh's own conception of what the Messiah will bring is more robust. "Those who hope for a temporal Messiah err just as much as the Moors who hope for a sensuous paradise." The coming of the Messiah will involve not just the political restoration of the Jewish homeland, but spiritual redemption as well, and will be accompanied by true happiness for those who have led a virtuous life. It will be a period of judgment, although not the final judgment that awaits us at the end of time.

Menasseh could not say for sure when redemption would arrive but he believed it to be close at hand, "for we see many prophecies fulfilled." The signs were everywhere. The arrival of the Messiah must, according to the ancient rabbis, be preceded by the thorough dispersal of the tribes of Israel, whom he will then lead back to Jerusalem. Thus, the discovery of at least some of those tribes in faraway lands—such as South America—was of crucial importance. And not just for Jews. Messianists made common cause with Christian millenarians, although, of course, they differed greatly in how they conceived of the imminent seminal event. According to Christian millenarians, it would be the Second Coming of Christ; for Jewish messianists, the first coming of the Messiah. Both groups, however, believed that the messianic arrival would not occur until after the people of Israel are completely scattered across the globe. Only then could they be reunited and restored to their kingdom.

Menasseh's messianist persuasions were behind what he had hoped would be the crowning achievement of his life: arranging for the readmission of the Jews to England, from which they had been banned since 1290 (although there were, at least unofficially, a fair number of Jews in London by the 1650s). The "complete dispersal" of the Jews, according to Menasseh's interpretation of tradition, meant that they would be residing in *all* nations and living among all peoples ("And the Lord shall spread you among all people, from one end of the earth to the other" [Deuteronomy 28:64]). Christian millenarians in England had their own reasons for working with Menasseh on his readmission project. If the Jews

were allowed back into England, not only would their diaspora be expanded, but their conversion would be facilitated and the Millennium brought one step closer.

Menasseh, then, received much encouragement from English friends and others to apply for the readmission of the Jews. Although he was preparing to cross the channel to begin negotiations as early as 1653, he was delayed by the Anglo-Dutch war. He was finally able to go over in 1655. Accompanied by his son Samuel, he made his presentation to the Lord Protector Oliver Cromwell. Menasseh appealed to Cromwell with both theological and (perhaps more important) economic arguments. He particularly wanted to bring to the Lord Protector's attention the financial benefits that usually accrued to a country that has a thriving Jewish community. After noting that "merchandising is, as it were, the proper profession of the nation of the Jews," Menasseh went on to remind Cromwell that "there riseth an infallible Profit, commodity, and gain to all those Princes in whose Lands they dwell above all other strange Nations whatsoever."[11]

Cromwell was quite taken by the Dutch rabbi and gave him a sympathetic hearing. Public opinion, however, was by no means so well disposed toward readmission. Some argued that strong and humiliating restrictions should be placed on the Jews—for example, barring them from the courts of law and prohibiting their employment of Christian servants. In other words, the Jews would not be granted many of the privileges or rights that they had been enjoying for decades in Holland. After several sessions, the conference convened by Cromwell to consider the issue was deadlocked; it adjourned before anything was resolved. Menasseh was greatly disappointed by the lack of results, particularly as he had devoted several years of his life (two of them in England) to this project. It was the final endeavor of his life.

Saul Levi Mortera was not an easy man to get along with. A stern rationalist with a strong preference for dispassionate philosophical thinking, Mortera had little patience for the messianistic and kab-

balistic nonsense of his colleagues. He also tolerated no dissent from his subordinates. Menasseh was not the only one to chafe under the chief rabbi's authority.

At around the time that he was putting Menasseh in his place, but just before the three congregations merged, Mortera took on one of the community's other rabbis, Isaac Aboab da Fonseca. The two men could not have been more unlike in their persuasions. For Mortera, truth was found in the Torah, the arguments of the rabbis in the Talmud, and the well-reasoned, intellectually persuasive theological and philosophical doctrines of Maimonides. Aboab, on the other hand, was given to mysticism. He preferred to seek understanding and spiritual enlightenment in *kabbalah*. It did not help matters that Aboab, like many of his congregants, had been through the Iberian Marrano experience himself—he was born a New Christian in Portugal—while Mortera, although born in Venice, was of Ashkenazic background.

The issue that brought the two rabbis nearly to blows was nothing less than that of the eternal fate of the soul.[12] In the early 1630s, some members of the community had taken to proclaiming that every Jew will necessarily enjoy a portion of eternal happiness in the hereafter, the "world to come." No Jewish soul, they insisted, will ever suffer eternal punishment. Simply by virtue of being one of the children of Israel, even one who commits the most heinous of sins is guaranteed a place in paradise. These people were thinking above all about what eternity had in store for their relatives and friends who had abjured Judaism and were living as *conversos* in Spain and Portugal, not to mention the many within their own ranks who had once committed the same sin. The unconditional, ultimate salvation of all Jewish souls meant that even those individuals of Jewish descent who had once practiced, or who were still practicing, Catholicism in the old country would find their final resting place beside God.

Rabbi Mortera was not at all pleased by this. It offended both his understanding of Jewish tradition and his sense of morality. Could it really be the case that a Jew, no matter how grave his sins and no matter how long he remained a sinner without repentance,

would not suffer eternal punishment for his wickedness? In his mind, the answer was clear: no. Such an opinion could lead only to wanton licentiousness because there would be nothing to fear in the long run because of one's misdeeds. According to Mortera, when the sages of the Talmud claim that "every Israelite will have a portion in the world to come," "Israelite" refers only to a righteous person, not universally to any Jew whatsoever. Someone who has failed to follow the laws of the Torah and who has openly denied the principles of the faith is not a righteous person and will be eternally punished for his transgressions, even if he has a Jewish soul.

Mortera's traditionalism only inflamed the passions of his opponents. In early 1635, Mortera's sermons at the Beth Jacob synagogue were being loudly disrupted by some youths who took offense at his views. The ruffians were not, Mortera believed, acting on their own. He accused Aboab, then the rabbi of the Beth Israel congregation, of "corrupting" and instigating them. He would not stand for this kind of disrespect. He became particularly incensed when his adversaries asked the leaders of the community to issue an injunction forbidding him from publicly expressing his views on the matter in his sermons. Mortera refused to give in. No matter how comforting it may have been, the doctrine of guaranteed salvation for all Jews was false and dangerous. Although he lived out his life among the former *conversos* of Amsterdam and preached to them in fluent Portuguese, it is easy to imagine the Ashkenazic rabbi's lack of empathy with what the members of his congregation (or their ancestors) had been through in their former lands. He obviously did not share their concern for the ultimate fate of Iberian apostates.

The governors of the Amsterdam congregations, upset by so vehement a dispute between their rabbis, did not know what to do. So they asked the more experienced leaders and rabbis of the older Sephardic community in Venice to rule on the question. The Venetians' reply, while diplomatically expressed, was crystal clear: Mortera is right, Aboab is wrong.

There is no indication that Aboab ever publicly retracted his views. As a practical matter, however, Mortera prevailed. When

the three congregations merged into one, in 1639, Mortera was made the chief rabbi. Aboab was given the lowest rank, just below Menasseh, although his salary was higher and his duties more extensive and prestigious than Menasseh's. In 1642, Aboab left for Brazil to minister to the Amsterdam Jews who had settled in Recife during the Dutch occupation of that territory. His departure from Amsterdam was almost certainly the result of lingering tensions with Mortera.

Being a rabbi in the Portuguese-Jewish community in Amsterdam in the first half of the seventeenth century could not have been easy. A rabbi's responsibilities in this period were broad. They included providing not just religious teaching and spiritual guidance, but also social and intellectual leadership. In Amsterdam, a rabbi's task was made even more difficult by the need to keep an eye on the potentially treacherous Dutch religious and political scene. He had to deal both with the suspicions of intolerant Calvinists and with the Jewish community's feelings of insecurity as refugee-guests. Above all, the rabbis of the first congregations in Amsterdam confronted the very idiosyncratic needs and demands of their own congregants. In effect, they had to create a proper Jewish community nearly from scratch. And the obstacles they faced and the resistance they met with were sometimes formidable.

Because most of the founding members of the Sephardic community were either *conversos* returning to the Jewish faith or Judaizing New Christians who were now able to practice openly for the first time in their lives, the Judaism inherited by the community had a special, rather unorthodox character. It had been formed over the centuries during which Iberian Jewish culture, while flourishing, was closely assimilated into the Catholic society in which Jews often had high status. The material and political rewards of blending in, when this was still a voluntary matter, were too great to be ignored. The Jews of medieval Spain took advantage of opportunities that were not available to their central and eastern European brethren. They became successful members of the profes-

sional classes, respected intellectuals, and even members of the royal courts in Castille, Aragon, and other kingdoms. The price of this, however, was evident in the religion that developed among them. Judaism in Iberia was strongly influenced by many of the rites, symbols, and beliefs of local Catholicism. For example, among the Jews of Spain were various ceremonies honoring Jewish "saints," the most popular of which was the celebration of the feast of St. Esther—that is, Purim. There was also an unusually strong concern with eternal salvation, albeit through the Law of Moses and not the Gospel of Jesus. This may explain the susceptibility toward messianic fervor in medieval and early modern Iberian-derived Judaism.

As we have seen, from the standpoint of normative Judaism, things got dramatically worse after the expulsion from Spain in 1492, when the golden age of Spanish Jewry came to a sudden end and its remnant was forced to submerge itself entirely into Christian culture. Henceforth, the *converso* communities in Spain and Portugal were cut off from the mainstream Jewish world. Over subsequent generations, their grasp of the rules and practices of Judaism grew sketchy and distorted. Their memories of how to observe the holidays, and even of the modes of everyday prayer, faded. They were not able to keep Jewish customs with any consistency, and they often relied on hearsay and creative guesswork. One historian notes that by the end of the sixteenth century, Judaizing *conversos* had given up not only circumcision, kosher butchery, and funereal rites—public activities that would be difficult to maintain under the watchful eyes of suspicious neighbors—but also the use of *tefillin* or phylacteries, ordinary Jewish blessings, and the celebration (however secret) of the most important Jewish holy days.[13] Some *halachot*, or laws, were scrupulously followed in one form or another while others, no less important, were completely neglected and forgotten. The Judaizing *conversos* had no rabbinical authorities to appeal to or texts to consult. They did not have ready access to Hebrew Torah scrolls, the Talmud, or any other books of rabbinic literature, the study of which is so central to an informed Jewish life.

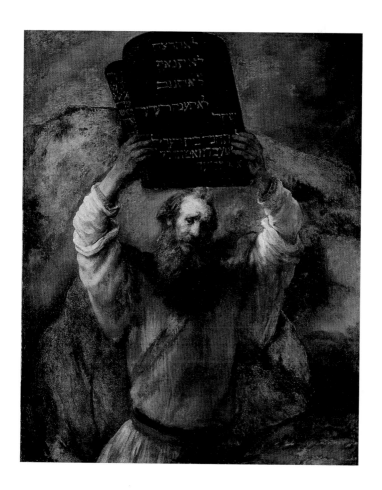

PLATE 4.
Rembrandt, *Ephraim Bueno*,
Rijksmuseum, Amsterdam. Photo:
Rijksmuseum, Amsterdam.

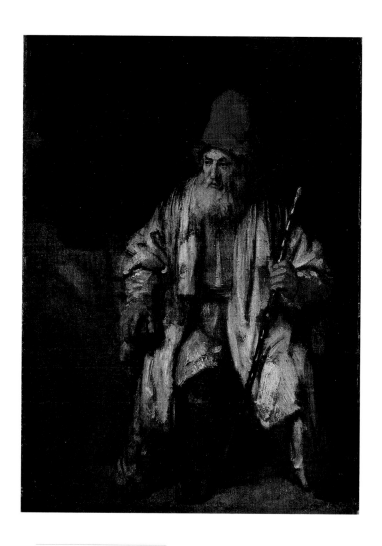

PLATE 5.
Rembrandt, *Old Man in an Arm-
chair*, Staatliche Museen zu Berlin,
Gemäldegalerie. Photo by Jörg P.
Anders, © 2003 BPK.

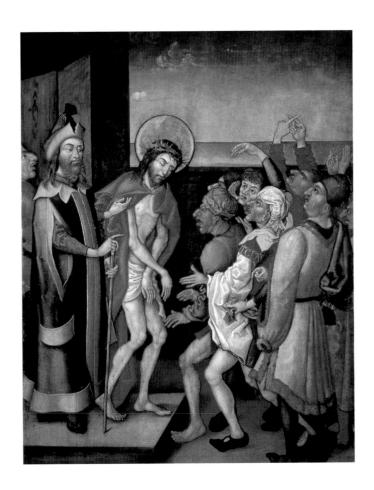

PLATE 6.
Ecce Homo, School of Schongauer (fifteenth
century), Musée d'Unterlinden, Colmar,
France. Photo: O. Zimmermann, © Musée
d'Unterlinden, Colmar.

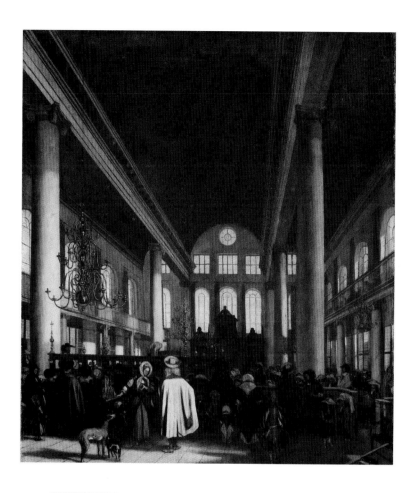

PLATE 7.
Emanuel de Witte, *Interior of the
Portuguese Synagogue in Amsterdam*,
Rijksmuseum, Amsterdam. Photo:
Rijksmuseum, Amsterdam.

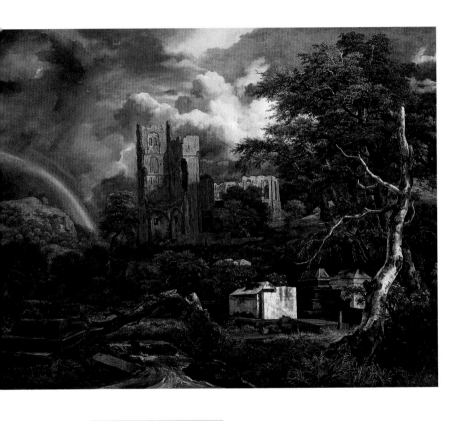

PLATE 8.
Jacob van Ruisdael, *The Jewish Cemetery*,
1655/1660, The Detroit Institute of
Arts. Gift of Julius H. Haass in memory
of his brother Dr. Ernest W. Haass.
Photograph © 1996 Erich Lessing/Art
Resource, New York.

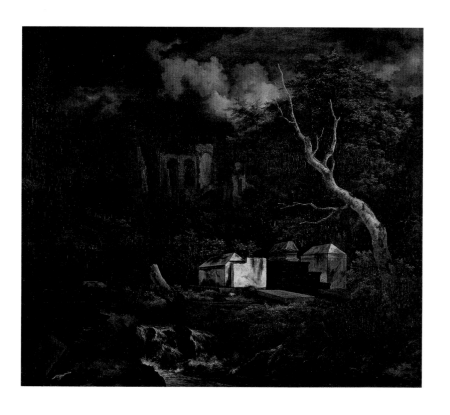

PLATE 9.

PLATE 9.
Jacob van Ruisdael, *The Jewish Cemetery*,
Staatliche Kunstsammlungen, Dresden.
Photo © Erich Lessing/Art Resource,
New York.

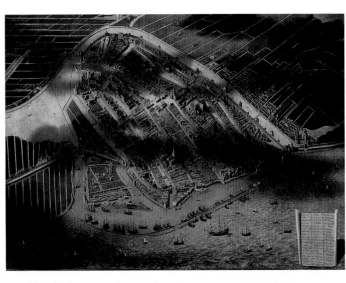

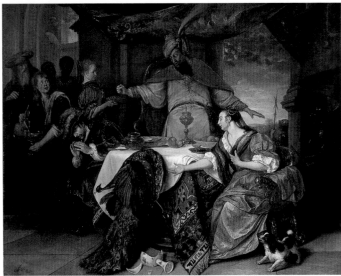

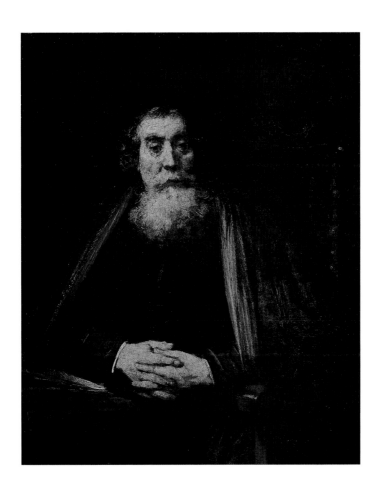

PLATE 10.
(opposite, top)
Jan Christiaensz.
Micker, *View of Amster-*
dam, Amsterdam His-
torical Museum.

PLATE 11.
(opposite, bottom)
Jan Steen, *The Wrath of*
Ahasueris, ca. 1670.
Barber Institute of Fine
Arts, University of
Birmingham/ Bridge-
man Art Library.

PLATE 12.
(above) Rembrandt,
Old Man in an Armchair,
Uffizi Gallery, Florence.
Photo © Scala/ Art
Resource.

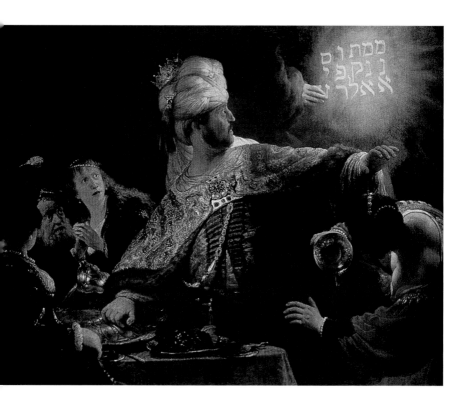

PLATE 13.
(above) Rembrandt,
Belshazzar's Feast,
National Gallery,
London. Photo © Art
Resource, New York.

PLATE 14.
(opposite, top) Pieter
Saenredam, *Nave of the
Buurkerk, Utrecht, from
North to South* (oil on
panel), 1644. National
Gallery, London/Bridge-
man Art Library.

PLATE 15.
(opposite, bottom)
Emanuel de Witte,
Interior of a Church,
1668, Museum Boij-
mans van Beuningen,
Rotterdam.

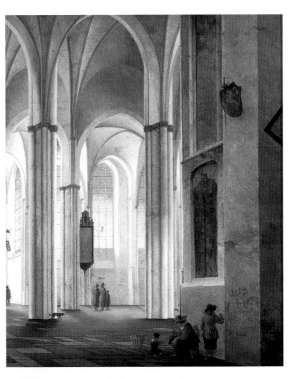

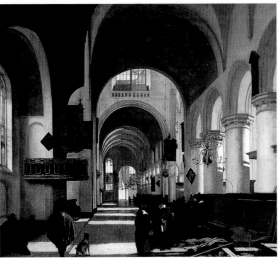

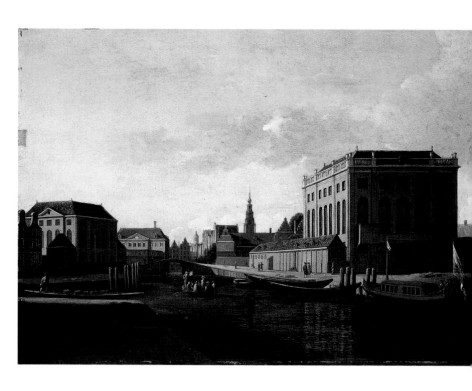

PLATE 16.
Gerrit Berckheyde, *View of the
Sephardic and Ashkenazic Synagogues*,
Stadelsches Kunstinstitut, Frankfurt.

PLATE 17.
Jacob van Ruisdael, *Wheatfields*,
Metropolitan Museum of Art,
Bequest of Benjamin Altman, 1913
(14.40.623). Photograph © The
Metropolitan Museum of Art.

PLATE 18.
Jacob van Ruisdael, *Landscape
with Blasted Tree by a Cottage*,
Fitzwilliam Museum, Cambridge
University.

For these reasons, the earliest Jews of Amsterdam required outside help for their reintegration into Judaism. They were eager to return to the fold, so they sought dedicated and knowledgeable teachers who would ease their transition. The story of how the two Ashkenazim from Emden, Moses and Aaron Halevi, helped the first group of Portuguese merchants return to Jewish practice is only the most legendary instance.

Most of the rabbis of the Amsterdam Sephardim in the first half of the seventeenth century came from outside the community. Joseph Pardo, the first rabbi to lead a congregation in the city, had been born in Salonika but was living in Venice when he came to serve Beth Jacob. His son David later became the second-ranked rabbi in the united Talmud Torah synagogue. The Neve Shalom congregation, meanwhile, imported Judah Vega from Constantinople. He was followed in 1616 by the strict and contentious Isaac Uziel from Fez, Morocco. Uziel, in turn, trained Menasseh ben Israel and Isaac Aboab. All of these rabbis were of Iberian background and were sympathetic to their congregants' situation and needs—unlike Mortera, who arrived in Amsterdam from Venice in 1616 and was chosen to head Beth Jacob two years later.

These *chachamim* corrected or abolished altogether various practices that they deemed inconsistent with Jewish law and tradition. They supervised the conformity of the community's liturgical, moral, and social activities with *halachic* requirements. Pardo, for example, prohibited the members of Beth Jacob from gathering in the synagogue on the three Saturdays preceding *Tisha b'Av* (the ninth day of the month of Av, on which Jews mourn the destruction of the Second Temple). This custom, he argued, as reverent as it seemed, violated the holiness of the Sabbath. The rabbis also sought to put an end to the adulterous liaisons that many men in the community pursued with their servant women, a common enough practice among the Spanish and Portuguese upper classes but strictly forbidden under Jewish—not to mention Dutch —law.

Amsterdam's Sephardic rabbis faced an enormous task in reeducation. It took more than mere learning. A successful rabbi had

to be a charismatic figure, one who could inspire others not just to govern themselves according to Jewish law but also to think in new ways about their identity and their loyalties. Many of the unorthodox practices had the force of habit and the authority of class and tradition behind them. These congregants took great pride in their noble Iberian heritage. The rabbis charged with reforming them had a very frustrating job.

Menasseh only wished that he could play a greater and more respected role in it.

<center>⸻⸻</center>

In the print collection of the Museum Het Rembrandthuis on Jodenbreestraat there is an etching done in 1636 (figure 15). The impression is from the etching plate's third state. The half-length portrait shows a rotund man who seems to be in his late thirties. His coat is open, and a broad white collar flows out to his shoulders. A wide hat with a large but nearly shapeless brim rests above his round face. He has heavy-lidded eyes, full lips, and a broad, flat nose.

Is he a Jew? There is no reason, on first glance, to think so. The dress is typically Dutch. He looks like the sitters for many other Rembrandt portraits. If he is wearing a *kippah*, we cannot tell because of his hat. There is a thin scarf around his shoulders, but it is not obviously a prayer shawl. His hair is cut moderately short, just on the ears, and there are no side-curls, or *peyyot*. No book or piece of paper with Hebrew letters is at hand to provide any clue about the subject.

What about his beard? He has a goatee and a mustache, both scruffy and not very full. The goatee is long and cut square at the bottom. It looks a lot like the beard on Ephraim Bueno in Rembrandt's etching of that physician. It is also like three of the beards in de Hooghe's print of the circumcision ceremony, and like the beard in the engraved portrait of Dr. Abraham Zacuto by S. Saveri in 1634. Obviously this was a popular fashion among Amsterdam's Sephardim. It is certainly not typical of the beards worn by the city's Ashkenazic men, who went for the fuller, Abrahamic look.

FIGURE 15. Rembrandt, *Menasseh ben Israel [?]* (etching), The Pierpont Morgan Library, New York, NY. Photo © The Pierpont Morgan Library/Art Resource, New York.

But the Portuguese made it a point of pride that they did not look like the eastern European Jews. In the first catalogue raisonné of Rembrandt's works, composed by the dealer Gersaint in 1751, the etching of Dr. Bueno is described as showing a man wearing *une barbe à la Juive*, a beard in the Jewish style.[14] But this tells us more about eighteenth-century French fashions than about Dutch trends a century earlier. In seventeenth-century Holland, Jews did not have a monopoly on this style. The same kind of beard is worn by many of Rembrandt's men, including Arnout Tholincx, the husband of Catherina Tulp, in his 1656 portrait; Herman Doomer,

the Amsterdam framemaker, in a 1640 painting; and Jacob Trip, in his 1661 portrait.

Nonetheless, a consensus has emerged—with some dissenters, of course—that this etching of 1636 is of a Jew. And not just any Jew, but Menasseh ben Israel. There is some similarity to the portrait of the learned Menasseh, the *Theologus et Philosophus Hebraeus* of Amsterdam, that was done by the Jewish artist Salom Italia in 1642 (figure 16). The beard, collar, and coat, even the straight row of buttons that begins under the chin and the narrow shawl around the neck, all look the same. But the face, while there is a family resemblance—and even making an allowance for Italia's artistic shortcomings—is not close enough. The eyes of the man in Rembrandt's etching are noticeably farther apart than those in Italia's picture, whose subject also has a longer, thinner nose than Rembrandt's sitter. The two portraits are probably not of the same person.[15]

Another portrait taken to depict Menasseh is by Govaert Flinck, Rembrandt's student. It has a superficial likeness to the Rembrandt etching (figure 9). The beard is a bit longer, but its shape is right; the large hat is there too, albeit with better blocking. However, if Menasseh was thirty-eight years old at the time that he sat for Italia in 1642, as explicitly indicated on the print, then the man who is in "the forty-fourth year of his life" in Flinck's 1637 painting is not Menasseh. But then what has happened to the painted portrait of Menasseh that the records show was in the art collection of a member of the Portuguese community?

The severe, gaunt face of Rabbi Aboab was captured in a 1685 mezzotint by the Dutch artist Aernout Nagtegaal (Aboab, incidentally, has the same kind of beard as the man in the Rembrandt etching) (figure 13). There are two images of the kinder, gentler looking Rabbi Sasportas: an engraving by Pieter van Gunst and a painting by Johannes Luttichuys (figures 11 and 12).

But where is Saul Levi Mortera? The most important rabbi of the century for Amsterdam's Jews is not represented by any authenticated portrait. He is often believed to be making a cameo appearance, Zelig-like, in this or that context: the face of the old

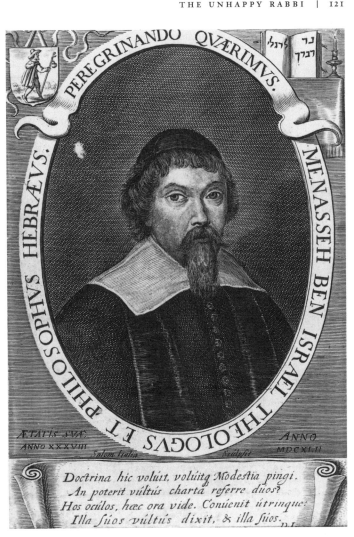

PEREGRINANDO QVÆRIMVS.

MENASSEH BEN ISRAEL

THEOLOGVS ET PHILOSOPHVS HEBRÆVS.

ÆTATIS SVÆ
ANNO XXXVIII

Salom Italia

Sculp.

ANNO
MDCXLII

Doctrina hic voluit, voluitq̃ Modestia pingi.
An poterit vúltús charta referre dúos?
Hos oculos, hæc ora vide. Conúenit útrinque:
Illa fúos vúltús dixit, & illa fúos.

FIGURE 16. Salom Italia, *Menasseh ben Israel* (etching). Photo courtesy of the Library of the Jewish Theological Seminary, New York.

man behind the grandfather holding the baby in de Hooghe's *Circumcision;* standing at the *tevah*, or reader's platform, at the center of Veenhuysen's engraving of the interior of the synagogue; even the man in the 1636 etching by Rembrandt that is supposed by

others to be of Menasseh. But none of these have even a reasonable claim to being images of the man who dominated the community through his will and his intellect for over forty years. Perhaps this highly legalistic Ashkenazic rabbi was more scrupulous about the Second Commandment than his Portuguese congregants.

And yet the sightings continue. There is a painting by Rembrandt in the Uffizi Gallery in Florence titled simply *Old Man in an Armchair* (plate 12). It was done sometime in the early 1660s. By 1713, it was in the collection of the Medici family. Perhaps the work was bought by Cosimo III when he visited Rembrandt in Amsterdam in 1669. It is a very dark canvas. The back of the chair is only faintly visible in the deep shadows behind the sitter. The dramatic chiaroscuro of the foreground, where the old man's face and hands and the edge of the crimson shawl around his shoulders emerge from the darkness, give the painting its depth. His *barbe à la Juive* is long, unruly, and gray, although the hair on his head is dark. His lined cheeks are ruddy, his eyes dark. He stares pensively downward at something in front of the picture plane. The man's features, while captured with unmistakable individuality, are coarsely painted. This is the familiar late Rembrandt, the artist whose rough style was the object of scorn among many of his contemporaries.

Is it Rabbi Mortera? The temptation to think so has proven irresistible to many.[16] Sadly, this can be only wishful thinking. There is no documentary information whatsoever as to who the sitter is. Moreover, unless the painting was done in or before 1660—and this seems unlikely—Mortera would have been unable to sit for it, since he died that year. Finally, there is one additional question raised by such an identification: Why would a portrait of one of the most beloved figures of the city's Sephardic community have been so relatively quickly shipped off to Florence into the hands of the Medicis? Why was it not kept within Mortera's family, or at least within the congregation as a memento of their late leader?

Anyone looking for a portrait of Mortera must be satisfied with the simple drawing—hardly a serious work of art—made by Abraham Idanha in 1686, twenty-six years after the rabbi's death (figure

17). It shows the rabbi vigorously preaching from a pulpit underneath a six-candle chandelier. On each side of him, descending away from the lectern, are four congregants, eight in all, with their *tallitot* brought up like hoods over their heads. It is a perfect design for a commemorative Chanukah menorah, with the *chacham* himself serving as holder for the *shamash*, or central candle.

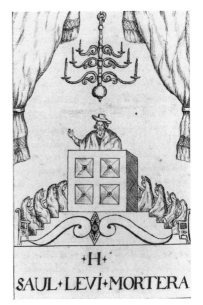

+H+

SAUL+LEVI+MORTERA

FIGURE 17. Abraham Idanha, *Hacham Saul Levi Mortera* (drawing), Butler Rare Book and Manuscript Library, Columbia University, New York.

Belshazzar was the son of Nebuchadnezzar and king of Babylon. He was fond of the trappings of wealth, including jewels, precious metals, and sumptuous feasts. But this most powerful person in the land had trouble reading the writing on the wall.

One day Belshazzar gave a banquet for a thousand of his noblemen. After some wine had "warmed" him, he called for the vessels of gold and silver that his father had taken from the sanctuary of the Temple in Jerusalem when the Babylonians sacked that city, "so that he and his nobles, his concubines and his courtesans, might drink from them." They filled the vessels with wine and toasted "the gods of gold and silver, of bronze and iron, and of wood and stone." Then, suddenly, in the midst of the revelry, a vision appeared: a hand writing on the palace wall. "The king could see the back of the hand as it wrote." It was a terrifying apparition. The words were unfamiliar to the king and his retinue.

The king's mind was filled with dismay and he turned pale; he became limp in every limb and his knees knocked together. He called loudly for the exorcists, Chaldeans, and diviners to be brought in; then, addressing the wise men of Babylon, he said, "Whoever can read this writing and tell me its interpretation shall

be robed in purple, and honored with a chain of gold around his neck and shall rank as third in the kingdom" (Daniel 5:7).

None of his wise men could make sense of the writing.

The queen then entered the hall. Upon learning the reason for the king's troubled countenance, she informed him that there was, indeed, a person who could interpret the words. "There is a man in your kingdom who has in him the spirit of the holy god, a man who was known in your father's time to have a clear understanding and godlike wisdom . . . [he] is known to have a notable spirit, without knowledge and understanding, and the gift of interpreting dreams, explaining riddles and unbinding spells" (Daniel 5:10–11). She was referring to Daniel, who had been brought to Babylon with the other Jewish exiles. Nebuchadnezzar had appointed him chief of the magicians, exorcists, and diviners and given him the name Belteshazzar.

Daniel was brought in. He declined the gifts that the king offered him in return for his help and proceeded to interpret the writing. He pronounced the words on the wall, *mene mene tekel u-pharsin*. The writing was in Aramaic. Daniel interpreted it to mean that the downfall of Belshazzar's kingdom was imminent. He explained how Belshazzar's father had been deposed and humiliated when he, in his arrogance, refused to recognize the ultimate sovereignty of God. Only when he "came to know that the Most High God is supreme over the kingdom of men" was he restored to his throne. But Belshazzar, Daniel said, has not humbled his heart; he has "set himself up against the Lord of heaven." He drinks freely from the vessels of the Temple and has worshiped gods other than the true one. Belshazzar's days, Daniel concluded, are numbered. Literally so: *mene* (in Hebrew, *mina*) means "numbered," but it also refers to a coinage; *tekel*, or *shekel* in Hebrew, is a weight or another coinage, and represents one-sixtieth of a *mene*. *U* means "and." And *pharsin* means "two *pheres*," with a *phere* being half a *shekel*. The declining values indicate that Belshazzar's kingdom is coming to an end.

Mene: God has numbered the days of your kingdom and brought it to an end; *tekel:* you have been weighed in the balance and found

wanting; *u-pharsin:* and your kingdom has been divided and given to the Medes and Persians. (Daniel 5:26–28)

That very night Belshazzar was slain and "Darius the Mede" (most likely Darius, king of the Persians from 521 to 486 B.C.E.) took over the land.

This episode from chapter 5 of the Book of Daniel is the subject of one of Rembrandt's most remarkable paintings (plate 13). The work is from the late 1630s and may have been done for a Jewish patron. Belshazzar, dressed in elaborate oriental robes, looks over his shoulder in horror at the hand that has emerged from a cloud to write on the wall. As Belshazzar swings around, his right arm, covered by a gold- and jewel-encrusted cape, knocks over a golden goblet of wine (one of the Temple vessels); his left arm is raised, as if to ward off the apparition. His head, encased in an elegant turban topped by a crown that matches his cape, is turned as far as it will go over his left shoulder. The king's eyes bulge. His companions—three women in fancy dress and an old man—recoil in fear. A woman with a low-cut bodice spills her wine.

In the upper right corner of the canvas are the words themselves. The hand is in the process of finishing the final letter of the last word. The Hebrew characters glow with their own golden light.

If one tries to read the Aramaic in Rembrandt's painting the way Aramaic and Hebrew are usually read, horizontally across from right to left, the writing makes no sense whatsoever; they are not even real words. Only when the letters are read vertically down each row, starting at the right and moving leftward column by column, does the message from Daniel 5:25 appear.

The form in which the message was written for Belshazzar was a subject of some debate among the ancient rabbis. The biblical text itself gives no indication of the format of the words; it just says that the king could not read them. In the Talmud, when the question is raised as to why Belshazzar and his retinue could not understand the writing, a number of possibilities are proposed. According to Rabbi Jochanan, it was because the message proceeded horizontally but with each word written backward, from

left to right. Rabbi Ashi agreed that the words were to be read horizontally, but insisted that the difficulty stemmed from the fact that the first and second letters of each word were transposed. Finally, Rabbi Samuel suggested that the writing had to be read vertically, not horizontally—just as we find it in Rembrandt's painting.[17] There are even more solutions to the problem offered in the *Midrash Rabbah*, including some suggestions as to how the message might have been encoded.[18]

Why did Rembrandt adopt in his painting the same interpretation of the story given by Rabbi Samuel? Almost certainly because of Rabbi Menasseh.[19]

In the seventeenth century, Christian writers either ignored or rejected the various rabbinic solutions to Belshazzar's perplexity. In artistic depictions of the subject, the issue is avoided as the words on the wall either appear in normal (and readable) Latin or are omitted altogether. Rembrandt alone showed an interest in the Jewish tradition. And, what's more, he chose the one Talmudic solution that involved the most radical and complicated visual arrangement of the Hebrew/Aramaic characters. On the face of it, this seems rather strange indeed.

However, in a book published in 1639, *De termino vitae* (The end of life), Menasseh gives only one account of the apparition: the vertically oriented presentation of Rabbi Samuel. He makes no mention of the other possibilities considered by the ancient sage's colleagues. No one else in the period who discusses the story does this. Menasseh even provides in his book an illustration of the words themselves in five vertical rows of three, just as they appear in Rembrandt's painting. To be sure, Menasseh's book did not come out until well after Rembrandt was done with the canvas. But how can we ignore the fact that just when Rembrandt was working on this painting, he was living on the back street of Vlooienburg island, on Zwanenburgstraat next to the Sugar Bakery—only five houses away from Menasseh?

In a busy city, and Amsterdam was one of the busiest, it is easy not to know one's neighbors. Vlooienburg was a crowded district. Its inner streets and alleyways were densely populated, mostly by

Ashkenazic Jews. The back wharfs of the island, where both Menasseh and Rembrandt lived overlooking the Binnen Amstel, were the bustling center of various trades and businesses. There is no reason why any two people in the neighborhood, even those living on the same block, should have had more than a passing recognition of each other's face. Why should a Christian painter who spoke only Dutch and a Jewish rabbi whose first language was Portuguese know each other?

But they *did* know each other. Maybe they were even friends. Some years after Rembrandt had finished Belshazzar's feast, as we shall see, they worked together on a project of great importance to the Jewish messianist. Why assume that this later collaboration was only the beginning of their relationship? More likely, it was its culmination. It was only natural, then, that when Rembrandt was plotting out the apparition in the Belshazzar painting, he simply walked fifty yards down the street and asked Menasseh how the words went.

Menasseh and Rembrandt had a number of close acquaintances in common. Ephraim Bueno, for one. Rembrandt's physician sitter and Menasseh's patron could well have been the one who first introduced them. There was also a wider circle in which both Rembrandt and Menasseh moved. Cornelis Claeszoon Anslo, a Mennonite preacher, sat for two portraits by Rembrandt in 1641: one was a painting, an intimate double portrait with his wife, Aeltje; the other was an etching. His son, Gerbrand Anslo, was a cloth merchant. Gerbrand was also a good friend of Rembrandt's original dealer (and cousin-in-law), Hendrick Uylenburgh. Now Menasseh and the younger Anslo enjoyed a warm relationship. Gerbrand studied Hebrew with Menasseh and became quite proficient in the language. He even dedicated a Hebrew poem to his teacher. The rabbi returned the favor and dedicated one of his own books, *On Human Fragility*, to Gerbrand. Menasseh, in his remarks to his pupil, recalls with pleasure the time they spent together. "You both visit my home and treat me honorably when I enter yours."[20] Perhaps Rembrandt already shared some of the millenarian interests that so occupied Menasseh and Anslo.[21]

Whatever the circumstances of their initial meeting, what probably brought the two men together, in the end, was need. Rembrandt's need. He wanted to get the details right. Menasseh, perhaps more than anybody—with his easy ability to explain matters Jewish to non-Jews, and with his knowledge of rabbinic literature, mysticism, and messianism—could help him. Right down to the serif of the *aleph*.

To the artist unfamiliar with Hebrew—and how many gentile artists of this time were not?—it was a troublesome language to represent. The proper shape of the characters, the spacing of the words and sentences, the grammar—all required great attention to detail (and some outside help). It was much easier to caricature the script than to render it accurately. It did not matter much anyway, since it was usually ancillary to the subject being portrayed. But Rembrandt was different. No other non-Jewish painter in history included as much Hebrew in his art as he did. And no one equaled his ability to make the Hebrew—real Hebrew—an integral element of the work, central to its message and not merely a decorative or trivial motif.

In northern Netherlandish and Dutch paintings and prints of the sixteenth and seventeenth centuries it is not that unusual to find Hebrew or Hebrew-like characters, especially in biblical scenes. Usually they appear as minor details—on a book leaf or an article of furniture—for added effect. They are intended to convey a sense of antiquity or biblical authenticity to the setting. Or, as when the Hebraic lettering is on a piece of clothing, such as the trim of a cloak or a head covering, it identifies one individual or another as a Jew. In most cases, it is not true Hebrew that appears, but either imitations of Hebrew forms—blocklike letters pointing in the right direction (figure 7)—or real Hebrew letters arranged in a nonsensical way. The only genuine words that appear with some regularity and consistency are the tetragrammaton, the four-letter name for God (*yod, heh, vav, heh*); and, in paintings of Jesus on the cross, the Hebrew or Aramaic inscription that is tradition-

ally included along with Greek and Latin translations on the notice that Pontius Pilate is said to have attached over Jesus' head to indicate his crime: "Jesus of Nazareth, King of the Jews." There are also, on occasion, representative phrases from the Ten Commandments in depictions of the two tablets of the Law, whether they are shown in Moses' hands or in some other context.

Some artists, however, did go to the trouble of representing proper and complete Hebrew, full sentences from recognizable sources. The Dutch painter Gabriel Metsu, in his *Christ and the Woman Taken in Adultery* of 1653, includes all ten commandments in Hebrew clearly and correctly written on the tablets. And the robe of the Jewish priest in a painting attributed to Cornelis de Vos, *The Presentation in the Temple*, is bordered by several unmistakable texts from Exodus 13 ("Every first born is holy to me . . ."). But no one went as far as Rembrandt did to make the Hebrew itself a part of the story.

The overall quantity is not what is important here. Hebrew is present in only a tiny fraction of Rembrandt's enormous output of paintings and works on paper. Still, the number is—relatively speaking—impressive. Eight works purport to represent Hebrew. Sometimes what is visible on the canvas or panel is only a linguistic caricature, the kind of quasi or ersatz Hebrew of the sort that appears elsewhere in art. In other cases, genuine Hebrew words are clearly discernible. The subjects of *The Rich Man from a Parable* of 1627 and *The Prophetess Hannah*, sometimes believed to be modeled by Rembrandt's mother in 1631, are reading out of books, supposedly Scripture, with Hebraic-like lettering. There are some recognizable Hebrew words in an open book lying on a table in the foreground in *Judas Returning the Thirty Pieces of Silver* (1629). A member of the crowd in *St. John the Baptist Preaching* of 1635–1636 wears a prayer shawl bannerlike around his head and shoulders with some Hebrew lettering on it. He is one of the Pharisees who has come to hear John preach. Rembrandt himself holds an open Hebrew Bible in the self-portrait as the Apostle Paul from 1661 that now hangs in the Rijskmuseum in Amsterdam, although the script in the book is mock-Hebrew.

The paintings in which actual, carefully selected Hebrew texts are depicted in a bold and forthright manner immediately relevant to the story being told are what concern us. They are some of Rembrandt's most famous works. There is Moses holding aloft the two tablets of the Law. The second tablet is in front of the first, and the large words of the last five commandments are easily read. And then there is the blazing message confronting Belshazzar. It is the most striking appearance of the language in all of painting. Rembrandt pictured Hebrew with great confidence. It is not something seen very often in Western art. The question is, from where did this confidence come?

Rembrandt was enrolled as a student at the University of Leiden in 1620. It is possible, but not likely, that he studied under the professor of Hebrew there, Thomas Erpenius. He almost certainly attended very few (if any) classes at Leiden. His devotion was to painting early on, and by the time his name appears in the university registrar's book, he was already apprenticed to Jacob van Swanenburg. His university matriculation was probably a maneuver, commonplace at the time, to avoid service in a civic guard and to gain the tax-free access to wine and beer that students enjoyed. (Descartes registered at the University of Leiden in 1630 for similar reasons.) Besides, as impressive as Rembrandt's Hebrew inscriptions are, no one who really knew the language would do some of the things that he does in his paintings. Characters that are of similar shape (such as the *resh* and the *dalet* or the *nun* and the *zayin*) are confused with one another.[22] And a letter is missing from one of the words in the seventh commandment in the front tablet in Moses' hands.

Rembrandt was not composing his own Hebrew or reading it straight from the biblical text itself. Rather, he was copying what someone else had written down for him. When it came time to deal with the presentation of the message to Belshazzar, what better man to turn to than the resident of 61 Zwanenburgstraat? Left to his own devices, Rembrandt would not have been able to paint *mene, mene, tekel, upharsin*, much less in such magnificent Hebrew characters.

Perhaps Menasseh became Rembrandt's special consultant on mysterious divine apparitions, with a particular expertise on those with hands coming out of nowhere to present a written message. An etching by Rembrandt from the early 1650s that we have already discussed shows a man, evidently a scholar of some sort, bent over a book on a table (figure 2). He is turned to look over his left shoulder at the window of his study. In front of the lower panes is a series of concentric circles, each bearing a written text. The vision, like the letters on Belshazzar's wall, radiate a sharp light. Just below the glowing disc is a hand pointing at what may be a mirror, in which a face—but not obviously that of the scholar himself—appears.

The etching has sometimes been identified as *Faust in His Study*. But there is no reason to believe that the figure in the print is the legendary alchemist and seeker of forbidden wisdom. The man has a prayer shawl around his shoulders and is almost certainly a Jew. He is probably a kabbalist, a devotee of Jewish mysticism. The words inscribed in the circles derive from various kabbalistic formulas. Snippets from Jewish prayer and variations on the name of God are encoded numerologically—a common feature of kabbalah—or arranged as anagrams. In the mystical tradition, it is believed that one can bring one's soul near to God by contemplating the divine name. The Jewish scholar depicted in Rembrandt's etching, through this vision, ascends closer to his goal.[23]

Was the etching commissioned by a Jewish patron, perhaps one of Amsterdam's Sephardim with a kabbalistic bent? Most likely not. One aspect of the work stands in the way of a purely Judaic reading.[24] In the center of the innermost circle of the ghostly vision, reading backward, are the letters R, I, I, N. This is a scrambled version of INRI, the abbreviation of *Iesus Nazarenus Rex Iudorum* hung on Jesus' cross.[25] This association of Jesus with the surrounding representations of God's name would remind viewers of the potential messianic dimensions of kabbalah mysticism.[26] Is the Jewish scholar depicted in the print supposed to be seeing, right at the heart of his vision, the truth about Jesus' divine nature? This would have been a welcome message to Rembrandt's

and Menasseh's millenarian friends, especially those who thought that the coming of the Messiah would be preceded by the conversion of the Jews. Although he was certainly not party to any conversionist program, Menasseh could very well have advised Rembrandt on the kabbalistic elements of this work.

<center>—⁂—</center>

Rembrandt's relationship with Menasseh was undoubtedly of great intellectual, even spiritual importance for the artist.[27] Perhaps it is not too much to say that the two men were kindred spirits. Despite their religious differences, they seem to have shared messianic persuasions, with each looking forward (in his own way) to the rapprochement of Jews and Christians and the arrival of the Anointed One. We see this reflected not only in Menasseh's writings but also, it has been argued, in Rembrandt's later works.[28] What is certain is that their collaboration went beyond merely one seeking the other's advice on a Hebrew inscription in a history painting and help with the content of a mystical vision in an etching. These were only preludes to a much larger cooperative engagement between Menasseh and Rembrandt.[29] The outcome of the enterprise is uncertain, and we do not know for certain whether either party counted it a success. There are, in fact, reasons for thinking that both men found it a frustrating experience.

At some point, Rembrandt must have had to remind himself why he had agreed to take on this project. He almost never did illustrations for books. There was the single etching of *The Wedding of Jason and Medea* that he had worked on seven years earlier for the published edition of the tragedy *Medea*, composed by his influential friend Jan Six. And this was over fourteen years after providing an etching, *The Ship of Fortune*, for Elias Herckmans's *Der Zee-Vaert Lof* (In praise of sea voyage). But now, in 1655, when his financial situation was at rock bottom and when, with all his legal problems, he had the least possible amount of time to devote to so unremunerative a task, here he was working hard on four different etchings for another friend's book. If Menasseh was paying him anything at all, it surely could not have been very much; Menasseh's means were just as meager as Rembrandt's. Perhaps Menasseh had

reminded Rembrandt of the help that he had provided on Aramaic warnings, Hebrew lettering, and kabbalistic apparitions. Of course, it is also possible that this was something that Rembrandt really wanted to do because it somehow furthered his own artistic, intellectual, and religious goals.[30] It is hard to believe, however, that at this point Rembrandt had much else on his mind beyond selling some major paintings to make enough money to satisfy his creditors and save his house on Breestraat.

It was a book about a rock. The *Piedra Gloriosa, o De la Estatua de Nebuchadnesar* (The glorious stone, or On Nebuchadnezzer's statue) was published in Amsterdam in 1655 by *el chacham Menasseh ben Ysrael.* The book bore a weighty and momentous mission. It deals, the author says, with "a heroic subject," and its scope is "the total history of the Hebrew people, until the end of time and the time of the Messiah." Written in Spanish so that it would be accessible to both Sephardic and gentile audiences, the work was meant to provide long-term comfort to Jews and Christians regarding what the coming messianic era held in store for them. Menasseh undertook the project at the urging of friends, who, he says, entreated him "to explain the dream of that great statue of Nebuchadnezzar and its interpretation."

In the Book of Daniel, King Nebuchadnezzar of Babylon—Belshazzar's father—challenged his wise men first to divine the content of the dream that he had had the night before and then to provide an interpretation of it. The wise men of Babylon were naturally flabbergasted at this challenge. If the king would only tell them what the dream was, they could provide its meaning. "But nobody on earth," they protested, "can tell your majesty what you wish to know; no great king or prince has ever made such a demand of magician, exorcist or Chaldean." The king was incensed, and threatened to put the men to death. Then Daniel arrived at the court and was brought to Nebuchadnezzar. The captain of the guard announced, "I have found a man among the Jewish exiles who will make known to your majesty the interpretation of your dream." Daniel, relying on God who alone "reveals secrets and has told King Nebuchadnezzar what is to be at the end of this age," proceeded to satisfy the king's wish.

As you watched, O king, you saw a great statue. This statue, huge and dazzling, towered before you, fearful to behold. The head of the statue was of fine gold, its breast and arms of silver, its belly and thighs of bronze, its legs of iron, its feet part iron and part clay. While you looked, a stone was hewn from a mountain, not by human hands. The stone struck the image on its feet of iron and clay and shattered them. Then the iron, the clay, the bronze, the silver and the gold were all shattered to fragments and were swept away like chaff before the wind from a threshing-floor in summer, until no trace of them remained. But the stone which struck the statue grew into a great mountain filling the whole earth. (Daniel 2:31–36)

The meaning of the dream, Daniel continued, concerns the fate of Nebuchadnezzar, his kingdom, and history itself. The statue's head of gold is the king of Babylon. Great as he is, the days of his reign and of his nation's supremacy are numbered. A second kingdom will eventually arise, ruling, like the first, over all the world. This will, however, be an inferior kingdom, represented by the silver parts of the statue. The belly and thighs of bronze stand for the next kingdom, more imperfect than the second. The fourth kingdom, a divided one ("part iron and part clay"), will be both strong and brittle, full of unstable alliances. Finally, there will appear a fifth kingdom, "one which shall never be destroyed." This ultimate reign, established by God, is represented in the dream by the stone hewn from the mountain. Like the stone's destruction of the statue, this kingdom will "shatter and make an end of all these [other] kingdoms."

The king is awestruck by Daniel's interpretation. He prostrates himself before the young man, orders that sacrifices and offerings be made to Daniel, and acknowledges the power and majesty of "the God of gods and Lord over kings."

Menasseh, not surprisingly, offers in the *Piedra Gloriosa* a messianic reading of the story of Nebuchadnezzar's dream of the statue. His goal in the book, which he dedicated to a Christian friend, Isaac Vossius, is to proclaim the Jewish millenarian doctrine. The end of time will bring the restoration of Israel, the Fifth Kingdom—after Babylon, Persia, Macedonia (under Alexan-

der the Great), and Rome—whose ruler will be the Anointed One. The stone that "is hewn from a mountain, not by human hands," *is* the Messiah, who will sweep away the other kingdoms represented by the statue and replace them with the kingdom of Israel ("[It] will grow into a great mountain filling the whole earth"). Menasseh refuses to speculate on exactly when this will occur, but it will certainly not be before the Jews are "dispersed to all lands of the earth." The book came out in the same year that Menasseh departed for England on his mission to persuade that country to allow Jews to settle there.

Menasseh insists that, contrary to Christian millenarian beliefs, the coming of the Messiah does not require the conversion of the Jews. They will remain God's chosen people and will be the primary beneficiaries of Israel's sovereignty. Nonetheless, Menasseh is concerned to reassure gentiles—at least, those who are righteous and just—that they have nothing to fear as the time for the Messiah's arrival approaches. The virtuous of the nations (*goyim*) will be rewarded in the kingdom, although their status will be inferior to that of the Jews.

The boulder that topples the statue in Nebuchadnezzar's dream is not the only noteworthy stone in the Hebrew Bible. It is generally overshadowed by two more famous rocks: the one on which Jacob's head rested while he slept and dreamed about angels ascending and descending a ladder, and the one that David put in his sling to launch and kill the Philistine giant Goliath.

> Jacob set out from Beersheba and went on his way toward Harran. He came to a certain place and stopped there for the night, because the sun had set; and, taking one of the stones there, he made it a pillow for his head and lay down to sleep. He dreamed that he saw a ladder resting on the ground with its top reaching to heaven, upon which angels of God were climbing up and down. (Genesis 28: 10–12)

> When the Philistine began moving toward him again, David ran quickly to engage him. He put his hand into his bag, took out a stone, slung it, and struck the Philistine on the forehead. The stone

sank into his forehead, and he fell flat on this face on the ground. (1
Samuel 17:48–49)

The episodes are well known and represent significant mo-
ments in the lives of their characters. It is not with this, however,
that Menasseh is concerned. Rather, his extraordinary claim in the
book is that the boulder in Nebuchadnezzar's dream, the rock
serving as Jacob's pillow, and the missile thrown by David are all
one and the same stone!

Menasseh sees the identical messianic message in each story:
great and powerful nations will give way when the Messiah ar-
rives, just as the statue is toppled by the stone. The angels climb-
ing up and down the ladder in Jacob's dream stand for the rise and
fall of nations. When he awakes, Jacob takes the stone that served
as his headrest and sets it up as a sacred pillar, much as the king-
dom of Messiah will be established in Israel. And it is, Menasseh
believes, no insignificant feature of the David story that he had
five stones in his pouch, corresponding to the number of king-
doms. His victory over Goliath represents the Messiah's victory
over other nations.

The consummation of Menasseh's messianic lesson lies in Daniel's
curious and disturbing vision (7:3–28). The prophet reports that he
saw a "great sea churned up by the four winds of heaven." From the
water arose four huge beasts, each different from the others. One
was like a lion, but with the wings of an eagle: "I watched while its
wings were plucked off and it was lifted from the ground and made
to stand on two feet like a man." The second beast was a half-
crouching bear, with three ribs in its mouth: "Up, gorge yourself
with flesh." The third creature was like a leopard with four bird
wings on its back. It had four heads and was "invested with sover-
eign power." Finally, there was the most terrible beast of all: "dread-
ful and grisly, exceedingly strong, with great iron teeth and bronze
claws. It crunched, devoured, and trampled underfoot all that was
left." It had ten horns. While Daniel watched, a small horn sprang
up and uprooted three of the others. The new horn had human eyes
and a mouth, and it was speaking.

Transfixed by the vision, Daniel then sees a number of thrones set in place in the heavens, and "one ancient in years" takes a seat amid a court.

> His robe was white as snow and the hair of his head like cleanest wool. Flames of fire were his throne and its wheels blazing fire. A flowing river of fire streamed out before him. Thousands of thousands served him and myriads upon myriads attended his presence.

The fourth beast, ruler over the others, was killed and its carcass thrown into the flames. Then David "saw one like a man coming with the clouds of heaven." He approached the ancient one sitting on the throne, and "sovereignty and glory and kingly power" were bestowed upon him. "All people and nations of every language should serve him; his sovereignty was to be an everlasting sovereignty which should not pass away, and his kingly power such as should never be impaired."

This prophetic dream is rich material for Menasseh's enterprise. Four beasts and four kingdoms, the most horrendous of which comes to a violent end. The fifth sovereign is a rational man, the Messiah. Anointed by God, he will rule eternally in a kingdom of the spirit. The message was clear.

All Menasseh needed now was a set of illustrations for the book. Why he turned to a Christian artist is a mystery. He could just as well have used any of the talented Jewish draftsmen in town. Perhaps he believed that a gentile would create more appropriate and accessible images for a gentile audience.

It turned out to be a more difficult job than Rembrandt initially thought. There were to be four images, one for each of the biblical stories (figure 18). Rembrandt first etched each scene within its own border on a single plate. Menasseh's text contains precise descriptions, and Rembrandt worked hard to get things right. After three states, he cut the plate into four separate pieces and worked further, touching and retouching them many times. Some of the changes from early to later states are minor: more definition here, less shadow there. Some, however, are major revisions. Rembrandt

FIGURE 18. Rembrandt, four etchings for Menasseh ben Israel, *Piedra Gloriosa*, Rijksmuseum, Amsterdam. Photo: Rijksmuseum, Amsterdam.

originally had the stone rolling from the right into the statue of Nebuchadnezzar's dream to shatter its legs from the hips down and knock them out from under it. Menasseh must have pointed out that the Bible explicitly says that the stone "struck the image on its feet," and that his own text speaks of it "sweeping away [the statue's] feet." Thus, in the final state of this print, the statue's legs are intact and only its feet are knocked out—cleanly severed—by the projectile, this time coming from the left. The thin, very humanlike statue is left looking, awkwardly, as if it were suspended in midair. It now also bears on its arms, head, and stomach the names of three of the four nations (Babel, Persia/Medes, and Greece). The legs, representing the divided kingdom, are labeled for the Roman and the Mohammedan empires.

The result of the collaboration is a striking set of images. Jacob, his head on a large stone, rests peacefully halfway up a wide ladder ("the middle of which corresponds to Jerusalem"). The smiling, solicitous angels who are not climbing upward seem more concerned with ministering to him than with descending. A diminutive David, meanwhile, has already released his rock and hit the mark; the towering Goliath, taking up a large part of the left side of the print, begins his collapse to the ground in a heap of armor. The Philistine giant's posture as he falls resembles that of the collapsing statue. And in Rembrandt's illustration of Daniel's vision, God himself, just below the open vault of heaven, towers over all and is surrounded by a host of angels. Before God stands a man—the Messiah—receiving his charge. Under the clouds that bear this divine load, in a darker realm, are the four beasts, led by the winged lion standing on its hind legs with its arms ferociously raised.

Menasseh must have been pleased with Rembrandt's work. He included the illustrations in the first edition of the *Piedra Gloriosa*. Though the pictures are missing in a number of extant copies of the book, they are in Vossius's own volume, still bound in its original cover in the Leiden University library. In a second edition, however, Rembrandt's prints have been replaced by a different set of images. For some reason, four new illustrations were commissioned from the Jewish artist Salom Italia for the work (figure 19).

FIGURE 19. Salom Italia, four engravings for Menasseh ben Israel, *Piedra Gloriosa*, Hebrew Union College, Cincinnati.

While Italia was apparently directed to reproduce Rembrandt's pictures as closely as possible, his efforts are clearly inferior. Jacob now seems to be resting not on a ladder but on a domestic stairwell; rather than being toppled over, the statue of Nebuchadnezzar's dream appears to be proudly levitating itself, *sans pieds*; and David and Goliath, instead of being engaged in deadly battle, look as though they are playing a schoolyard game, cheered on by their friends. In the illustration of Daniel's vision, the standing lion seems to be wearing a harlequin mask. The most striking difference of all, however, is the absence of God in this image. The anointed savior stands alone before the angelic choir; they bend their heads worshipfully in front of an empty space.

Some have taken this substitution to be evidence that Menasseh was unhappy with Rembrandt's etchings. It has been suggested that, in particular, he objected to the depicting of God. Bodily representations of the divine are unequivocally forbidden by Jewish law; the Second Commandment may allow for some kinds of images, but certainly not pictures of God himself. There were some things that even as cosmopolitan a rabbi as Menasseh could not accept. But if he had such strong objections, why would he have included Rembrandt's prints in the first edition?[31] Were the changes, in fact, made in response to negative rabbinical reactions to the earlier version? Both Jews and Calvinists would have taken issue with the image of God. But then why not just replace that one image, rather than all four?

Of course, it is possible that the reason for the substitution was more mundane and technical. Etchings such as those produced by Rembrandt have a limited lifetime; after a relatively small number of impressions, they grow dull. Italia's longer-lasting copperplate engravings, so close to being copies of the originals, might have simply replaced Rembrandt's worn etched plates.[32] The problem is, we do not know when this second edition was published. It could have been done without Menasseh's supervision. He left for London five months after the first edition appeared in 1655, and never saw Amsterdam again.

When Menasseh ben Israel prepared to return to Holland from England in November 1657, he was a broken man. Despite his best efforts and some lukewarm support from Cromwell, the English "Jewish Debate" that raged in pamphlets and speeches was working against him. The case for the readmission of the Jews had its partisans, but the naysayers mounted an effective campaign. Calumnies against the Jews—regarding their political unreliability and scurrilous business practices, their idolatry, and the ancient Blood Libel—and against Menasseh in particular had their desired effect. Although the Lord Protector was determined to look the other way and allow the Jews quietly to reestablish themselves, Menasseh regarded anything less than full and authorized admission as a failure.

When his son Samuel died in London in September, it was too much for the old man. He petitioned Cromwell to allow him to return to the Netherlands and to help defray the cost of his return voyage.

> May it please your Highnesse, my only sonne, being now dead in my house, who before his departure, engaged me to accompany his corps to Holland, & I [being] indebted here, I know not which way to turn mee but (under God) to your Highness for help in ths condition, emploring your bowells of compassion (which I know are great & tender) to supply me with three hundred pounds, & I shall surrender my pension seal & never trouble or charge your Highnesse any more.[33]

The Treasury, which thought Menasseh's request excessive, granted him two hundred pounds, only fifty of which were ever paid.

Grief stricken, Menasseh bore Samuel's body back across the English Channel and buried him in the Portuguese-Jewish cemetery in Middelburg. A flat stone, packed tightly among others, marks the grave. Menasseh himself was sick and exhausted. He died a little over a month later, on November 20. The Amsterdam Jewish community brought his body back to the city, and he was

buried with all due honor in the Sephardic cemetery in Ouderk-erke. It was a sad ending to an extraordinary life.

———⁂———

There is a certain kind of tale that was popular in seventeenth-century Europe, one that catered to the gentile penchant for sto-ries of Jewish conversion. These were enjoyed not because of some universal millenarian desire to hasten the coming of the Messiah, but because they fed the Christian sense of superiority. Jewish conversion was Jewish concession. When a Jew accepted Jesus as his savior, or even merely abdicated his Judaism, he was, in essence, saying: "I am wrong, you are right."

In these tales, a beautiful and virtuous daughter of greedy, ugly, and wicked Jewish parents is "saved" by a noble Christian man. Their love for each other conquers her religious loyalties. Shake-speare's *Merchant of Venice*, in which Jessica, the daughter of the vile Shylock, is rescued from her destiny—her Judaism—by Lorenzo, is only the most famous example of this type of narrative.

In Amsterdam in 1679, a short novel was published with the title *De Verliefde en Afgevallene Joodin* (literally: The amorous and apostate Jewish woman, but more commonly translated as The lovesick Jewess). The Jewish villain in the story, which is illus-trated with copperplate engravings, tries to murder the heroine by poisoning her. Instead of being her father, however, he is a rabbi. His name, undoubtedly familiar to all of the book's readers, is Menasseh ben Israel.

Esnoga

FOUR

LIKE MANY FESTIVITIES, this one began with music. There was a choir and an orchestra, and the crowd joined in the singing of prayers and psalms. Then came the procession. Led by boys carrying lighted candles, the rabbis and lay leaders of the synagogue entered the sanctuary from one of its side doors and marched around its perimeter three times. In their arms they carried the congregation's Torahs. Each scroll was dressed in its finest, gold-brocaded cover. On top of each pair of wooden handles was a *keter torah*, a silver Torah crown decorated with jingling bells. The building's brand new interior glowed with freshly painted walls and deeply stained wood. The elaborately carved *tevah* or pulpit platform and the ark of the Torah (*hechal*), both made from exotic Jacaranda wood imported from Brazil, were stunning. The polished brass chandeliers of varying sizes suspended on long rods

from the high ceiling and the sconces mounted on the pillars, to-
gether holding over a thousand candles, glistened in the late after-
noon sun. Despite the light streaming in from the seventy-two
windows on this warm Friday in August, all the candles were lit.

As the Torah scrolls were laid to rest in the ark, the chief can-
tor, or *chazzan*, Joseph de Farro, recited a blessing, while his assis-
tant, Imanuel Abenatar Mello, said a prayer for the government
and for the city. Then, the entire congregation joined together in
singing Psalm 29:

> Ascribe to the Lord, sons of gods, ascribe to the Lord glory
> and might
> Ascribe to the Lord the glory due to his name; bow down to the
> Lord in the splendor of holiness.

Le tout Amsterdam was there, Jewish and gentile. The congrega-
tion's men sat on the main floor, the women in the gallery above.
They were joined by the city's burgomasters, other high officials,
and the leading members of regent families, all dressed in their
finest. They brought their wives and children. Even casual visitors,
curious to see the celebration, dropped by. The benches were
packed and onlookers crowded at the railing by the entrance to
watch the proceedings. It was a stupendous show, the social event
of the year. The Portuguese Talmud Torah congregation spared
no expense for the dedication of its brand new synagogue.[1]

Among the invited attendees on August 2, 1675, was Romeyn
de Hooghe. Commissioned once again to capture on paper one of
the community's milestones—this time a public one—he produced
a number of etchings of the building and its inauguration cere-
mony. He was obviously impressed, both by the structure and by
the event. The massive synagogue complex—"The prayerhouse of
Jews, a builder's masterpiece," he called it—was, he noted, "the
Glory of the Amstel and its Senate." The crowd that gathered that
day and the rituals they witnessed, their dress and easy mingling,
the architecture of the building and the achievement it repre-
sented were, for him, a premier subject for representation and ad-

miration. He rendered the ceremony and its surroundings in typically meticulous detail. The faces, the poses, the fashions, even the mood itself are expressively captured for posterity. The viewer can almost tell what is being talked about in the many conversations taking place. It is, above all else, a picture of justified self-satisfaction, and not just among the Jews.

One of de Hooghe's commemorative prints of the ceremony was directed at a Dutch audience. At the top of the work, the city's emblem, the Maid of Amsterdam, separates the dominant Dutch text from its corresponding Spanish version. A more elaborate print, however—the one for sale today (in poster size) at the synagogue's gift shop—while ostensibly created for a general audience, really speaks to the Sephardim themselves (figure 20). It includes along its sides medallions with the names of the congregation's sitting *parnassim*, the members of the building and financing committees, and the men who officiated at the dedication ceremonies. On the bottom are poems in five languages: Dutch, French, Latin, Spanish, and Hebrew. The ecumenical message is reinforced by the symbolism at the top. This time, instead of separating the Dutch from the Spanish, the Maid of Amsterdam is joined on her cloud by three other figures: to her left is a woman representing the United Provinces of the Netherlands; to her right sits an allegory of religious toleration. Beside them is the figure of Judah holding a Torah scroll. The motto underneath reads: "Freedom of conscience is the strength of the Republic." Here, surely, was something in which all parties might take great pride.

The Friday evening services, which had begun at five o'clock, concluded with a traditional *kabbalat shabbat*, the "welcoming of the Sabbath." The celebrations continued, however, for another eight days. On Saturday morning, seventy-year-old Rabbi Isaac Aboab da Fonseca gave a sermon on the week's Torah portion. He concentrated on the story of Adam and ended with a plea to the congregation not to defile the synagogue with "profane conversation." One wonders whether he spoke in Dutch for the benefit of the visiting dignitaries. On each subsequent day through the following Friday, a different rabbi gave an address to the assembled

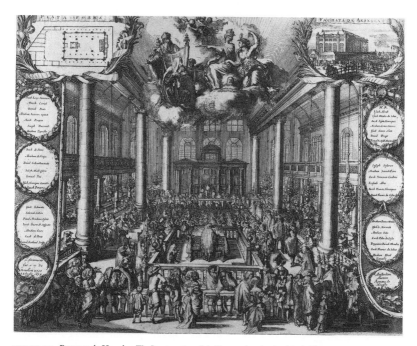

FIGURE 20. Romeyn de Hooghe, *The Inauguration of the* Esnoga *in 1675* (etching). Photo courtesy of the Library of the Jewish Theological Seminary, New York.

members of the community. Selomah de Oliveira, Isaac Saruco, Isaac Netto, Eliyahu Lopes, the twenty-one-year-old Isaac Vellozino, and, finally, David Sapharti, a grandson of one of the community's original *converso* members, all spoke in Portuguese on a variety of theological, philosophical, and political themes. By the end of the week, as things finally got back to normal, the congregation could resume regular worship services, only now in the spatial comfort of their magnificent new *beit ha-knesset,* house of gathering.

It was Rabbi Aboab who got things started. Chief rabbi since Mortera's death in 1660, his first move was to approach the congregation's board of governors during their weekly Sunday meet-

ing on November 16, 1670. He had in hand a petition filled with congregants' signatures to ask the board to consider building a new synagogue. The Sephardim simply needed a larger place for worship. With their numbers approaching twenty-five hundred individuals, the old synagogue, a converted warehouse on the Houtgracht that they had been using since 1639, was just too small. People were fighting for seats during services, Aboab said in his appeal to the board. The "unpleasantnesses" were so disturbing "that we cannot pay attention to praying to our creator."[2]

The *ma'amad* was agreeable to the rabbi's proposal. What may have helped sway their minds was the fact that the city's German congregation was nearing completion of its own stately new synagogue. There was no way that the Portuguese were going to be outdone by the Ashkenazim. The board thus appointed a committee, chaired by the eminent and wealthy Isaac de Pinto, to look into various plans. During that week's Sabbath service, Aboab gave a rousing sermon on the need for a new building, hoping to inspire moral support for the project, not to mention great financial gifts. The lecture was a success. During a fundraising campaign lasting only several months, over forty thousand guilders were pledged.

Not everyone supported the old rabbi's plan. There was some opposition from the start. The objectors saw no need to go to so great an expense when expansion of the old synagogue would do just fine. Later, David Sapharti, in his address during the week of dedication ceremonies, derisively compared these opponents to Moses' detractors when he commanded the Israelites to build the Tabernacle: "'Are we,' they said, 'to build a palace for God who already has a house and throw the needy Portuguese out of their house and into the street?'"[3] Calvinist resistance to Jewish expansion was not so easily dismissed. More than a few Dutch ecclesiastics had to be reassured that this architectural development (and the demographic changes it represented) was not a bad thing. This is, no doubt, why the congregation, in a petition to the city submitted at around the same time, reminded the municipal authorities of how well-governed the community was and how consider-

ate they were toward the city's concerns. The authorities were also reminded, once again, of the material contribution that the Jews had made to Amsterdam's economy.

The city expeditiously granted the Sephardim permission to build their new Esnoga. A site was purchased less than a month after Aboab's first visit to the congregation's boardroom.

———— ∞ ————

When the first Portuguese *conversos* settled in Amsterdam, the Dutch assumed that they were Christians—or at least that, as we have seen, was the public pretense. Those among the immigrants who sought to return to Judaism had to keep a low profile. Services, while probably held with some regularity, were conducted in private homes. The first congregation in the city, Beth Jacob, was named after its founder, Jacob Tirado, alias James Lopes da Costa, in whose house in Vlooienburg its members had been meeting since 1603. This may be the group that Moses Uri Halevi is said to have come from Emden to circumcise and lead in services. It was a serious and well-organized gathering of reintegrating Jews. As wealthy merchants, they had the resources to purchase a Torah and to have a silver shield made for it by a local smith. In 1609, they brought in Rabbi Pardo and his son from Venice to supervise them. In 1614, Beth Jacob rented a house on the Houtgracht called The Antwerper, which served as their synagogue until 1639.

The first home of the Neve Shalom congregation, which was founded in 1608, was a room in the house of Samuel Palache, Morocco's Jewish ambassador to the Netherlands. As the congregation's ranks quickly grew with increased Sephardic immigration, its members soon had to find a better arrangement. In 1612, they undertook to build a proper synagogue, also on the Houtgracht. They hired a Dutch contractor, Han Gerritszoon, who had to agree that no work would take place between sundown Friday and sundown Saturday. The building was completed, but the city authorities, at the insistence of the Calvinist consistory, forbade the Jews from furnishing and using it. Jewish worship in private

homes was one thing; owning a building for the express purpose of public worship was another. To get around this stricture, they had recourse to a mechanism commonly employed by Catholics, who also were not allowed to own houses of worship in Holland. The congregation sold the house to a prominent Dutch burgher, Nicolaes van Campen—a Catholic as well as a member of the city council that had prevented Neve Shalom from using the building in the first place—and then rented it back from him. By the time he died in 1638, public Jewish worship was a fact of life in Amsterdam, and his wife sold the building back to the congregation.

A dispute within Beth Jacob over the rights to its synagogue explains why in 1618 there were now three Portuguese congregations in Amsterdam. It is not clear who started the fight. There was some serious disagreement over doctrine and belief and over the prerogatives of power in the congregation. But it was also a contest between wills and egos. David Farrar, a physician and leader in the community, was a liberal firebrand. Not one to keep his opinions to himself, he was a man of impulsive behavior with very little patience and even less diplomacy. He also disliked authority. Deep down, it was whispered, he was a freethinker. On the other hand, his nemesis Rabbi Pardo was a conservative with profound respect for tradition and an inflexible understanding of Jewish law. He also thought that real power in a Jewish congregation should be vested in the rabbinate, and that its learned members were to be shown all due deference. Pardo, who was one of the original teachers charged with leading the former *conversos* back to traditional Judaism, was certainly not going to take his marching orders from some radical upstart.

In late 1618, Farrar was accused of having appointed as *shochet*, or ritual slaughterer—an extremely important function in any Jewish community—a man whom the rabbis concluded was unqualified for the job. When they asked Farrar to remove him from the post, he refused. But this insubordination was only the tip of the iceberg. Farrar was also reportedly found to be spreading heterodox opinions on the interpretation of the Bible, denying the importance of kabbalah, and working generally to undermine rab-

binic authority. He was denounced, and maybe even put under a *cherem*, by Rabbi Pardo, who was supported by the even stricter Isaac Uziel, chief rabbi of Neve Shalom. Farrar countered by reasserting his views on these matters and rejecting the rabbis' right to decide how the community should run its affairs. He also questioned their authority to issue a ban against anyone. This, he claimed, was the prerogative of the *ma'amad*, of which he, not coincidentally, was a member.

As a result of this bickering, Beth Jacob broke into two camps: one group stood behind Farrar, the other supported Pardo. The rabbi's group, seeing that it was the *parnassim* behind Farrar who controlled the purse if not the principles of the congregation, decided to secede from Beth Jacob and start a new congregation, called Ets Chaim (Tree of Life) and, later, Beth Israel. Their first act was to blockade and seize control of the house on the Houtgracht that Beth Jacob had been using as a synagogue. A fight over the congregation's property—movable and immovable—ensued. It took the reluctant intervention in 1619 of the Sephardic Beth Din in Venice and of a Dutch court in Amsterdam to settle the legal aspects of the matter. The Venetians refused to declare either camp right or wrong. But the local magistrates awarded the synagogue to the Farrar group, which was now joined by Saul Levi Mortera, who had stepped in as chief rabbi of Beth Jacob with Pardo's departure. Tension and resentment lingered in the community for some years, however, and the Pardo group made a number of appeals to outside bodies—to the rabbis in Salonika, for example—to come to their aid, all in vain.

Now out in the street, Beth Israel had to find a place to hold services. A member of the congregation, José Pinto, found two warehouses to rent, one on the Houtgracht itself and the other just behind it, off the Breestraat. They connected the two buildings to make one large structure, finishing it off with rough-hewn beamed ceilings and elegant galleries. It was, in the end, the largest of the three synagogues of the community. Thus, when Beth Jacob, Neve Shalom, and Beth Israel decided to put aside their differences and merge into Talmud Torah in 1639, the Beth

Israel building was chosen to serve as the united congregation's house of worship.

It needed some work, however, not only to accommodate the larger population, but also properly to reflect the community's wealth and stature. So the congregation purchased houses on both sides of the synagogue, incorporated them into the building, and opened up and completely remodeled the interior. The result was well worth the effort, as contemporaries testified and as can be seen in prints by de Hooghe and Veenhuysen (see figure 14). The ceiling now comprised four barrel vaults running from the front of the building to the back. Over the nave were the two central vaults. Wood beams laid perpendicular to the vaults were supported by simple Doric columns; from these timbers hung elaborate chandeliers. The *tevah* sat at one end of the main part of the room, the ark of the Torah at the other. (This is in keeping with Sephardic tradition; in Ashkenazic synagogues, where the reader's platform is called the *bimah*, it is generally positioned in the center of the room.) Rows of pews ran between the two and parallel to the vaults and side walls. These more comfortable (and more visible) seats, with back supports, were reserved for the older, wealthier, and more distinguished congregants. With this arrangement, they faced each other rather than the reader on the *tevah*. The other members of the congregation sat on rows of backless wooden benches in the aisles under the two outside vaults. Above these benches on both sides were the galleries, some of which were covered by lattice screens; this is where the women sat. Wives and daughters were expected to go immediately upstairs just after they entered the building and passed the spigot and basin where hands were ritually washed.

Except for the carved wood on the ark and the *tevah*, the synagogue's interior was devoid of decoration. As in all synagogues, there were no statues and no paintings. But neither was there any stained glass or calligraphic inscriptions. Such a plain interior was typical of the early Amsterdam Portuguese synagogues. Gentile visitors found this most remarkable. Charles Ogier, the secretary to Claude de Mesmes, Count d'Avaux, passed through the city in

1636 on his way back to Paris with his employer from a diplomatic mission. He commented that the "Jewish churches" in Amsterdam resembled the "new Calvinist temples," both in their layout and in their aesthetic simplicity.[4] (A visitor to Amsterdam today will certainly understand Ogier's sentiment, as one cannot help but be struck by the resemblance in the interiors of the Oude Kerke and the Portuguese synagogue.) It was in this austere setting that the congregation assembled, in July of 1656, to hear the writ of *cherem* of Baruch Spinoza read by one of its rabbis:

> The *Senhores* of the *ma'amad* [the congregation's lay governing board], having long known of the evil opinions and acts of Baruch de Spinoza, they have endeavored by various means and promises, to turn him from his evil ways. But having failed to make him mend his wicked ways, and, on the contrary, daily receiving more and more serious information about the abominable heresies which he practiced and taught and about his monstrous deeds, and having for this numerous trustworthy witnesses who have deposed and born witness to this effect in the presence of the said Espinoza, they became convinced of the truth of this matter; and after all of this has been investigated in the presence of the honorable *chachamim* ["wise men," or rabbis] they have decided, with their consent, that the said Espinoza should be excommunicated and expelled from the people of Israel. By decree of the angels and by the command of the holy men, we excommunicate, expel, curse and damn Baruch de Espinoza, with the consent of God, Blessed be He, and with the consent of the entire holy congregation, and in front of these holy scrolls with the 613 precepts which are written therein; cursing him with the excommunication with which Joshua banned Jericho and with the curse which Elisha cursed the boys and with all the castigations which are written in the Book of the Law. Cursed be he by day and cursed be he by night; cursed be he when he lies down and cursed be he when he rises up. Cursed be he when he goes out and cursed be he when he comes in. The Lord will not spare him, but then the anger of the Lord and his jealousy shall smoke against that man, and all the curses that are written in this book shall lie upon him, and the Lord shall

blot out his name from under heaven. And the Lord shall separate him unto evil out of all the tribes of Israel, according to all the curses of the covenant that are written in this Book of the Law. But you that cleave unto the Lord your God are alive every one of you this day. . . . No one should communicate with him, neither in writing, nor accord him any favor nor stay with him under the same roof nor [come] within four cubits in his vicinity; nor shall he read any treatise composed or written by him.[5]

Unlike most of the bans issued by the community, this one was never rescinded.

The outside of the enlarged Beth Israel building also received a face-lift. A new facade was added, with tall pilasters topped by Corinthian capitals and an ornate balcony just above the entryway. Unlike the interior, it did not look Dutch in any way. Instead, like the houses of some of the community's wealthier members, including Isaac de Pinto and Moses Curiel, it resembled an Italian Renaissance palazzo. Bas-relief festoons sat above the multipaned, wood-shuttered windows, some of which were covered with elaborate grillwork. On the Sabbath, well-dressed worshipers arriving for services on foot gathered to socialize on the front stoop, with its fancy built-in benches, before entering. It was an impressive spectacle, and Dutch passersby often stopped to watch the pageantry, to the great pleasure of the proud Sephardim themselves.

For a time Amsterdam's indigent German Jews also worshiped at the Portuguese synagogues on the Houtgracht. Even when, in 1635, the Ashkenazim were sufficiently organized to hold their own services in the Vlooienburg home of Anschel Rood, they had to borrow Torah scrolls from the Sephardim. Seven years later, in need of larger quarters, they rented space from David de Pretto, a member of the Portuguese congregation. This arrangement lasted almost thirty years. But with their numbers (and their means) rapidly growing under explosive Jewish immigration from the east, it eventually became clear that they, too, needed a full-size synagogue. Thus, on March 25, 1671, less than a year after first laying

the cornerstones on land that they purchased at the far end of Breestraat, just a few blocks down from what had been Rembrandt's house, the Great Synagogue was dedicated. It was a staid, square, and rather heavy-looking brick building that towered over the neighboring houses. Much less aristocratic in character than the Portuguese Houtgracht synagogue, it nonetheless represented a great achievement for a community that, just a few decades earlier, was regarded by the city's other Jews as an embarrassment.

The designer of the building was Daniel Stalpaert, the official city architect. A gentile was hired for the job because Dutch regulations forbade Jews from joining the mason's guild, to which one had to belong to practice architecture. Stalpaert was skilled at just the kind of republican civic look that municipal projects required. He had served as assistant to Jacob van Campen, the architect who designed Amsterdam's new Stadhuis in 1648. He was also experienced in building houses of worship, having designed the Oosterkerk on the city's east side and a church in Oudshoorn. For the German Jews of Amsterdam, he created a sober, single-vaulted building with thick columns, arched windows, and straight-backed pews; Monsieur Ogier would have recognized the style. There were three hundred and ninety-nine seats for men and three hundred and sixty-eight for women.

Even after the construction of the Ashkenazic synagogue, Amsterdam's Polish and Lithuanian Jews continued to worship separately from the Germans, usually (according to one observer) "in tiny little churches or large halls and rooms."[6] By 1673, however, they joined their fellow Yiddish speakers, who generously welcomed them into their congregation in the *Grote Schul*. The expanded community was under the spiritual leadership of Rabbi Isaac Dekingen from Worms. Together, along with Jews from other eastern European lands, they outnumbered the Sephardim two to one. Five thousand strong, they easily filled the new building to capacity.

Everyone agreed that these synagogues, both Sephardic and Ashkenazic, were something to be proud of. They served Amsterdam's congregations in important ways, not just for worship but as

functional centers of communal gathering and as public symbols of their arrival. But they were nothing compared to what master builder Elias Bouman wrought for the Portuguese Jews on the plaza at the end of Breestraat.

Today there are seven Ashkenazic synagogues in and around Amsterdam, but there is only a single Sephardic one. One summer several years ago, I stood waiting outside the wooden doors of the *Portugees-Israelitische* compound. It was a Saturday. Like many Jewish visitors to Amsterdam, I was there that particular morning as something more than a tourist. There are not many secular attractions in Europe in which the ordinary traveler can actively participate. You cannot walk into the British parliament buildings and make a speech; no one is permitted to hold a gladiatorial contest in the Colosseum in Rome; you can walk through the catacombs under Paris but you absolutely cannot add your dead ancestors' bones to the collection. With the great monuments on the standard religious itinerary, however, it is a different story. Visiting Catholics can take communion at a mass in Notre Dame de Paris, while Anglicans from all over are free to participate in worship at Westminster Abbey. For Jewish tourists the highlights are fewer and farther between. But they should certainly make it a point to spend a Saturday in Amsterdam, where, except under special circumstances, one can attend the *shacharit* service and Torah reading on Shabbat at the Portuguese synagogue.

Unfortunately, there were special circumstances the Saturday morning of my visit. Two weeks earlier, a Jewish cultural center in Buenos Aires had been destroyed by a bomb. Anxiety and security at synagogues and Jewish monuments and religious sites worldwide were heightened as a result of the terrorist act. As far as I could tell, there were no Dutch police around that day; the congregation seemed to have taken protection into its own hands. It took some talking to convince the large young men standing guard at the gateway that I was there only to observe Shabbat (and to see their synagogue). Many tourists were turned away. A small

number, including a group of orthodox Jews on tour from Israel, were admitted without delay. When I brought out the yarmulke that I had in my pocket and showed them the *siddur*, or prayer book, in my hand (in violation of the Sabbath restriction against carrying things outside the home), the guards relented, but with a warning that there was a bar mitzvah that day and that I should show respect for the occasion.

Rembrandt never got to see this synagogue. Construction did not begin until a dozen years after he had left the neighborhood, a broke and humbled man, and two years after he died. That is a shame, for us, since he, as much as anyone, would have found it a source of great wonderment. Although I doubt that he would have found reason to incorporate it into a painting, and despite his dislike for new buildings,[7] perhaps it would have merited an etching or a drawing, later to be included in some composition that needed a "temple."

I crossed over the threshold of the gated entrance on the street, walked through the gift shop, and came to a large, open courtyard. The entrance to the synagogue itself is at the far end of the quad. Dutch regulations in the seventeenth century stipulated that there could be no direct access from the street into houses of worship other than those of the Dutch Reformed Church. The yard is surrounded by a low brick wall, the inner side of the perimeter buildings that house the winter sanctuary, the congregation's offices, and other functions. The main synagogue is unheated, and services are held there only between Passover in early spring and Simchat Torah in the fall. The celebrated Ets Chayim Library is still in the compound, but the community's archives have been moved to the city's municipal collection. Small groups of worshipers were gathered in the yard. They conversed while playing children ran around them.

The inside of the synagogue was still fairly dark on this Saturday morning. The candles in the chandeliers were not lighted, and there is no electricity in the building. The first thing I noticed upon entering—before the polished bronze, before the towering height of the vaulted ceiling, even before the beautiful wood of the

ark—is the floor. It is covered with fine sand to absorb moisture and dirt and to muffle footsteps on the pine floors.

There are still several hundred members of this congregation, although many live outside the city center and few show up on a regular basis. Most of them, however, seemed to be present this morning. All of the seats in the main sections in front of the *tevah* were occupied. I found a place in the back of one of the aisles. Over the next three hours, I was alternately engaged in the service and distracted by my surroundings, caught between the living present and the history I had come to find. I did not, of course, hear any Portuguese spoken. Nor was Spanish used in the service, as was common three hundred and fifty years ago. Those languages disappeared from the community sometime in the eighteenth century. The readings were in Hebrew, the sermon (or *devar Torah*) in Dutch. The rabbi was an old man, pale and gaunt. He did not appear at the pulpit until it was time for him to deliver his lecture. He had been quietly sitting the entire time off to the side. But as he approached the lectern, he grew animated. Turning to the bar mitzvah, he explained to the boy about to become a man all of his new responsibilities. He raised his voice, he swayed, he gesticulated. His *tallis* almost went flying off as he threw his shoulders forward to emphasize a particularly important point. He seemed to me awfully severe. But there was warm feeling and good humor in his address. He was only doing what every other rabbi does in this situation: trying to instill a strong sense of Judaism in a boy who might be tempted to see this as the end rather than just the beginning of his Jewish studies. The people around me laughed at various remarks. My Dutch is good, but in the poor acoustics of the cavernous synagogue I understood barely a word of what the rabbi said. Still, I was mesmerized. Not because I had never seen a rabbi warn a thirteen-year-old about faithfully fulfilling his duties; I myself had been on the receiving end of such a lesson. Rather, for the briefest of moments I thought I knew what it would have been like to hear Saul Levi Mortera (who died well before the building was ever conceived) or Isaac Aboab da Fonseca lecture this very same congregation (albeit in Portuguese) on a finer point of the Law.

The land for the new building was acquired on December 12, 1670. On April 7 of the following year, Moses Curiel, Joseph Israel Nunes, Imanuel de Pinto, and David de Pinto (the son of Isaac) took turns laying the four cornerstones that they had purchased as major donors to the project. The total cost of the synagogue was one hundred and eighty-six thousand guilders. Major gifts and loans came from both Jewish and gentile sources. It also required a large measure of goodwill from the Dutch.

The Sephardim could not have chosen a better architect. Not only was Elias Bouman experienced in large public projects, but he also had strong business and personal connections with the Jewish community. He had already worked on a number of commissions from the Portuguese. When the merchant David de Abraham Cardoza wanted to build a mansion on the Binnen-Amstel, he turned to Bouman. His neighbor, obviously impressed, did the same. Bouman was also present at the wedding of Mozes Israel and served as the arbitrator of a dispute between Jacob Aboab Ozorio and Joshua Abendana. Perhaps most important of all, he was—and how many Dutch architects could claim this?—familiar with the construction of synagogues. He had served as the builder working under architect Stalpaert for the Ashkenazic *schul*. Five years after finishing the Esnoga, he became Stalpaert's successor as the official city architect of Amsterdam.

The rapid pace of planning and construction, with less than six months having passed from Aboab's first meeting with the congregation's board to the laying of the cornerstones, was not sustained, mainly because of circumstances that could not possibly have been foreseen or controlled by the community. The projected completion date was May 1672. But in April of that year, disaster struck the Netherlands. After several months of fruitless negotiations between the republic and France, Louis XIV, resentful of Dutch alliances and economic countermeasures against French encroachment in the southern Netherlands, invaded the north. He was soon joined by England and a number of German states. The Dutch, overwhelmed from three sides, suffered enormous losses.

This would turn out to be one of the darkest years in the history of the republic. Military defeat, territorial retrenchment, economic turmoil, and, most horrific of all, the brutal and barbarous assassination of the man who had been the political leader of the Netherlands for the last twenty-two years—it was all too much for the young nation. It resulted in one of those momentous turning points in Dutch history, called *wetsverzettingen*, in which the political map is turned completely upside down. By the end of the year, the grand pensionary of the States of Holland, Johan de Witt, was dead, torn to pieces by a mob angry over losses to the French; the position of stadholder was reinstated in the person of William III; Orangist factions had seized the local councils; and the liberals were in general retreat. William's conservative Calvinist supporters were now in control.

With the future of the republic itself at stake, this was not a time to be diverting resources to the construction of an ostentatious synagogue. The Sephardim accordingly ceased building. Only in early 1674, after the Dutch had gained the upper hand, the French occupiers were in retreat, and the end of the war was near, was work on the synagogue resumed. A severe storm that blew out windows and destroyed some of the exterior caused further delays later that year. The congregation was determined, though, to finish the synagogue as quickly as possible. By the summer of 1675, the members of Talmud Torah had their new home.

It was magnificent. Bouman created not just a synagogue but a functional monument. It was what today would be called a Jewish community center, but in ever so grand a style. There was the main sanctuary for worship, offices, meeting rooms, archives, a school, a smaller sanctuary, a library, a *mikvah* or ritual bath, lodgings, and even a mortuary. Bouwman seems to have consulted on its design with Jacob Judah Leon, a member of the community who was famous for dedicating his life to studying and reconstructing (in miniature) the destroyed Temple in Jerusalem. The wooden model of Solomon's handiwork that Leon, a Hebrew teacher in the congregation's school, kept on display in his home was considered by many to be a faithful rendering of the ancient structure. Leon's

treatise on the Temple, *Retrato del Templo de Selomo*, was translated into several languages and was widely studied throughout Europe. Because of his fanatical devotion to—some would say obsession with—the Temple, he earned the nickname Judah Templo. Bouman was probably instructed by the community to make the new Esnoga in the image of Leon's reconstruction.

The compound dwarfed the Ashkenazic synagogue across the street. That was, of course, the point. The sanctuary's redbrick exterior rises imposingly from the row of short outbuildings surrounding it. Virtually free of ornamentation except for a balustrade that encloses the roof and a few pilasters between the tall arched windows, the building from the outside makes its impression through mass rather than artistry. Much taller than anything else in the neighborhood, it did not take long for the Esnoga to become a familiar feature of the city's skyline. It is even recognizable as a prominent landmark in Jacob van Ruisdael's 1681 cityscape painting, *A View of Amsterdam from the Amstel* (Fitzwilliam Museum, Cambridge).

Erecting this complex could not have been an easy job. In addition to the political and social obstacles that had to be overcome before so large a project could be carried through (some Dutch worriedly complained that what was being built was not a house of worship, but a fortress), there were the basic practical engineering problems that faced any construction in waterlogged Amsterdam—the same kinds of problems with which Daniel Pinto was so familiar from raising his Breestraat house. Bouman knew his city, however. The edifice rests on three thousand wooden piles and brick barrel vaults, and its foundation is deep under water.

The interior resembles the inside of the old Houtgracht synagogue, especially in the placement of the *tevah* at the western end and the ark to the east, the direction of Jerusalem, the arrangement of the rows of pews and benches, and the setting of the upper-floor galleries. Over the nave was a single vault, with a smaller vault above each aisle. On each side of the nave are two huge Ionic pillars; a row of six additional, smaller columns hold up each balcony. There is enough seating between the two levels for

twelve hundred men and (in the balconies) four hundred and forty women. There is standing room for visitors in the entrance gallery.

As beautiful in its architectural simplicity as the synagogue is, the focus of attention, the pièce de résistance is—as well it should be—the elaborately wrought ark of the Torah at its far end. Donated by Moses Curiel, the *hechal* extends across the width of the nave and rises almost twenty-five feet. Its tripartite structure is divided by Ionic columns. The wings have triangular frontons, while the taller central portion is topped by an arched fronton that contains carved tablets of the Law with gold lettering. Instead of a traditional curtain, the cabinets of the ark have doors; their interiors are lined with red gilt leather, and they contain a number of Torah scrolls.

The synagogue has changed very little since the seventeenth century. The wood pillars have been replaced by stone, and there is now an enclosed wooden vestibule at the sanctuary's entrance. The building and its contents have survived the ravages not only of time but also of modernization. The true miracle, however, is that they have also survived the ravages of war and hatred. Almost alone among the synagogues of Holland, this unmistakable monument to Jewish achievement was left standing, undamaged, by the Nazis. Inside the *hechal* is a Torah said to be the one brought to Amsterdam from Emden in 1602 by Moses Uri Halevi.

In 1680, the sixty-three-year-old painter Emanuel de Witte walked into the Amsterdam Portuguese synagogue and went to work. Over a span of thirty years, de Witte had made a name for himself with depictions of church interiors. This new project was essentially no different from so many others. He would treat the Esnoga just as he had the Oude Kerk in Delft, the Sint Jans-Kerk in Utrecht, and the Nieuwe Kerk in Amsterdam. He had painted Protestant churches and he had painted Catholic churches. The Jewish synagogue was just one more opportunity to display his proficiency with light, color, and architectural form. When he was

done, there would be three paintings, each memorializing not just a building but an environment, with all the social and political relationships that it represented in the Dutch golden age.

De Witte was born in Alkmaar in 1617. His father, Pieter, was a schoolteacher who had a particular interest in geometry. His mother was Jacomijntje Marijnus. That is almost all that is known about his family and youth.

In 1639, after an apprenticeship in Delft with the still-life painter Evert van Aelst, de Witte returned to Alkmaar and entered the local chapter of the Guild of St. Luke, to which all professional painters had to belong. By the end of the year, however, he was in Rotterdam. One year later, the peripatetic young man was back in Delft with his wife and two daughters. He remained in Delft for ten years, where he concentrated on history works with biblical and mythological subjects (sometimes in the guise of genre scenes) and portraits of local notables. If that had been the sum of his art, then he would now be known as just another competent, perhaps highly talented but perfectly ordinary, artist in a society teeming with painters.

What happened, in fact, is that de Witte changed directions. The artistic *wetsverzetting* coincided roughly with his move to Amsterdam in 1652. He continued to do the occasional genre piece and landscape, and one or two of his domestic interiors or market scenes from this period are truly outstanding, ranking with those of Pieter de Hooch or Jan Steen. But most of his attention was turned toward a new and, at this point, exclusively Dutch type of painting.

Suddenly, the focus was on buildings. And it was put there by a highly original and technically brilliant painter named Pieter Saenredam.

Although it was something that other artists had dabbled in before him, Saenredam is often called "the first portraitist of architecture." Saenredam was born in Assendelft in 1597, and spent most of his life in Haarlem, where he died in 1665. Although deeply attached to Haarlem and its architectural landmarks, and unlike more sedentary artists, such as Vermeer, who rarely left

Delft, Saenredam traveled all over the provinces to paint churches and public buildings, inside and out. He was a highly skilled draftsman with an obsessive concern for detail. Before putting brush to panel or canvas, he would observe and record a site with a number of meticulous drawings. These sometimes sat for almost thirty years before finally being transformed into a painting. The studies on paper allowed him to refine proportions, play with the point of view, capture fine architectural features, and, above all, work out the perspective. Saenredam was a genius at perspective. One gets the sense that what he enjoyed most in painting large public spaces was the opportunity to render complex perspective with great precision.

The result was a body of stunning architectural paintings, many of which capture different parts of the same building and even provide different vantage points of the same precise interior space. The nave of the Mariakerk in Utrecht appears, in three separate paintings, from south to north, from east to west, and diagonally from the southwest. The St. Bavokerk in Haarlem is seen across the nave, then from the Brewers' Chapel toward the Christmas Chapel directly opposite, and then across the choir from the north ambulatory toward the new organ. Saenredam depicted St. Laurenskerk in Alkmaar (three paintings), Nieuwe Kerk in Haarlem (four paintings), Buurkerk in Utrecht (five paintings), St. Janskerk and St. Pieterskerk in 's-Hertogenbosch, St. Odulphuskerk in Assendelft, and so on. What strikes the observer is not only Saenredam's skill in representation, but also—despite the obvious potential for monotony—his inventiveness, his ability to make each painting of the same building (and even of the same corner) provide a new experience of that space.

The interiors are almost invariably captured from a low angle. They are austere. Saenredam's palette is monochromatic, with creamy walls ranging from white to gold to taupe. They are balanced by floors in shades of gray, with touches of terra-cotta and washed-out pink.

The windows in these buildings are clear; there is no stained glass. The architectural ornamentation is very reserved. Except for the occasional hanging placard or banner and a few isolated paint-

ings, the interiors are mostly barren. There are rarely more than a few people present in Saenredam's paintings, and there is almost never anything noteworthy happening. What is front and center in any single work, what changes from piece to piece, is the light and the line. And, somehow, that is more than enough to hold our attention.

Saenredam also painted many exteriors, secular and sectarian: the old town hall in Amsterdam, the facade of the Mariakerk, the town hall of Haarlem, even the palace of Frederick V in the Palatinate and the Colosseum in Rome. And he was not alone. Anthony de Lorme in Rotterdam, Hendrick van Vliet, the brothers Job and Gerrit Berckheyde, and, above all, the Delft master Gerrit Houckgeest specialized in "painting perspectives, churches, halls, galleries and buildings, both interiors and exteriors" (to quote from the biographical sketch of Saenredam in the painter Arnold Houbraken's early-eighteenth-century book *De groote schowburgh der Nederlantsche konstschilders en schilderessen* [The great theater of Dutch painters and etchers]). It was a minor but significant school in seventeenth-century Dutch art.

Cathedrals and chapels, castles and city squares, even sitting rooms and mangers were common settings in Italian, French, and early Netherlandish painting. But they were always just that: settings, and therefore secondary to the story being represented. Now it was the building itself that was the subject of the artwork. These were neither genre interiors nor landscapes or cityscapes. The new works constituted a species unto themselves. They provided Dutch (and even southern Netherlandish) artists and spectators a new opportunity to indulge their enjoyment of describing. The Dutch took great pleasure in realistic naturalism in art, even when the scene depicted was imaginary, as was often the case. Moreover, the church interiors, with their long lines, deep receding, multilayered spaces, angular proportions, and high, cavernous vaults, catered to the Dutch taste for perspective. These works were even known at the time as "perspectives."

The paintings also gave the Dutch the chance to show off their bare walls. This was important to a society that had recently thrown off the yoke of Catholic domination and whose first revo-

lutionary act, in the *Beeldenstorm*, or iconoclastic fury, of 1566 was to strip their churches clean of images. There are no icons, no crucifixes, no devotional pictures in Saenredam's interiors. The pale, vertical masses of his pictures are ostentatiously empty (plate 14).

Architectural painting found an enthusiastic audience among sophisticated, wealthier patrons. There were not many specialists in the field, and a painter could easily corner the market in a city. Sometime before his move to Amsterdam, Emanuel de Witte had decided that this was where the future of his art lay. His first dated architectural work is the *Old Church of Delft*, painted in 1651. Over the next forty years, he went on to produce over one hundred and thirty church interiors. De Witte worked mainly in Delft and Amsterdam. He never achieved the success of Saenredam, but neither did he aspire to be merely an imitator of that more accomplished painter's style. The older artist perfected a new category of painting; de Witte took it in new directions.

There are immediately discernible differences between the paintings of these two masters. De Witte works with a richer palette. Stone-hued architecture is overlaid with splashes of red, green, and deep brown in tapestries, window drapery, wooden furniture, and clothing. Even the monochromatic elements in his compositions are imbued with greater contrasts than in Saenredam's works. The chiaroscuro depth achieved between light and shadow is more pronounced. In a 1680 church interior set in the Amsterdam Oude Kerk, the figures stand in late afternoon shadows in the lower portion of the painting, while the upper parts of the walls around them are bathed in light. Another interior from 1668 (now in the Museum Boymans van Beuningen, in Rotterdam) has alternating, strongly contrasting bands of light and shade across the floor. A crimson patch at the bottom of a woman's dress is illuminated by the incoming sunshine. De Witte is interested less in line and space than in color and light (plate 15).

Saenredam's pictures have an open, even rarefied atmosphere; de Witte's are denser, his compositions more cluttered. It is harder for a spectator to orient himself, perhaps because de Witte's skill with perspective is weak. In a de Witte painting it is often difficult

to find the central vanishing point; sometimes there is none. What is rendered is not so much space based on perspective as an interior with atmosphere and tone. And while Saenredam was often representing an actual church that the spectator could recognize, de Witte frequently combined elements from different buildings. (Still, a good number of de Witte's church interiors are identifiable—for example, there are over twenty paintings of the Amsterdam Oude Kerk.)

The most striking difference between de Witte and Saenredam, however, is in the human figures. Saenredam's people are diminutive accessories. Dwarfed by the vaulted space that encloses them, they are isolated, faceless, and mute, even when they are posed for conversation. De Witte's figures, on the other hand, are engaged, animated. They act and interact in the space they inhabit. There is talk, gesture, performance. They are also larger than Saenredam's characters. Rather than being minor details seemingly added to an architectural picture for aesthetic reasons, de Witte's people are agents in an architectural space. De Witte may not have been able to handle all the intricacies of perspective, but he knew about story. De Witte's architectural paintings are, in a sense, genre paintings transferred from the tavern or the kitchen to the church.

De Witte achieved fame and popularity in Amsterdam; he was, after all, the only painter of church interiors in the city. This seems, however, to have provided him with little comfort. We do not have much information about his life even after 1652, when he settled in Amsterdam for good, and what we do know is sad. In 1658, a year when he was occupied with several pictures of the Oude Kerk, his second wife Lysbeth and one of the two daughters from his first marriage, Jacomijntje, were caught stealing from a neighbor's house. They were arrested, and Lysbeth was banished from the city for six years. The seventeen-year-old Jacomijntje was sent for one year to the *Spinhuis*, a correctional facility for women and girls. It was believed that time spent spinning and weaving would have beneficial effects on the wayward female character. This affair brought de Witte's family life to a sudden and pathetic end. Neither the daughter nor her stepmother is ever mentioned again.

Alone, de Witte did not do well. He was depressed and he had serious financial problems. In 1660, he entered into indentured servitude with a local notary. The agreement gave the official all the paintings that de Witte produced while in his service; in turn, de Witte received room, board, and an annual stipend of eight hundred guilders. This was only the first of several such arrangements. He did continue to paint. Many of his richest and most memorable works come from the period after his personal misfortune, including the portraits of the Portuguese synagogue.

In the end, it all proved too much for the poor man. His body was found in a frozen canal in 1692, eleven weeks after his disappearance. According to Houbraken, it was suicide.

———— ⊗ ————

"I came to Amsterdam," John Evelyn wrote in his diary during a tour of Holland in 1641. "The first thing I went to see was a Synagogue of the Jewes (it being Saturday) whose Ceremonys, Ornaments, Lamps, Laws, and Scholars, afforded matter for my contemplation." A Shabbat service was in progress in the Houtgracht building, and Evelyn was captivated by what he saw. "The women were secluded from the men, being seated above in certaine Galleries by themselves, and having their heads mabbl'd with linnen, after a fantastical and somewhat extraordinary fashion."[8] As with many other English visitors to the city, it was his first experience of Judaic ritual. Jews were still officially banned from England. While there probably were several hundred Jews in London, public worship was out of the question. Thus, tourists came across the channel to Holland eager to see for themselves Shylock's people at prayer. Sir William Brereton, who had been in Amsterdam seven years earlier, described in his travel journal an "upper room" in which the Jews met to pray; he calls it "a neat place." He stayed for morning Shabbat services, *shacharit*, "from nine to half twelve," and then went back after lunch for afternoon worship. What he found most remarkable was the manner of worship, which was more informal than anything he was expecting. "Here in this congregation, no good order, no great zeal and devotion here appearing; much

time spent in singing and in talking." He notes, too, as Evelyn does, the strange ceremonial dress. "They have all white mantles of a kind of linen but short; these they wear over their hats, which they never put off during all their being in church."[9] The synagogues in Amsterdam and elsewhere were soon standard items on the itinerary of English tourists in the Netherlands.

They were not alone. Visitors from all over Europe, and especially France and Italy, made it a point when in Amsterdam to go to Vlooienburg to see for themselves the Jews at prayer. Sometimes they went to all three synagogues on the same day. The Frenchman Ogier, during his tour in the summer of 1636, made a first stop one Saturday at the Beth Israel congregation, where he was especially taken by the ark of the Torah, the *tevah* from which the scroll of the Law was read, and the layout of pews and benches. At the Neve Shalom synagogue later that same morning, all he noted was the floral motif painted on the walls. After 1639, when there was only one synagogue, guests, both invited and spontaneous, became so numerous that regulations were issued specifically to govern their reception and to minimize disturbance to services. The problem was not the visitors themselves. Rather, the *ma'amad* noted in August 1649, congregants were rising frequently from their seats to greet the *goyim*. This disruptive practice had to stop, the board ordered, and a month later they added a fine of two guilders for anyone who violated the rule. The task of officially welcoming and offering seats to visitors would henceforth belong to the group of men sitting behind the *tevah*.[10]

Foreigners strolled down Breestraat ("a street they have called the Jews' street," according to Brereton) and along the Houtgracht to see the expensive private homes and the crowded backstreets and kosher markets that made the quarter seem so distinctive in character. They came to see "the extraordinary rich Jews" and the world they had recreated far from their original homeland. The poor Ashkenazim, however, were closer to the romantic, biblical image they had of the ancient Israelites. Besides visiting the synagogues in the neighborhood, many Christians went out of their way to see the model of Solomon's Temple in Jacob

Judah Leon's home. The *ma'amad* was so concerned about the crowds that congregated at the teacher's house that they tried to impose limits on the hours during which this "museum" would be open. They were especially annoyed by the "scandalous" fact that "*goyim* were entering the house of Jacob Jehuda Leao R[ubi] on sabbath days" and Jewish holidays, such as Passover.[11]

The Dutch were just as interested in Breestraat and its environs as were the foreign tourists. In the 1619 *Remonstrance* in which he lays out his recommendations regarding the admission of the Jews to Holland, Hugo Grotius warned that Christians should be prohibited from entering "Jewish houses of prayer."[12] He was concerned above all to prevent the kinds of theological discussion between Jews and gentiles that such visits would undoubtedly encourage. His warnings fell on deaf ears. As we have seen, there was among the Dutch a shared interest in things Jewish. And unlike the English or the French—or at least those who did not travel—there was no reason why they had to settle for etchings when they could so easily go and see the real thing. Thus, the Dutch from Amsterdam and beyond came to witness firsthand how Jews prayed, to study their movements and their dress. They visited the synagogues that they imagined were constructed on biblical plans. They wanted to experience the sound of Hebrew and to hear the melodies of the chants and songs. By the 1640s, a visit to the Houtgracht synagogue and a promenade along Breestraat had become a casual weekend activity among the Dutch. As Menasseh ben Israel noted, "ordinarily the synagogues are full of Christians; which with great attention, stand considering, and weighing all their [the Jews'] actions, and motions." [13] A crowd of talkative women from Utrecht may be the reason why Ogier took so little note of other features of the Neve Shalom house of worship on the day of his visit. They distracted and annoyed him, particularly because he had come expressly to see the celebrated Menasseh ben Israel; unfortunately, the loquacious Dutch tourists had the rabbi cornered in endless conversation.[14]

The 1675 Esnoga made the greatest impression, as was intended. One visitor from abroad insisted that it was one of the

finest synagogues he had ever seen, "the largest in Europe (if not in the world), being much superior to those we our selves saw in many other Parts, where the Jews are most numerous."[15] Another noted how well it compared to the synagogue built by the German Jews: "The Portugueze Jews here are extraordinary Rich, and their Synagogue is a stately Building whereas that of the High-Dutch is but mean and contemptible."[16] Certainly this was an opinion that gratified the Portuguese.

A trip to a synagogue—whether one of the three houses used by the Portuguese congregations before the merger, the building used by Talmud Torah after 1639, the Great Synagogue built by the Ashkenazim in 1670, or especially the *meesterstuck* constructed by Bouman just across the street—was de rigueur for seventeenth-century tourists in Amsterdam, just as a visit to the Rijksmuseum, Rembrandt's House, and the home of Anne Frank is for today's traveler. They were directed to them by guidebooks and popular travel writing. Melchior Fokkens informed would-be visitors all about the Jews' "Churches or Synagogues, as they call them: the Portuguese have the largest, next comes that of the Germans or Smoutsius, while the Polish Jews have tiny little churches, or large halls and rooms suited to the purpose."[17] The *Beschrijvinge van Amsterdam* (Description of Amsterdam) that Tobias van Domselaar first published in 1655 contains a long description of the Houtgracht hall and of what one is likely to see taking place inside during services. It was accompanied by the detailed engraving of the empty synagogue's interior by Veenhuysen (see figure 14), as was the 1664 guide to Amsterdam for German travelers produced by Philip von Zesen. The new Esnoga had place of honor in the 1680 book *Alle de voornaamste gebouwen der wijdvermaarde koopstad Amsterdam* (All the most important buildings of the famous merchant city of Amsterdam), as well as in the updated version of Domselaar compiled in 1693 by Caspar Commelijn. Both books contained specially commissioned etchings of the *Joden Tempel*.

Not all visits to the synagogues were as casual as those by curious tourists. In 1638, Maria de Medici, wife of the late Henri IV

and now Queen Mother of France (her son was Louis XIII), was present one day during services at Neve Shalom. Her kinsman, Cosimo III de Medici, soon to be Duke of Tuscany, paid a visit to the Houtgracht synagogue in 1668. William III, however, waited until 1691, almost twenty years after assuming the stadholdership of Holland and two years after being crowned king of England, before he made an official appearance at the Esnoga. We do not know why it took so long for the most powerful person in the republic to pay homage to a community whose finances were so important to the nation's economic health and whose loans often helped him through difficult times. It was, nonetheless, a fruitful visit. Looking around the interior, he concluded that wooden columns were not worthy enough for such a splendid structure. He suggested that they be replaced with stone pillars, and even helped the congregation procure them.

The visit of visits, however, and the community's proudest moment before the completion of the 1675 synagogue, occurred on May 22, 1642, when royalty came to the Houtgracht looking for a handout. The eleven-year-old daughter of King Charles and Queen Henrietta Maria of England, Princess Mary, was set to wed thirteen-year-old Prince William II, the son of Prince Frederick Hendrick, stadholder of Holland, and his wife, Amalia van Solms. This was, as so many royal marriages of the time, a political arrangement, an attempt to pacify the relationship between the House of Orange and the House of Stuart.

One year earlier, Gaspar Duarte, a Portuguese merchant dealing in precious stones, had supplied the stadholder with a gift for his future daughter-in-law: a four-diamond brooch worth eighty thousand guilders. Now, the prince himself brought the English queen to see his Portuguese congregation. But this was not just a sightseeing trip. Henrietta Maria was in Holland to secure a loan. Charles, because of his militaristic adventures, was in dire need of money, and his wife was on a mission to pawn her crown jewels. The wealthy Sephardic merchants were willing to help, and her visit to the synagogue on the arm of Frederick Hendrick was a key factor in securing their cooperation.

This was the first visit to an Amsterdam synagogue by a member of the House of Orange, and the Jews did not underestimate what was required for the momentous event. The scrubbed and polished synagogue was decorated in a most elegant manner for the royal guests. Dress was formal, and everyone was on their best behavior. The celebration was crowned by a welcoming oration delivered by the famous Menasseh ben Israel. His speech was calculated to gratify the stadholder's and the Dutch regents' sense of beneficent greatness.

> We no longer look upon Castille and Portugal but Holland as our fatherland. We no longer wait upon the Spanish or Portuguese king, but upon The Excellencies the States-General and upon Your Highness as our masters, by whose blessed arms we are protected, and by whose swords we are defended. Hence, no one need wonder that we say daily prayers for Their Excellencies the States-General and for Your Highness, and also for the noble governors of this world-renowned city.[18]

Henrietta Maria went home with her loan. The Sephardim, however, were suspicious about the English court's solvency, and they insisted that the stadholder guarantee the money.

All these visitors, both common and aristocratic, were a distraction. Nevertheless, the Jews were happy to oblige their guests. This was partly a matter of pride. It gave the Jews the chance to show off not just their buildings but also their traditions and their communal achievement, as well as their personal wealth. Inside the synagogue, they could demonstrate their piety; outside, their acquisitions. They liked to bring people into their homes to see their art collections and into their libraries to view manuscripts and rare books. But it was more than just a matter of vanity. There were also important educational and political ends to be achieved by all this openness. By putting themselves on view to the gentiles and by giving them the chance to witness Jewish life at home and at prayer, they hoped to make the point that Jews and Christians had much more in common than the Jews' nemeses within the

Dutch Reformed Church would have people believe. Most important of all, they wanted to convince others that Judaism was not an inferior creed. By enlightening gentiles about Jewish ways, they sought to win sympathy and understanding from both rulers and ordinary citizens, and perhaps a higher degree of civil equality.

This celebrity meant, however, that they had to be careful about the impression they made. With so many visitors, there was a danger of overexposure, particularly when those guests, most of whom were witnessing a service for the first time, were unfamiliar with Jewish (and especially Portuguese Jewish) ways. Thus, the *ma'amad* issued a variety of regulations governing the congregation's behavior in the synagogue. There were rules about who sat where, about moving around the synagogue when the Torah reading was in progress, about when to rise and when to sit during the service ("Certain people are accustomed to stand while the entire holy congregation is sitting, which arouses great reproach among the strangers"), about "profane" conversations (the Portuguese had a tendency to discuss business in the sanctuary on Shabbat), and even about how best to conduct oneself during prayer (not too ostentatiously). There was a warning against fistfights, both among the congregants and between Jews and visitors, and a prohibition against carrying weapons without permission.

> No person may raise his hand to strike his fellow in the synagogue, nor may anyone come to these places carrying a sword, dagger, stick, or other offensive weapon, except a walking stick needed to lean on. In case some person or persons carry said weapons or raise their hand against their fellow in said places, we will have them placed in *cherem* and separated from all our brothers, as soon as it happens. . . . In case someone of our nation has a quarrel with non-Jews and needs to carry some weapon for his defense, he will inform the gentlemen of the *ma'amad*; and, if they find the reason justified, they will give permission to carry it for his defense.[19]

The Jews believed that they had to keep their house in order. Here they were, a relatively self-governing society within a soci-

ety, former refugees of the Inquisition (some of them several generations removed) dependent on the goodwill of their Protestant hosts. They wanted to be seen as a well-governed, peaceful, and devout community. The regents of Amsterdam expected no less, and told them as much in 1619 when they issued various regulations for their conduct. It was not just a matter of not violating Dutch law. The Jews also wanted to impress upon outsiders that they kept to a close observance of Jewish law. To this end, they needed to be on their best behavior on Shabbat, when gentiles were often present.

They may have been more cautious than necessary. There was no chance that the Dutch would turn them out, not with the contribution that the Portuguese were making to Amsterdam's economic and cultural flourishing. Even so, the community of "foreign residents" had their enemies. Conservative Calvinists continued to be unhappy with such a large and increasingly influential contingent of nonbelievers. These intolerant rigorists had to be reassured. Perhaps, too, foreign visitors might carry home positive reports of Jewish life and achievement in the Netherlands. This would help the cause of opening to Jewish settlement some of those countries that had expelled their Jewish populations centuries before.

Not every gentile attending synagogue services was pleased by what he encountered. A Jewish service is worlds away, in ceremony and in purpose, from the kind of worship to which a Christian is accustomed. English visitors seem to have been particularly taken aback by what appeared to be the total lack of decorum in the synagogues they visited. Philip Skippon in his 1663 *Account of a Journey Made thro' Parts of the Low Countries, Germany, Italy and France* wrote with surprise about the "no good order" that reigned during the service. "We observed some of the *Jews* to bow at times (*quer.* whether at the name of *Jehovah?*), they seemed very careless, discovering and laughing with strangers in the midst of the service; when they were dismissed, many of them went down singing until they came to the street."[20] The physician John Northleigh, who was in Amsterdam a few decades later, thought that there was

too much "laughing, talking, and idly wandering, as if about pro-
phane Affairs, though in a Presence so sacred."[21]

Most of the company passing through the Amsterdam syna-
gogues in the seventeenth century was probably not so judgmen-
tal. The Dutch, in particular, were more tolerant of confessional
differences than the English. Freedom of religion was enshrined
in Article 13 of the Union of Utrecht: "Every individual should
remain free in his religion, and no man should be molested or
questioned on the subject of divine worship." This was one of the
founding principles of the republic, and was a truly remarkable
statement for the time (although when it was drafted in 1579,
there was certainly no thought that it would someday cover Jewish
worship). The local Christians regarded the Jews with a mixture of
casual curiosity, suspicion, intellectual interest, prejudiced distaste,
and even admiration. The sentiments were returned.

Mutual regard is a complex phenomenon. In seventeenth-cen-
tury Amsterdam, everyone had an eye on everyone else. When the
Dutch visited the synagogues to look at the Jews, the Jews looked
back at the Dutch looking at them. This highly self-conscious,
multiply reflective moment was captured brilliantly by Emanuel
de Witte when he painted his three interiors of the Esnoga.

Although De Witte was not as meticulous as Saenredam, particu-
larly when it came to perspective and representational accuracy,
when he depicted an architectural interior, he made sure he knew
the building. Just as important, he knew the story he wanted to tell.

De Witte painted three views inside the Esnoga. This no doubt
required numerous visits to the synagogue to familiarize himself
with its layout and many hours sitting in the building to work
through preliminary sketches and drawings. Unfortunately, we do
not have for de Witte the paper record of extensive preparation
that we do for many of Saenredam's church paintings.

Only one of the works bears a date, 1680, but all of them most
likely were done around the same time. Two were painted on can-
vas, one on a wooden panel. The canvas versions are today in the

Rijksmuseum, Amsterdam (color figure 7), and the Israel Museum in Jerusalem. The panel was last seen in Berlin in 1945; its present whereabouts are unknown.

There is no extant record of any commission to de Witte for a portrait of the synagogue. It is certainly possible that some members of the Portuguese Jewish community asked Amsterdam's celebrated painter of church interiors to do the paintings. One of the works, called only "*De Joode Kerk,* van Emanuel de Wit," was sold at a public auction in Amsterdam on April 9, 1687. It went for twenty-eight guilders, but there is no indication of either seller or buyer. From his research in the archives, however, the historian Yosef Kaplan has identified one of the earliest owners of one of the other two paintings.[22]

On September 28, 1687, David de Abraham Cardozo, a relatively wealthy member of the community, rewrote his will. He was not well, and, although he would live for another few months, on this day he summoned the notary Padthuizen to his home to draft, first in Dutch and later in Spanish, a new last testament. Among his goods he makes special mention of "a painting that is in his possession, which depicts the Portuguese synagogue in this city, which was painted by Emanuel de Wit." Whereas one year earlier he bequeathed the painting to his nephew Abraham Nehemia Cardozo because he wanted the work to remain in the family, he now left it to his "good friend," Jacob Nunes Henriques. No reason is given for the change.

Cardozo, then, was one of the first owners of one of the Esnoga paintings; he was, Kaplan suggests, probably also its patron. He certainly had the means to commission an artist of de Witte's stature. By this time de Witte's own financial situation was desperate and his price probably relatively low anyway. We can be sure that the work had pride of place on the wall in Cardozo's house on Sint-Anthonisbreestraat near the Zuiderkerk, and was much admired, even coveted by his Portuguese guests.

All three paintings situate the viewer at the same vantage point within the synagogue, just inside the building's entryway, behind and to the side of the *tevah.* The view runs straight down the cen-

tral aisle toward the towering ark and the windows in the high arch behind it. The Berlin and Jerusalem versions place the viewer to the left of the pulpit; the Amsterdam version, to the right. This perspectival line is very much like that which de Witte uses in some of the Protestant and Catholic churches that he painted at around the same time. From slightly off-center, a long view stretches down the nave to terminate at the tall pulpit and choir that dominate the far wall near the center of the paintings.

The three Esnoga works differ in a number of ways. All of the chandeliers that hang over the main aisle of the synagogue are present in the Berlin and Jerusalem paintings; many of them, however, are omitted—perhaps to open up the line of view—in the Rijksmuseum canvas. The paintings are also distinguished in how near they bring the viewer to the action. In the Berlin version, one comes closest to the group of people congregating in the visitors' gallery. The Jerusalem version situates one farther back. In the Amsterdam image, one is even farther away, which opens up a larger view of the interior space, especially the ceiling.

There are also variations in the action taking place in the synagogue: differences in the worshipers, particularly those who are standing; and differences in who is looking at whom, and especially in the number of spectators and in the positioning of their children and pets. The most prominent figure in the foreground of all three paintings is a man, a gentile visitor, with his back to the viewer, but his clothes and posture are different in each version. Moreover, in the Rijksmuseum scene, he is engaged in conversation with a young woman; in the other two, he stands alone.

But what the viewer notices above all are the similarities among the three paintings. They are markedly alike and all tell basically the same story. The Sephardim on the far side of the railing are in the midst of their service. The figure standing on the *tevah* is leading them in prayer or perhaps the Torah reading. They are being studied by the day's contingent of gentile visitors. Some of the well-dressed spectators are raptly attentive to what is going on at the other side of the barrier; some are occupied with other matters (one woman is looking back to the child behind her) or chatting

among themselves. For them it is obviously as much a social event as an ecumenical expedition. Close inspection, moreover, shows that the Jews themselves have been distracted from their devotional purpose. Many of them are standing to look back at the visitors. A few are trying to see who today's guests are; others are curious about what the gentiles find so interesting. (The version in the Israel Museum has a man sitting at the rear of the *tevah* looking down at the curious gawkers.) The scene is a perfect visual metaphor for the concern among Amsterdam's Jews about how they are being perceived by others.[23]

Viewers of the paintings are among the visitors to the synagogue. We stand with the gentile spectators and look on from their point of view. These paintings are, then, despite their inclusion in the canon of Jewish art, Dutch paintings. The viewer looks in from without upon a specific group of "others"—Jews—in their house of worship. And just because of this, the paintings are even more remarkable for what they do not do. They are conspicuous, both in de Witte's oeuvre and in the history of art, for their ordinariness. Or, to put the point paradoxically, they stand out precisely because they do not stand out. They are no different from many of de Witte's other architectural paintings.

Consider the Amsterdam version. While it is more populated than the other two works, this picture, with its larger view of the building, is less densely packed. There is a greater clarity of depiction here, and it is easier to read.

Despite the fact that it is probably midmorning, the sunlight is coming in rather low, even for a winter's day at this northern latitude. It streams almost horizontally straight through the windows and shines directly on the south side of the massive pillars. Much of the painting is monochromatic in golds, browns, and yellows. A mass of black coats and hats anchor the bottom of the canvas. But what catches the eye are touches of bright color. Thin red sashes between the windows. A red-trimmed blue overcoat slung from the shoulders of a man in the foreground. There is a red ribbon in his hat and he wears red stockings. De Witte often uses red and black in his figures to relieve the chromatic uniformity of the architec-

ture. In other works, a striking crimson cape, the hint of a red dress, or a blue sleeve escaping from beneath a black cloak divert attention from stone and wood to the living drama that they frame.

The people in the synagogue, both gentiles and Jews, are like those in de Witte's other paintings. They are fashionably attired burghers. The Sephardim are dressed no differently from the visitors, except for prayer shawls on the men. They stand, watch, talk, and point. They could just as well be gathered around the tomb of William the Silent in the Nieuwe Kerk in Delft (as in a 1656 painting) or congregated beside the choir of the Janskerk in Utrecht (1654). To the informed viewer, however, there are some odd notes here. It is unlikely that women, even tourists, were allowed on the main floor of the sanctuary during services; they would have been asked to join the other women in the gallery above. And the two small boys to the right foreground, apparently young Portuguese Jews who have temporarily escaped from the service but who are nonetheless thumbing through a prayer book, are wearing *tallitot*, which is customarily not done until after one is a bar mitzvah, at the age of thirteen. But these improbable features, like so many of the details of de Witte's architectural paintings, are artistic choices. They are exactly what make the work more than a mere document.

Then there are the dogs. Two of them. A small black-and-white spaniel sniffs around a tall, thin hound. The two canines are present in all three paintings. In the Rijksmuseum version, the woman talking with the red-stockinged gentleman gestures at them, as if to make a point. Jewish dogs? No, there are dogs in *all* of de Witte's architectural interiors. Every single one. They come in twos or threes, usually with a master nearby. Some stand or sit, and seem to be watching the proceedings. Others run, play, circle, sniff, and beg for food. One dog pisses against a pillar in the Oude Kerk in Delft. But that is all right. Dogs piss. They are everywhere: in Reformed churches and Catholic churches, places of business and family sitting rooms.

Saenredam, too, included dogs. So did Gerrit Houckgeest. It is not just the Dutch painter's passion, however; dogs are especially common in Venetian painting in the Renaissance. A dog was an

easy symbol of any number of virtues: patience, obedience, constancy, faithfulness, and natural at-homeness in the world. A dog was thus a fitting symbol of religious faith, perfectly proper in a house of worship. What may appear odd to us in de Witte's painting was clearly understood by his patrons. Dogs complete the world. Their painted presence in a synagogue is not a sign of contempt or derision; on the contrary, it is an act of inclusiveness. Their insertion is a way of saying that nothing in this building is so very different from what goes on in any other church in the republic. De Witte does for the Portuguese Jewish synagogue in Amsterdam exactly what he does for Holland's Protestant and Catholic churches. The architectural framing, the perspective, the postures and grouping of figures, the light, the atmosphere, the color . . . and the dogs. The Esnoga in Amsterdam is like the Oude or Nieuwe Kerk in any Dutch city (plate 15).[24] It is just another architectural interior, just another opportunity to capture the expansion of sunshine, the play of color and the blocking of incident, all in an enclosed space.

We are a far cry here from the synagogue of Regensburg as portrayed by Albrecht Altdorfer in the sixteenth century. In a pair of realistic architectural etchings done shortly before the building was destroyed, Altdorfer, who, as a member of the town council, had signed his name in support of the Jews' expulsion from the town, included a Latin inscription over one of the prints: "In the year of the Lord 1519, the Jewish synagogue in Regensburg, by a just judgment of God, was completely destroyed."[25] And there is not a trace in de Witte's painting of the medieval tradition of depicting Synagoga, the allegorical personification of the synagogue and Judaism, as a defeated and humiliated character. Conquered by victorious Ecclesia and associated iconographically with sin, death, and hell, the poor figure is often seen dragging herself through altarpiece panels, illuminated manuscripts, and stained-glass windows with downcast eyes, a broken staff in her hand, and arms bearing upside-down (overthrown) tablets of the Law.[26]

De Witte will have none of that. His respectful portrayals of the Jewish congregation and the architectural achievement of which it was so proud pays homage not only to the particularities

of a foreign religion and its customs but also to its local representatives' social and cultural integration, as well as to the toleration that made that integration possible. The objectivity and neutrality of de Witte's depiction, his refusal to make a judgment in a painting that shows two groups of people making judgments of each other, the ordinariness of a work that despite its rare subject is instantly recognizable as belonging to a certain genre of Dutch art, does more to elevate this building and its occupants than any celebratory print of the synagogue could possibly do.

— ⸙ —

It would be too much to say that de Witte was riding the crest of a new trend within architectural painting, a kind of synagogue subgenre. Still, in the final two and a half decades of the century, as de Witte was sinking deeper into depression, a small number of artists made sure that it was possible to become familiar with Bouman's creation without ever stepping foot in Vlooienburg.

No one depicted the Portuguese synagogue, inside and out, more than Romeyn de Hooghe. In a series of twenty prints that he produced just around the time of the building's dedication, in addition to the commemorative pictures of the inauguration ceremony itself, he shows the *Joode Kerk* from a variety of positions and in a number of settings. The pictures range from bare outlines, ground plans, cross sections, and perspectival views to richly detailed renderings. Some of the etchings highlight notable features of the synagogue complex: the forecourt and entrance just inside the compound's walls; the auxiliary structures surrounding the sanctuary, including the schools, offices, and *mikvah*; the holy ark; and the *tevah*. Others focus just on the building, sometimes in splendid isolation from any context, like a heavenly city unto itself. Unlike the pictures of the synagogue in the contemporary guidebooks, de Hooghe's are not dry analytical images. De Hooghe presents the architectural center of a living community. In one print, the ark is surrounded by worshipers in *tallitot*; in another, people in conversation enter the doorway of the sanctuary for morning services. A third etching shows an old rabbi—most likely

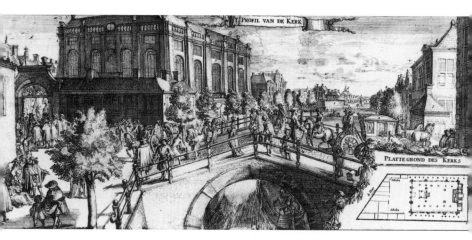

FIGURE 21.Romeyn de Hooghe, *View of the Portuguese Synagogue with Bridge* (etching), Gemeentearchief Amsterdam.

the blind octogenarian Isaac Aboab—being led up to the *tevah*. The richest print of all shows the synagogue rising above the hustle and bustle of the quarter (figure 21). The broad bridge in the foreground is packed with traffic. Families stroll by the outer wall on their way to and from the compound. Trees along the canal beside the synagogue are in full leaf; groups of gentlemen stand under them to conduct their business. The title of the print is *'t Profil van de Kerk*, but it is, in fact, a profile of a neighborhood.

Equally impressive is Gerrit Berckheyde's rendering of the Esnoga and the Ashkenazic synagogue in the 1680s (plate 16). While he painted his share of church interiors, Berckheyde preferred the outdoors. His cityscapes are faithful but overly neat and orderly depictions of familiar urban settings and buildings in Amsterdam, Haarlem, and the Hague. A skilled expert in perspective, he had a flair for detail and clarity. One can practically count the stones in the plaza in his painting of Dam Square in Amsterdam. In his street view off the river Spaarne in Haarlem, light from the setting sun plays off the precisely delineated redbrick facades. In his exterior view of the Portuguese synagogue, seen from across a canal, it is again late in the day. The building's south side is

warmly lit by the last rays of sunlight. Only a few people are about, and the boats on the narrow waterway have been tied up for the evening.

Of course, the Esnoga was never as popular a subject for painting as the other religious buildings around town. Still, it is surprising that, given the financial means of the Sephardic community and the pride they took in their new synagogue, only the four oil paintings by de Witte and Berckheyde remain. Why were David de Abraham Cardozo and (perhaps) two of his colleagues the only members of the Talmud Torah congregation to commission full color portrayals of the building? The apparent dearth of personal portraits of the Sephardim might be explained by scruples about the Second Commandment, or by our difficulty in identifying Jewish (as opposed to gentile) sitters. But despite the architectural and aesthetic similarities, there is no mistaking the Esnoga for a Reformed church. And given the emotions invested in the synagogue and the role it played in the life of the community and the city, it is a puzzle why only two artists, on just three canvases and a panel, painted it.

Of all the images of the synagogue, de Witte's paintings are far and away the most effective. Unlike de Hooghe's etchings, they are not commemorative pictures. They are deeper and more interesting, and not just because of the pigmented medium. Despite the ample detail and populated spaces, and regardless of how much they show us about what it was like to walk in the Esnoga's shadow in late-seventeenth-century Amsterdam, story is still subordinate to documentation in de Hooghe's prints. And Berckheyde's ultrasanitary architectural paintings are more like Saenredam's than de Witte's. The human figures are small and incidental. Whatever they are doing, attention is drawn away from them to their surroundings. In de Witte's paintings of the interior of the Portuguese synagogue, the architectural setting, the arches, pillars, and chandeliers; the atmospheric effects of light pouring in through windows; and the single-point perspective that draws one to the ark of the Torah at the rear of the building are indeed stunning. But viewers are equally drawn by what is going on within. A

wealth of religious, social, and political life, seventy-five years of struggle, suspicion, and success, are captured in a few casual but profoundly significant glances.

———⁂———

When services ended, I lingered a bit in the sanctuary. The congregants had filed out first. They congratulated the family of the bar mitzvah and remarked on the rabbi's long sermon. The tourists who were sitting in the side galleries had to wait for the main aisle to clear before they could leave. A few stayed behind to admire the size of the synagogue, the carved wood of the ark, and the building's old fashioned virtues. The Israelis, with whom I sat (and sometimes talked) during services, closely examined the crimson hand-woven Oriental rugs leading up to the *tevah* and the tapestry covering the lectern, while I could not take my eyes off the light playing on the rough stone of the pillars. It was an image I would have loved to have captured on film, perhaps later to try my own hand at painting. But because it was the Sabbath, I could take no pictures.

After ten minutes, I was the only one left inside. Crunching through the sand on the floor, I made my way slowly to the wooden vestibule. Through the open doors I could see large and small groups of people milling around outside in the bright sunshine. Men and women reunited in the courtyard. It had been comfortable inside, but was hot in the open, shadeless cobblestone quad. It was one of the warmest summers on record in Amsterdam. I was ready to get out to the street and find a breeze. Just as I was about to leave, I turned to have one last look at the synagogue's doorway.

I had been anxious to get inside that morning, and had not noticed the writing above the entrance. There, on a plain black background framed by stone columns, were Hebrew words in gold: *Be'shanat ve'ani berov chasdecha abo beitecha lifek.* The central quote is from Psalm 5:8: "In the greatness of your mercy I will come into your house." Certain letters were marked by dots above them to show the original planned year of the synagogue's completion, 5432 (1672).

As I backed away, I remembered something I had read in a book about the Esnoga. I looked again and there it was. The gilt characters convey one more piece of information. It is a modest testimonial to the rabbi who made the building of this synagogue his personal mission. The *aleph*, *bet*, *vav*, and *aleph* of *abo*, together with the first letter of the next word, *beitecha*, a *bet*, spell out a name: Aboab.

The World to Come

FIVE

ON NOVEMBER 5, 1638, the body of Hannah Deborah Senior, beloved wife of Miguel d'Espinoza, was loaded onto a barge for the two-hour trip up the Amstel River to the Sephardic cemetery. The relatively young woman left behind five children. Miriam, the oldest, was nine. There was another girl, Rebecca, and three boys, Isaac, Baruch (or Bento), and Abraham (Gabriel). Baruch was six when his mother passed away, still decades away from philosophical infamy. He inherited his mother's respiratory problems and died at the age of forty-four, twenty-one years after being expelled from the congregation for his "evil opinions and monstrous deeds."

The members of *Bikur Cholim* came to the house early in the morning. They carried Hannah's coffin to the canal along which the family lived, the Houtgracht, where the low, flat boat was moored. Along with a contingent of mourners, they accompanied the body

to the burial grounds in Ouderkerk, a small village about five miles away. There, in the community's mortuary, the society's representatives washed Hannah's body and dressed it for interment.

It was already a familiar voyage for Miguel, and one that he would make several times again. Before his own death in March 1654, he had buried three wives, his father, and four children at the Beth Chaim (House of Life) cemetery. He lost Rachel, his first wife, after only five years of marriage. Neither of their children survived infancy. The first baby died before it could be named on the eighth day; the second, premature and stillborn, was buried on April 29, 1624. The body of Isaac d'Espinoza, Miguel's father, was buried in Ouderkerk in 1627. He had lived in Nantes, France, after fleeing Portugal, but had moved to Rotterdam by 1623. Miguel's first son, named for his grandfather, died in September 1649. He was followed two years later by Miriam.

When Hannah had been dead for two years, the fifty-two-year-old Miguel, who was in desperate need of a domestic partner to help him raise two girls and three boys, married Esther Fernand (alias Giomar de Soliz) in 1640. Esther was a forty-year-old widow who had only recently arrived from Portugal. She lived only thirteen more years, and was buried on October 24, 1653. Miguel himself was not well during Esther's final illness. Six months later, his surviving children, Rebecca, Baruch, and Abraham, accompanied their father's body along the route that he himself had so often traveled.

The Portuguese Jews of Amsterdam worked long and hard to secure the right to bury their dead within a reasonable distance from the city. Their first request to the municipal authorities for permission to purchase land for a cemetery in 1606 was denied. They tried again two years later, with no greater success. They were thus forced to continue to use the property in Groet, outside Alkmaar, that they had purchased in 1602. It was twenty-five miles by road, and (depending on the conditions) sometimes took two days to reach. This posed a problem for a community that was commanded by its own religious law to bury the dead within one day. To make matters worse, they were required, by a province-

wide regulation that was in effect until 1721, to pay a passage tax
to every Reformed church they passed.

The people of Alkmaar would have been happy to have Ams-
terdam's Jews relocate closer to their burial grounds. Such well-
connected merchants would have brought great economic benefits
to the town. Thus, in 1604, two years after granting them permis-
sion to buy the land for their cemetery, the Alkmaar town council
was the first in Holland officially to allow Jews to settle within city
limits and to practice their religion openly. It was one of many
towns and cities that tried to entice the Portuguese away from
Amsterdam. The Amsterdam city authorities were concerned
about this, and in 1614 they agreed to the Jewish purchase of land
in Ouderkerk. It was not, in the end, a very onerous concession—
the land was there, some distance from the city proper—and it
made life (and death) easier for the Jews in Vlooienburg.

Ouderkerk was a small farming village south of Amsterdam on
the river. It was considerably less liberal than the cosmopolitan
city within whose bailiwick it lay, so it is not surprising that many
of its inhabitants were unhappy about having a Jewish cemetery in
the neighborhood. When the Beth Jacob and Neve Shalom con-
gregations bought a farm "with a brick house, a haystack and an
orchard" from Jacob Backer just off the main street for twenty-
seven hundred guilders, locals protested. Even the managers of
the toll gates on the river along the way tried to hold up the trans-
portation of the Jewish dead. Several times the Portuguese had to
go to the Amsterdam and provincial authorities for help in main-
taining their right of passage on the Amstel.

Part of the reason for the resistance by the local residents was
their strong, and in this case convenient, sense of patriotism. They
had a sentimental attachment to the particular parcel of land the
Sephardim bought. Some believed that this farm was the site of
the first castle owned by the twelfth-century lords of Amstel, Eg-
bert and Gijsbrecht II. In this new nation still struggling for total
independence, emotions ran high for concrete local symbols of the
long-fought battle for confessional sovereignty. To sell such his-
torically charged land to the non-Reformed—to Jews!—to bury

their dead seemed to some to be an act of national, even religious sacrilege. Nevertheless, the sale went through.

The Jewish cemetery at Ouderkerk, like the synagogues in the city, soon became a popular destination for tourists. Dutch and foreign visitors frequently made the pilgrimage up the Amstel to see how the Jews observed death. Domselaar's guidebook to Amsterdam, Fokkens's "description of the spacious, famous merchant-city," and other manuals all mention the cemetery and its environs. The English travelers Brereton and Evelyn, during their respective visits to the city, each took a day to see for themselves what now lay in Farmer Backer's fields. Writing in 1641, Evelyn notes that

> I went to a place (without the Towne) called Over-kirk, where [the Jews] had a spacious field assign'd them for their dead, which was full of Sepulchers, and Hebrew Inscriptions, some of them very stately, of cost: In one of these monuments, looking through a narrow crevise, where the stones were disjoynted, I perceived divers bookes to lye, about a Corps (for it seems [that] when any learned Rabbi dies [they] bury some of his Bookes with him, as I afterward learn'd); of these, by the helpe of a stick that I had in my hand, I raked out divers leaves, which were all written in Hebrew characters but much impair'd with age and lying.[1]

Evelyn was impressed by the expensive tombs and monuments and the mysterious *gravitas* of the place.

He was not alone.

Among the non-Jewish visitors to Ouderkerk in 1653 was a young artist from Haarlem. He was on one of his many trips into nature to capture vistas of the Dutch countryside. He would go on to become the greatest of all Dutch landscape painters. On this excursion, the twenty-five-year-old Jacob van Ruisdael had in hand only a sketchbook, some black chalk, and a pen. He was making preparatory drawings for at least two paintings that incorporated parts of the Beth Chaim cemetery. The only known paintings based on the Jewish burial grounds, they are among the most

famous but enigmatic works in his oeuvre (color figures 8 and 9). One reason for their continued and powerful interest is that it is not immediately clear what exactly Ruisdael took himself to be portraying. Are they simply descriptive, if romanticized, renderings of yet another picturesque scene of which there are so many in the seventeenth-century Dutch world? Or is there some deeper meaning embedded in the lush, fantastic landscapes?

The Beth Chaim cemetery was not just a place where Amsterdam's Portuguese Jews buried their dead. It was also an important repository for the community's most cherished religious, social, and aesthetic values, as well as a symbol of some of its most potent hopes and fears. This is reflected in the beautifully carved tombstones in Ouderkerk and the finely selected layout of its graves, and in the sermons preached on the Houtgracht.

More than any other Jewish community in Europe at the time, the Sephardim of Amsterdam took great interest in what happened to a person after death. They were especially concerned with the fate of the soul. Was the spirit immortal? Would it enjoy in *olam ha-ba*, the world to come, an everlasting reward for virtue in this life? Was there eternal punishment awaiting the souls of sinners?

There is no compelling theological reason why the members of a Jewish community should be so concerned with these questions. Judaism's focus is on its *mitzvot*, or commandments, and the centuries-long rabbinic discussion about them is on how one should act in this life. There is no specific Jewish dogma on the afterlife, no universally accepted and mandatory doctrine of the soul or compulsory eschatology of heaven and hell. Indeed, there is no reason why a Jew must believe anything on this set of issues. Rabbinic tradition does have as one of its nonnegotiable tenets the doctrine of *techiyat hametim*, the resurrection of the dead. When the Messiah comes, the bodies of the deceased will be reanimated and brought to the Holy Land. There they will enjoy an extended period of peace and happiness under renewed Jewish sovereignty.

Maimonides explicitly includes this doctrine among the thirteen essential articles of the Jewish faith. It is also an important part of the central prayer of the daily Jewish liturgy, the *Amidah*, or Eighteen Benedictions, in the opening sections of which God is repeatedly praised for bringing the dead back to life. There is also in rabbinic Judaism a dominant but very general doctrine of the world to come, a belief in an ultimate divine reward (for the righteous) and punishment (for the wicked). But there is a good deal of debate about just what this is supposed to involve. There is no clear and universally accepted opinion regarding a disembodied soul, nor of what may or may not await the soul and/or the body in some otherworldly realm. These are traditionally looked upon as speculative metaphysical matters, about which there is a good deal of latitude for a variety of opinions. It is all a matter of philosophical *aggadah*, storytelling, not religious *halachah*, law.

Things were different, however, in Jewish Amsterdam. Perhaps it was a result of the Catholic theological and cultural background of so many of the community's members; or maybe it was their familiarity with (and desire to respect) Dutch Reformed beliefs in immortality and divine reward and retribution. Either way, the leaders and congregants of Talmud Torah spent a large amount of intellectual and emotional energy on these questions.

The debate between Rabbi Mortera and Rabbi Aboab in the 1630s over the eternality of punishment of Jewish souls is one highly visible manifestation of this interest. It was one of the most serious internal crises faced by the community in the period, and had lasting repercussions on the careers of the rabbis involved and on the organizational structure of Amsterdam's Sephardim. It obviously mattered a great deal to the Portuguese whether or not all Jews after death had a place reserved beside God in the world to come. One thing was absolutely clear: there was no room in the community for anyone who denied altogether a life in the hereafter. Despite the deep and irreconcilable differences between Mortera and Aboab, there is a fundamental assumption that is essential to both of their positions: the soul *is* immortal in a very personal sense, and it will be rewarded or punished after death.

The rabbis and the *ma'amad* would come down very hard on anyone who publicly questioned this most basic principle.

In the 1620s, a heretic of questionable emotional stability gave them the opportunity to do so. Uriel da Costa's family had arrived in Amsterdam from Portugal in 1612. Like other *converso* newcomers, the twenty-six-year-old Uriel and his brothers underwent circumcision, and they learned the rituals and observances of regular Jewish life. But da Costa was deeply dissatisfied with the Judaism he encountered in Amsterdam. It did not meet his expectations of an authentic biblical religion. He yearned for a pure devotion to the Law of Moses. What he claimed to have found instead was a sect of latter-day Pharisees who practiced a degenerate religion of meaningless and superfluous rules. Da Costa questioned the validity of the Talmud, the Oral Law that according to Jewish tradition was given to Moses at the same time as the written Torah. He scorned the small rituals and tasks that make up an observant Jew's day. What bothered him most, however, was the emphasis on postmortem reward and punishment in both the Christianity in which he was raised and the rabbinic Judaism to which he turned in Amsterdam. In his *Propositions Against the Tradition*, published in 1616 during a brief sojourn in Hamburg, Da Costa denounced "the vanity and invalidity of the traditions and ordinances of the Pharisees" in ten theses. He attacked especially the doctrine of the immortality of the soul. To make sure his argument received a hearing in higher circles, he sent a copy of the work to the Sephardic rabbis in Venice.

It was heard. Venice responded to da Costa's broadside with a *cherem* pronounced against him on August 14, 1618, by Rabbi Leon Modena, who had been Rabbi Mortera's teacher. Modena condemned those "who contradict the words of our sages and who, notwithstanding the gaze of Israel, destroy above all the fences around the Torah, claiming that all the words of our sages are a chaos and calling stupid all those who believe in these words."[2] Modena's judgment had great force in Hamburg and Amsterdam, because the Venetian congregation served as a kind of mentor to those younger communities.

Da Costa was put under a ban in Hamburg as well for his opinions. Before returning to Amsterdam a short time later, he had decided to give his view on immortality a more systematic presentation. In 1623, he composed a spirited critique of the Jewish religion, *Examination of the Pharisaic Traditions*, published in Amsterdam the following year. Among the objects of his attack are the practice of circumcision and the use of various articles of Jewish ritual, including phylacteries, prayer shawls, and the attachment of *mezuzot* to doorposts. The issue to which he gives the greatest amount of attention, however, is the immortality of the soul. Da Costa writes that he had been troubled by the doctrine of immortality for a long time. The belief in eternal reward and punishment was a source of much anxiety to him in his youth, and he left the Catholic religion just because of the torment that the fear of eternal damnation caused him. "Certainty eluded me, and the means to attain that eternal life, which I had been indoctrinated to believe in as the ultimate goal of human existence, seemed out of reach. . . . In truth, the most distressful and wretched time in my life was when I believed that eternal bliss or misery awaited man and that according to his works he would earn that bliss or that misery."[3] Relief came only when he realized that the soul is just a part of the body and, thus, completely mortal.

Alerted by the Hamburg congregation, the leaders of the Amsterdam Portuguese community were alarmed by the heretic's return to the city. The seriousness with which they regarded da Costa's denial of immortality is shown by the trouble they took to sponsor a printed refutation by Samuel da Silva, a Hamburg physician, of da Costa's not yet published views. Da Silva's treatise, *On the Immortality of the Soul*, is a point-by-point attack, more rhetorical than philosophical, on da Costa's theses. The Amsterdam *ma'amad* added its own response to the manuscript on May 15, 1623, in the form of a *cherem:*

> The rabbis, in the presence of delegates from the three boards of elders, held meetings with Uriel in the course of which mild and gentle

persuasion was applied to bring him back to the truth. Seeing that through pure obduracy and arrogance he persists in his wickedness and wrong opinions, the delegates from the three boards of elders, together with the boards of wardens and the consent of the rabbis ordained he be excluded as a person already excommunicated [i.e., in Venice and Hamburg] and accursed of God, and that . . . no communication with him is henceforth permitted to anyone except his brothers, who are granted eight days to wind up their affairs with him.[4]

Da Costa was undeterred. He defiantly published his *Examination of Pharisaic Traditions.* This was too much for the Amsterdam Jewish leaders. As da Costa himself tells the story,

No sooner had [my book] appeared in print than the senators and rulers of the Jews agreed to lodge a complaint against me before the public magistrate, setting forth that I had published a book to disprove the immortality of the soul, and that with a view to subvert not only the Jewish, but also the Christian religion. Upon this information I was apprehended and sent to prison.[5]

His incarceration ended after ten days, when his brothers bailed him out. To control the contagion, an order was issued—whether by the municipal magistrates or the Sephardim, we do not know—that all copies of da Costa's book should be burned publicly. The Jewish community's governors had only one final regret: because of the absence of an Inquisition in the Netherlands, they could not condemn da Costa to death.

This was only the beginning of a recurring cycle of offense, punishment, repentance, and reconciliation that characterized da Costa's relationship with the Amsterdam congregations for the next fifteen years. Eventually, it became too great a burden for such an unstable person. The final act of atonement demanded of him before (once again) reentering the community pushed him over the edge. In 1640, after being stripped to the waist, publicly whipped, and forced to lie prostrate at the synagogue's doorway

while the entire Talmud Torah congregation walked out over his body, Da Costa went home and shot himself in the head.

What da Costa and other heretics in the community—such as Spinoza, among whose alleged offenses at the time of his own ban in 1656 was "claiming that the soul is mortal and dies with the body"—ran up against was a battery of rabbis who went out of their way to make clear to their congregants the importance of immortality and reward and punishment in the world to come. It was an impressive and formidable lineup.

In Amsterdam in the seventeenth century, and especially from the time of the union of the three original congregations in 1639 to the building of the Esnoga in 1675, four rabbis stand out for their learning, charismatic personalities, and, above all, authority and influence upon the community. These include Rabbis Mortera, Aboab, and Menasseh, with whom we are already familiar. In 1639, they were joined by Rabbi Moses Raphael d'Aguilar. Raised and educated in Amsterdam—at one point he was Mortera's pupil —d'Aguilar in turn went on to become an esteemed teacher and mentor to many of the community's leaders.

These men were, without question, the spiritual and intellectual leaders of the Portuguese congregation. Other rabbis came and went, some merely as visitors, but these four *chachamim* were a relatively continuous and highly prominent presence among the Amsterdam Sephardim. And each one of these rabbis wrote a substantial treatise on the immortality of the soul.

Rabbi Aboab composed his *Nishmat Chaim* (The breath of life) in 1636, at the time of his dispute with Mortera. The title of Aboab's book refers to the moment in Genesis when God, by "breathing into his nostrils the breath of life," made Adam come alive. Among the many writings of Rabbi d'Aguilar is the *Treatise on the Immortality of the Soul*, in which he argues on rational and scriptural grounds that the soul is an immaterial and incorruptible substance that survives the death of the body and is the recipient of divine reward and punishment in the afterlife. In 1636, Menasseh ben Israel published *On the Resurrection of the Dead*, an explanation of what awaits body and soul when the Messiah ar-

rives. This was followed fifteen years later by his own *Nishmat Chaim*, a long book on the nature of the soul, its temporary union with the body in this life, and, through an intellectual and spiritual union with God, its immortality. Rabbi Mortera's treatise, *The Immortality of the Soul* (or, as it is sometimes called, *The Soul of Man*), is, unfortunately, long lost. Its lessons on immortality and God's judgment, however, are present in many of his extant homilies.

Jewish Amsterdam in the seventeenth century was clearly no place to express one's doubts about what the afterlife holds in store for the human soul. The rabbis and many of their Portuguese congregants were deeply committed to the traditional Judaic doctrine of the resurrection of the body and to a full-scale account of immortality. The Beth Chaim cemetery, then, bore great emotional weight for the community. It was an intermediate resting place for their departed loved ones. Bodies waited there to be brought back to life and gathered with the rest of Israel in Jerusalem under a new king from the House of David; souls, in turn, departed to receive their reckoning from God.

Great hopes and great fears were vested in the land at Ouderkerk. Sometimes—as in the theological and philosophical treatises composed by the rabbis—they were well reasoned and lucidly articulated. On at least one occasion, however, they found a particularly passionate, even irrational expression in a mania that almost tore the community apart.

In May 1665, the Messiah arrived.

Sabbatai Zevi was born in 1626 in Smyrna, in what is now Turkey, to an Ashkenazic family from Greece. The date of his birth on the Jewish calendar was Tisha b'Av, and the rabbis traditionally regarded this day given to mourning for the destruction of the Temple in Jerusalem as the birthday of the Messiah. Zevi eventually came to take this coincidence very seriously. As a boy, he was a precocious and melancholic scholar. Having received a standard religious training in Talmud and rabbinic law, Zevi turned at an early age to close study of the *Zohar*, a work of Jewish

mysticism from thirteenth-century Castille. He was awarded the title *chacham* while still in his teens, although he never formally served as a rabbi for a congregation. Zevi was, however, a charismatic teacher, and he soon attracted a fair number of followers. They studied Talmud with him, and the more devoted ones adopted his strict, ascetic practices to prepare themselves for mystical insight into the hidden secrets of the Torah. Among these practices was sexual abstinence. Zevi is reported not to have consummated any of his several marriages. He was also subject to great mood swings and bouts of paranoia. He was unpredictable, highly sensitive, and sometimes incoherent. As Gershom Scholem, the great scholar of Jewish mysticism, puts it, "there is no doubt that Sabbatai Zevi was a sick man."[6]

Zevi's beliefs about the meaning of Torah, the nature of God and his presence in the world, and the mystical path to enlightenment were very unorthodox. He accepted the kabbalistic belief that one can intuit God's being through various intellectual but not entirely rational practices. He supplemented this process of "spiritual elevation" with a complicated metaphysical picture of God, as well as with a physical regimen that included celibacy and self-mortification. Zevi went beyond anything envisioned by traditional Jewish mysticism. He drew a difficult path to illumination that very few would be able to follow. This, of course, only increased the fascination he held for his followers.

In 1648, a year marked for the redemption of the Jews according to some authorities, Zevi began frequently pronouncing aloud the tetragrammaton. This is strictly forbidden by rabbinic Judaism, and local religious leaders took it as a sign of Zevi's psychological instability and potential subversiveness. He was expelled from Smyrna around 1651, and wandered for some years around the Mediterranean. He reached Palestine in the early 1660s. In Jerusalem, he came into contact with a yeshiva student named Abraham Nathan ben Elisha Chaim Ashkenazi. Shortly thereafter, this young man, while studying kabbalah in Gaza, experienced a mystical vision that he claimed awakened him to Zevi's messianic mission. In early 1665, Nathan of Gaza, as he was now known,

publicly announced that Zevi was the Messiah. Zevi allowed himself to be convinced. Acting as the Messiah's prophet—in effect, taking on the role of Elijah—Nathan generated an enormous amount of enthusiasm for his master. Members of the lower classes in Palestine were especially susceptible to Nathan's appeal and started to prepare for salvation.

Not everyone was persuaded of the legitimacy of Zevi's campaign. He was quickly excommunicated by the Jerusalem rabbinate and banished from Palestine in the summer of 1665. At this point he made his way back to Smyrna. After taking over that city's synagogue, suspending the force of Jewish law, and proclaiming himself "the Lord's Anointed," he announced that the Redemption would take place on June 18, 1666. Word began to spread about the arrival of the Messiah. In a short time, Jews in various parts of the Middle East and Europe were gripped by a messianic frenzy. The daily concerns of ordinary life were forgotten. People sold their goods, ignored the commandments of the Law (particularly regarding fasts and festivals), and prepared for a mass return to the Holy Land. Their opponents, not at all taken in by Zevi but fearful for their lives and property, kept silent.

Sephardim were particularly susceptible to the Sabbatean madness. Jewish communities in Salonika, Constantinople, Livorno, Venice, London, Hamburg, and the West Indies were strongly affected, but so were Ashkenazim in Poland and Germany. The most important center of messianic activity around Zevi, though, was Amsterdam. By the second half of the seventeenth century, many Portuguese Jews throughout Europe looked to the Dutch community as an intellectual and spiritual bellwether. What they wanted now, with their gaze turned northward, was confirmation that Zevi was the real thing.

They were not disappointed. Amsterdam's Jews fell hard. No community devoted more energy and resources to the Sabbatean movement than the Vlooienburg contingent. It went so far that one of the Talmud Torah congregation's former rabbis, Jacob Sasportas, now living in Hamburg, issued a scolding to his erstwhile congregants: "The eyes of all Israel were upon you when this

error began, and if you had rejected the reports, or [at least] not accepted them as certainties, the other communities would not have fallen into error, for they followed your example."⁷

The ongoing war with England and the plague of 1664–1665 had ravaging effects on the Netherlands. Many thought that the death rate was exacerbated by the comet of 1664. The more messianic spirits among Amsterdam's Jews were looking for an indication that all of this suffering had some purpose. When the reports about Zevi, one of whose wives had lived briefly among the Amsterdam Ashkenazim, began arriving in November of 1665, there was much rejoicing. Rabbi Sasportas wrote that

> there was a great commotion in the city of Amsterdam, so that it was a very great trembling. They rejoiced exceedingly, with timbrels and with dances, in all the streets. The scrolls of the Law were taken out of the Ark [for ceremonial processional] with their beautiful ornaments, without considering the possible danger from the jealousy and hatred of the gentiles. On the contrary, they publicly proclaimed [the news] and informed the gentiles of all the reports.⁸

The members of the community, now led by the mystically inclined Chief Rabbi Aboab, threw all caution to the wind as they abandoned themselves to joyful anticipation of their return to Jerusalem. Merchants neglected their businesses, everyday affairs were disrupted, and ordinary religious observance was suspended. Many Amsterdam Jews dropped all mundane matters and arranged immediately to travel to the Holy Land. Among them was Moses Curiel, Romeyn de Hooghe's patron. If he ever left, though, he was not gone long, for he was back in Amsterdam within two years to celebrate the circumcision of his son. Before his own departure for Jerusalem, Abraham Pereira, one of the wealthiest members of the community and a fervent Sabbatean, offered to sell his country house at a substantial loss. He refused to take any money from the buyer, however, "until that man is convinced in his own conscience that the Jews have a King."⁹

The Amsterdam Jews named their sons Sabbatai and Nathan. They added new prayers for the Messiah to their liturgy, intro-

duced weekly recitations of the priestly blessing (formerly pro-
nounced only on major festivals), and planned to exhume their
dead from the cemetery in Ouderkerk to take the bodies to Pales-
tine. Amsterdam's Jewish publishers began producing Hebrew,
Spanish, and Portuguese editions of the prayer book composed by
Nathan of Gaza. In a letter to his friend Sasportas, Rabbi Aaron
Sapharti, a colleague of Aboab's and a fellow Sabbatean, reported
on the general delirium of

> the Holy Congregation whose fervor is beyond description. If you
> beheld it with your eyes you would agree that this is the Lord's
> doing. For they spend all day and all night in the synagogue as on the
> Day of Atonement, and on the Sabbath they offered more than ten
> thousand silver florins. More benches had to be added to our yeshiva
> [for the many penitents and worshippers] and [if you were here] you
> would behold the world upside down. For [at] all the houses where
> they used to play at dice and lotteries, they have of themselves
> stopped it, without [waiting for] an order from the heads of the con-
> gregation, and all day and night they put the Law of the Lord to
> their hearts.[10]

The community, in short, had lost its collective mind.

Few of those not taken in by the false Messiah and his prophet
were brave enough to make their views known in public. Leyb ben
Ozer, an Ashkenazic notary in Amsterdam at the end of the cen-
tury, describes the boldness of one unbeliever:

> A Sephardic merchant called Alatino denied all the reports and let-
> ters, and said in public, "You are mad! Where are the signs? Where
> are the tidings that the prophet Elijah is himself to bring? Where is
> the celestial Temple [that is to descend on Jerusalem]? Where are the
> [eschatological] wars that are foretold? Why have we not heard of
> the Messiah b. Joseph who is to fall in battle?" But everyone cursed
> him and said, "Surely he shall not behold the face of the Messiah."[11]

Leyb notes that Alatino's end was seen as prophetic: "One day as
he returned from the Bourse in order to have his meal, between

202 | THE WORLD TO COME

the washing of the hands and the breaking of the bread he fell down and died suddenly. When this became known to the Jews, and to the gentiles too, a great fear and trembling fell upon them." Rabbi Aboab himself told Sasportas of the "quarrel and contention" dividing the members of the congregation into camps, with the Sabbateans far outnumbering their opponents and "set on mischief against whoever opposes their faith."[12]

It all ended sadly. In 1666, the world of the Sabbatean enthusiasts came rudely crashing in upon them. In February of that year, Zevi was arrested in Constantinople by the Sultan and imprisoned in the fortress at Gallipoli. The charges by the authorities, who had been watching the messianic movement in their midst with increasing concern, included fomenting sedition and immorality. Zevi was given a choice between death and becoming a Muslim.

In September 1666, the Messiah converted to Islam.

———∞∞∞———

The road to Ouderkerk aan de Amstel winds along a quiet stretch of the river. The tree-lined avenue is bordered by farms, open fields, and comfortable homes. Some of these were built centuries ago as summer refuge for Amsterdam's elite. The large houses are surrounded by green lawns, fruit trees, and flower and vegetable gardens. It is hard to believe that a great city lies within just a few miles of such rustic tranquility.

The village sits at the junction of the Amstel and Bullewijk Rivers. It is named for the eleventh-century church, St. Urban's, that dominated the square until a huge storm—the same squall that knocked out the windows of the Esnoga—destroyed it in 1674. An eighteenth-century replacement now stands on the original site. Before a church was finally built in Amsterdam proper, the city's residents would make the trek to Ouderkerk for Sunday worship.

In the village center, stucco houses with tile roofs stand next to older brick buildings beside a placid waterway. Some of the properties on the river have wooden docks for small craft, with automobile tires serving for bumpers. A cobblestone walkway runs

along the shoreline; fisherman stand in the grass between, waiting for fish to bite. There are restaurants and cafés on the river, and Ouderkerk remains a popular spot for a day's excursion for boaters, bicyclists, and walkers. On a fine day, the tables on the outdoor patios are filled.

On an unseasonably mild February day during a recent visit to Amsterdam, a friend and I headed out to Ouderkerke. It was stormy, with a hard wind blowing in from the southeast. It was too strong of a headwind for biking, so we decided to make a run out of it. Almost twenty kilometers, round-trip. Clad in light winter running gear, we took the Metro to the Amstel station, to avoid having to jog through the city.

The road along the river is a flat, narrow causeway, and the few cars forced us occasionally to run in the mud on the side. We passed a luxurious estate with the name "Amstel Rust" ("Rest on the Amstel"), and stopped for a moment at the bend in the river where Rembrandt would come out to sketch. There is now a statue of him there overlooking the water, just on the outskirts of Amstelveen, where much of Amsterdam's Ashkenazic Jewish community has resettled.

The Beth Chaim cemetery in Ouderkerke is across from the church, just off the main street and before a small bridge. The perimeter of the grounds is bordered by the Amstel River on one side and a small stream on the other. The cemetery covers a dozen or so acres that are divided into sections by gates and hedgerows. Large trees provide shade in the summer, and the tall, rough shrubberies give each division a leafy privacy. Until a few years ago, the grassy grounds were so overgrown that it was hard to find one's way around. Recent renovations have cut back a lot of the growth, and the place now seems cleaner and more open.

The inaugural burial to consecrate the grounds was on April 11, 1614. At the time of his son Joseph's death, David Senior was one of the *parnassim* of the Beth Jacob congregation. He was thus given the sad honor of having his child be the first to be interred at Ouderkerk. Since then, over twenty-five thousand Jews have been buried within the ivy-covered brick walls. There are a few

large tombstones, statues, and mausoleums, but most of the graves are marked by marble and stone slabs lying flat on the ground. Many of these have sunk into the sod and are barely visible except for a small piece of rock peeking through the grass. They are heavily weathered, and the inscriptions in Hebrew and Portuguese are often illegible.

Some of the earliest and most important members of the community have their eternal resting place in Ouderkerk: Samuel Palache, the Moroccan ambassador in whose home the Neve Shalom congregation began meeting; Joseph and David Pardo, the father and son rabbis from Venice who did so much to reeducate the Portuguese in Jewish ways; and Abraham Farar, who was in Amsterdam by 1606, trading under the alias of Simon Lopes Rosa and in whose name the cemetery was purchased. Moseh Musafia was buried on May 27, 1643; he served a term as administrator of Beth Chaim. Debora, the daughter of Rafael Jesurun and a member one of the leading families among the Portuguese, died in May 1629 and was buried in section ten; among the contributors to her funeral was a young Daniel Pinto, still decades away from his home restoration project.

Abraham Pereira never made it to Jerusalem to greet the Messiah. He and his friend, Isaac Nahar, a doctor, booked passage in March but got only as far as Italy. After tarrying a while in Venice, Pereira was set to depart for the Holy Land and the yeshiva he had founded in Hebron. However, after he got word of Zevi's conversion to Islam, he returned, crestfallen, to Amsterdam. He is buried beside his wife.

Miguel d'Espinoza, on the other hand, lies far from his first wife, Rachel. And only some of his children are buried here. Gabriel and Rebecca spent their last days in the Caribbean. Gabriel died in Jamaica, Rebecca and her two sons in the Dutch colony of Curaçao. Miguel's middle son Baruch, barred from Jewish burial by the permanent ban pronounced upon him, lies in the municipal cemetery in The Hague. Interment at Ouderkerk was not to be taken for granted; it was an honor, reserved for true (through the maternal line) and upstanding members of the Portuguese-Hebrew Nation.

Spinoza had forfeited the right. There was no place for heretics at Beth Chaim.

All of the great rabbis of the community are buried in the center of the most prominent and accessible section of the grounds. Isaac Uziel, who died on April 1, 1622, lies there. So does Menasseh ben Israel, who received in death the respect from his community that he felt he never got in life. Rabbi Mortera's grave is marked by a large slab, a deep crack running along its lower left corner. Four rosettes frame a Portuguese prayer for salvation that runs along the sides of the stone. Above the long Hebrew text inscribed on the central portion is an emblem topped by a crown, on which is written *Keter Torah*, Crown of the Law, the name of the yeshiva that he directed. It is a modest but fitting tribute to the man who did so much to establish Amsterdam as a center for Jewish learning.

Not all of the community's families were so restrained in the way they memorialized their dead. By the final decades of the century, minimalism had given way to ostentation. It is in Ouderkerk, and not on the walls of their homes, that one gets a good sense of what the Amsterdam Sephardim thought of the Second Commandment's prohibition against graven images.

Jewish sepulchral art in the Middle Ages and the Renaissance was generally characterized by aesthetic reserve. If there was anything on a gravestone beyond the identification of the person and an inscription in Hebrew, it was limited to simple and very conservative decoration. Most families kept to standard motifs: emblems, geometric designs, Jewish religious symbols (such as the star of David, a menorah, a spread-fingered hand to ward off the evil eye, a shofar, or a lulav), and organic forms (trees, bushes, flowers). Sometimes there are animals, mythical beasts, and celestial objects (the sun, the moon, stars), but these tread perilously close to the biblical proscription against idolatrous forms.

In Amsterdam in the second half of the seventeenth century, however, there was a wild expansion of artistic license. Nowhere else at any time have Jews had such elaborately illustrated tombstones. Some subjects on the stones follow a popular motif in sev-

enteenth-century Dutch art, the *vanitas* theme. It is an appropriate visual stimulus to thought within the funereal context. The graves are marked with reminders of the transience of life and of all earthly goods. The *memento mori* can be expressed either by the objects depicted (skulls, hourglasses, broken or delicate items) or through more explicit allegory (such as Father Time carrying his scythe).

More surprising is the tendency in Ouderkerk toward full narrative art. Human figures, alone and in groups, posed and in action, appear in elaborate settings. The scenes, often taken from the Bible, are represented in striking and dramatic definition. The sacrifice of Isaac, Jacob asleep on the ladder, Rebecca greeting Abraham's servant as he returns from looking for a wife for Isaac, Rachel dying in childbirth, and David playing the harp are common themes on individual and family memorials. Even God, in complete violation of both the letter and the spirit of Jewish law, makes an appearance.

Sometimes the carving is in low relief. On many gravestones, however, it is worked so deeply that it borders on full sculpture. The gravestone of Mordechay Franco Mendes presents four richly detailed scenes, including a densely populated tableau containing both humans and animals that shows Abraham making the covenant with Abimelech. The scene on Moses van Mordechai's marble tombstone is even more elaborate. His four-tiered memorial has Moses holding the Ten Commandments at the top, with David and his harp on one side and Abraham receiving his divine guests on the other. Beneath that is a Portuguese inscription surrounded by a ladder bearing angelic traffic over a sleeping Jacob, and a depiction of King Solomon receiving the Queen of Sheba. Another level down, Sarah holds the baby Isaac, Rebecca hands a drink to Abraham's servant Eliezer, and Rachel fetches water from the well. The bottom contains a portrayal of Mordechai being led in triumph on a horse by Haman, flanked by images of Judah and Benjamin. All on one tombstone!

It was not uncommon for the stone to have been designed by the person who was to be buried beneath it. The story an individ-

ual had depicted was often related to his or her given name. Thus, the grave of David Rocha is marked by a stone showing David playing the harp. Abraham Senior Teixera de Mattos' tombstone portrays Abraham welcoming God's angels. His sister-in-law Rachel is memorialized by a representation of the biblical Rachel dying after giving birth to Benjamin; apparently she, the wife of Samuel Senior Teixera, also died in childbirth.

The Ashkenazim were undoubtedly scandalized. This was not the way a Jewish cemetery should look. No matter what one thought of the Portuguese taste for paintings and prints, this exhibition of relief sculpture and especially the depiction of human and divine forms was, they must have thought, clearly a violation of God's prohibition. Indeed, the Sephardim seem not to have fully divested themselves of their assimilation to Spanish and Portuguese Catholic culture. In the domain of the dead, one truly sees their aristocratic pedigree in the lands of idolatry. How else to explain the coats of arms and graven images on their tombstones? A number of stones in the Ouderkerk cemetery do have non-Iberian names on them. This is where the Ashkenazim themselves brought their deceased while they were materially and spiritually dependent on the Portuguese Jews. But after 1642, when they purchased their own cemetery in Muiderberg, the German and eastern European Jews sent their deceased to await the coming of the Messiah under simple, imageless gravestones that stand upright.

─◦◦◦◦─

Enter any major museum—the Metropolitan in New York, the Louvre in Paris, London's National Gallery, the Prado, or the Hermitage—and head for the European paintings. From the early Byzantine images with the endless display of gold leaf designed to elevate the spirit to divine thoughts, walk to the medieval panels, the diptychs and triptychs with their praying patrons and the crucifixions standing within receding blue-green landscapes. Pass, slowly, through the rooms devoted to the Italian Renaissance, glancing only casually at the triangularly oriented portraits of mothers and holy children.

As you arrive in the galleries devoted to Florence in the early sixteenth century, look past your immediate surroundings toward the rooms to come. Cast your eyes through multiple thresholds to the far walls, two, three, even four galleries away. To any seasoned museumgoer, it is immediately clear from this vantage point where the seventeenth-century Dutch works hang. You can see them, even across so large a space, on the distant walls. It is not the jolly tavern scenes that give them away; you cannot make those out from here. It could be those perspectively perfect black and white tiled floors, there to orient the viewer in genre interiors, that provide the essential clue. But these, too, are very indistinct from where you are now standing. It is, instead, those horizontally striated paintings, each with a broad, light-colored band running across its upper two-thirds and a narrower, darker strip below. This is what first catches the eye. As you get closer, perhaps one gallery away, you notice that the top portions of these pieces are in mottled blues, whites, and grays. The bottoms of the paintings tend to be in shades of green and brown. Enter the room in which they hang and you see that most of the drama on the canvases takes place in their upper sections. Here there is motion, event, change; light, clouds, storms.

It's the skies! Those glorious, expansive, serene, threatening, blustery, transparent, opaque, unpredictable, incandescent, monstrous, divine Dutch skies. These are what tell you that you are in the realm of Netherlands landscape. The light-stippled leaves on the trees, the lush growth of the forest, the flat land, the inviting dirt path that draws you in, past the windmill in the foreground, toward the cottage beyond, to the steepled church in the village on the horizon: these are nothing without their stratospheric frame, the majestic blue sky, the gray mist filtering the late afternoon sun, the wind-swept clouds, the approaching storm.

And nobody painted Dutch skies and their terrestrial undergrowth better than Jacob van Ruisdael.

Everything was poised to make this a certainty. Nature and nurture conspired well. Jacob's father Isaack was at the center of Haarlem's art world. He was an art dealer and frame maker, as

well as a gifted painter of landscapes and outdoor scenes. In addition to an auspicious genetic endowment, he gave his son some of his earliest lessons in painting out-of-doors. The two sometimes worked side by side in front of the same panorama. Jacob's uncle and Isaack's brother, Salomon van Ruisdael, was himself a renowned landscape artist, one of the finest in the republic. When it was time for the twenty-year-old Jacob to enter the town's Guild of St. Luke, in 1648, Salomon was its dean.

If one was going to be a landscape painter in the first half of the seventeenth century, whether or not your last name was Ruisdael, there was no better learning environment than Haarlem. The town played an important role in the development of a peculiarly Dutch approach to the countryside, and a vigorous and now much beloved tradition in landscape painting evolved among its specialists. In contrast to the heroic and mythical landscapes found elsewhere, the landscapes coming out of Haarlem by masters such as Esaias van de Velde and Jan van Goyen were, if not always real, realistic. They were drawn not from history or literature or the artist's inspired fantasy, but from observation. They capture the natural world itself, not some idealized realm. Instead of ivy-covered ancient ruins peopled by gods, heroes, and saints, there is rough, craggy flora and coarse byways. The space is sparsely populated, with working people going about their business in the rural neighborhoods in which they live.

Not that these painters were producing naive transcriptions of the skies, pastures, trees, streams, hills, and wooded avenues they saw in front of them. Their works may be "imitations of nature," but they are not mere copies of external reality. They are, rather, carefully crafted, imaginatively arranged, highly selective creations. The Haarlem painters demonstrate that a realistic Dutch landscape can be as dramatic as a history painting, as emotionally expressive as a portrait, and as religiously charged as an icon. Even so, there is no better manifestation of what one scholar calls "the mapping impulse in Dutch art," no clearer demonstration of the taste for the "art of describing" than Dutch landscape painting.[13] And the Haarlem masters did it better than anyone else.

Jacob van Ruisdael was well placed to take advantage of all that his native town had to offer. With an art dealer father, the young Jacob would have been exposed to a wealth of paintings by local *fijnschilders*. In addition to tutelage from Isaack and Salomon, he could watch the great Goyen himself at work, for the celebrated painter lodged in the Ruisdael house in 1634. Unlike de Witte, Ruisdael found his thematic *metier* right from the start. He was painting rustic landscapes several years before he was even old enough to join the guild. By the time he moved to Amsterdam in 1656, he had a strong reputation for the technical quality of his work and the charm and originality of his subjects. Patronage came from high circles, and there is little reason to believe the report from his earliest biographer, Arnold Houbraken, that when Ruisdael died in 1682, he was living in utter poverty.

Ruisdael's pictures, as well as those by his student and friend, Meindert Hobbema, have come to epitomize the school of Dutch landscape painting. They are typically what come to mind when one thinks of the genre. Take, for example, his *Wheatfields* from the 1660s. A country road bearing solitary walkers at the center of the lower part of the canvas recedes to a stand of trees that hide a small house. Golden patches of sunlight fall on the uncut grain between the shadows cast by the clouds. This warm scene is dominated by a massive sky, its blue expanse filled with light and dark billowing clouds (plate 17). Or consider the more densely packed *Wooded Country Road* in the Los Angeles County Museum of Art, which brings the viewer to a fork in a dirt path. A large, sunlit oak tree stands at the center of the painting, where shepherds and wayfarers navigate a large puddle. Or choose any one of the magnificent views of Haarlem, one-third land and two-thirds sky. Some of them show rows of linen laid out in a field to bleach in the sun. The massive St. Bavo's Church, visible for miles over the astonishingly flat land, towers over the city in the background. The giant cumulus clouds overhead, however, reveal the true scale of things.

Anyone who has ever taken a walk or a bicycle ride in the Dutch countryside knows that Ruisdael painted exactly what he saw. Part

of the pleasure of standing in front of a Ruisdael landscape is the feeling that one has been transported back to seventeenth-century Holland, that it is you walking along the sandy path toward the little *dorp*, or village, surrounded by misshapen trees and sun-spotted fields under the blustery sky.

That is why the results of Ruisdael's visits to the Ouderkerk cemetery are so surprising.

At first glance, Ruisdael's paintings of Beth Chaim seem typical. All the standard elements are there. The sky is as full of drama as ever. There is dead and decaying wood in the foreground—fallen, rotting trees, as well as a dead birch still standing—a running stream, and leaves illuminated by sunlight (plates 8 and 9). The composition is denser than in many of his other landscapes but still recalls works such as the *Landscape with Blasted Tree by a Cottage* of some years earlier (plate 18). His palette in the Ouderkerk paintings, while dark, remains essentially the same as before. Instead of a windmill or cottage, there are ruins and a cluster of gravestones, and they inhabit their verdant setting in just as organic a manner. In one work, a pair of figures stand solemnly over a grave, but they are, as always, secondary to their natural surroundings.

Ruisdael seems to have done for the Portuguese Jewish burial grounds exactly what de Witte did for the Portuguese Jewish synagogue. While the three paintings of the Esnoga portray it as a typical Dutch architectural interior, the Haarlem master has turned the Ouderkerk cemetery into an ordinary seventeenth-century Dutch landscape.

Or has he? Titles and first impressions can be deceiving.

There is something about the two paintings, each of which is usually called *The Jewish Cemetery* and which we have come to think of as depictions of Beth Chaim, that makes them stand out in his oeuvre. The atmosphere in both works seems more fantastical, more emotionally charged than what we tend to find in a Ruisdael landscape. It all appears somewhat dreamlike. The sky,

while smaller, is more intense than usual, the terrain more haunted. Then there is the crumbling, empty stone shell of a building in the background—a castle? a church? Mist hovers overhead and there is a rainbow. And, of course, the graves.

The first tombstone that one notices—because its white marble is illuminated, like the birch tree in front of it, by a shaft of sunlight breaking through the clouds—belongs to a man who was not even a member of the Amsterdam community. Elias (or Eliahu) Montalto was born into a *converso* family in Portugal, but he later settled in Livorno, where he returned to Judaism. While practicing medicine in Venice, he took under his wing a young rabbinical student named Saul Levi Mortera. Mortera became the doctor's secretary and accompanied him when Montalto was called to France to be the personal physician of Maria de Medici. Montalto must have enjoyed an extraordinary reputation for his medical skills to be admitted to the French court, as Jews were still officially banned from living in the realm of Louis XIII.

Nor were they allowed to die there. Thus, as his final days drew near, Montalto expressed a wish to be laid to rest in the new Jewish cemetery outside Amsterdam. When he passed away in Tours in 1616, Mortera took his body to Ouderkerk. His tomb, the most prominent one in both Ruisdael works, is a large stone box with a prismatic cap. The broken square tablet that rests against it in the paintings, and that originally (and, thanks to a restoration project, today once again) fit neatly onto its front as a headstone, is inscribed with Hebrew. The foot of the tomb, unseen on Ruisdael's canvases, bears a Portuguese epitaph honoring a renowned member of the *Nação*. Mortera liked Amsterdam, and its new Jewish community was in need of a rabbi. So he stayed to serve the Beth Jacob congregation.

Just behind Montalto's memorial is the tomb of David Farrar, the contrary liberal of Beth Jacob who caused so much trouble for Rabbi Pardo and whose stubbornness in 1618 precipitated the split into two congregations. Farrar was, despite his freethinking ways, a leader of the community. He died in 1624. His grave is marked by a plain stone slab and a simple headpiece. It is barely visible in the paintings.

Next to Montalto is the elaborate sarcophagus of Issac Uziel, the conservative rabbi from Fez who came to Amsterdam to lead Neve Shalom until his death in 1622. A clothlike covering carved out of red marble is draped over his bier. Beside him, in the largest tomb of the group, is Abraham Israel Mendez, who died in 1627. Originally from Malaga, Mendez joined the leadership of Beth Israel soon after his arrival in Amsterdam.

In the left foreground of Ruisdael's paintings, separated from the other graves by a rushing stream but tenuously connected to them by the tree that has fallen bridgelike across the water, is a mysterious dark tomb with a half-cylindrical column on top. Here lies Abraham Franco Mendes *o velho* (the old one), one of the first Portuguese to settle in Amsterdam. A wealthy merchant, he was an early investor in the Dutch East Indies Company. He died in 1614, just after the Ouderkerk grounds were purchased.

The tombs, then, are real.[14] They lie in Ouderkerk just as they appear in the paintings. Any member of the Portuguese community in the 1650s would immediately recognize the monuments included by Ruisdael in both works. He would also know what individuals they stand to memorialize. I suspect, though, that no matter how many times he may have visited the site of Beth Chaim, the densely overgrown, hilly, majestic setting into which Ruisdael has placed the gravestones would not be familiar to him at all.

Ruisdael was still living in Haarlem with his father when he first traveled to Ouderkerk. It was almost twenty miles, not a casual day's outing, but shorter than some other journeys he took in search of subjects for his art. With black chalk, pen, and gray wash, he worked on two drawings of those four tombs (figures 22 and 23). The graves, in a tableau unmistakably taken from nature, are shown from opposite vantage points. In one of the studies, Amsterdam is faintly visible on the horizon. In its companion, the village's St. Urban's Church appears through the foliage in the background. Its spire, to be blown over in twenty years, rises high above the trees. The rooster that crowns its weather vane appears to be flying along with the birds in the sky.

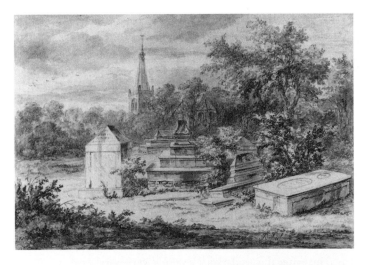

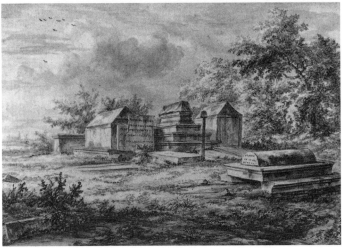

While they are obviously related to the paintings, these drawings are finished, signed works, not mere preliminary sketches. They might have been commissioned, although who in Haarlem would be asking a barely established artist to draw a Jewish cemetery twenty miles away remains a mystery. It is not entirely implausible, however. Haarlem was one of the first municipalities in

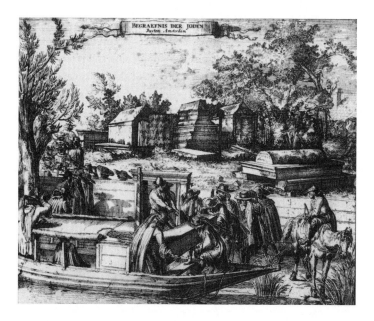

Holland to allow Jews to settle and practice their religion openly, and at the time of Ruisdael's outing to Ouderkerk there was a small Jewish community there.

The drawings became quite well known in their time through engraved reproductions made by Abraham Blooteling in 1670. They were also incorporated into a pair of etchings of the Ouderkerk cemetery by Romeyn de Hooghe in 1675, part of the series of illustrations that he produced to commemorate the inauguration of the new synagogue. In one print (figure 24), de Hooghe depicts a funeral procession as it arrives by horse-drawn barge at the gate of Beth Chaim. A long train of mourners dressed in black winds its way through the cemetery to the open grave. The mem-

FIGURE 22. (opposite, top) Jacob van Ruisdael, *The Portuguese-Jewish Cemetery at Ouderkerk on the Amstel* (drawing), Teylers Museum, Haarlem.

FIGURE 23. (opposite, bottom) Jacob van Ruisdael, *The Portuguese-Jewish Cemetery at Ouderkerk on the Amstel* (drawing), Teylers Museum, Haarlem.

FIGURE 24. (above) Romeyn de Hooghe, *The Jews' Cemetery* (etching), Gemeentearchief Amsterdam.

bers of a group in the foreground bow their heads as the coffin is lifted out of the boat. Many of the men are wiping tears from their eyes. The five tombs shown in the etching come right out of Ruisdael's drawing. Although ostensibly part of the background, they dominate the scene. The second print (figure 25) presents an even more dramatic moment. In the setting of Ruisdael's other drawing, de Hooghe portrays a number of weeping and wailing figures who are flinging themselves upon the tombs. They are observing *yahrzeit* and are overcome with grief on the anniversary of the deaths of their loved ones. The title of the etching is *Memorial Ceremonies on the Graves.*

Except for a few genuine letters on a gravestone in the lower corner of one of de Hooghe's prints, none of these artists bothered to include real Hebrew writing in their depictions of Beth Chaim. The broken headstone lying against the tomb in one of Ruisdael's drawings is covered with scribbles. Would a Jewish patron have settled for this? Would Rembrandt?

In the spring of 1816, Johann Wolfgang von Goethe walked into a picture gallery in Dresden to view the works in the Saxon Royal Collection, one of the most magnificent art collections in all Europe. A man of heightened aesthetic sensibility and impeccable taste, Goethe was well versed in the visual language of painting. The great poet's eyes and imagination were caught by three pictures he saw there, none for the first time. All were by Ruisdael, one of his favorite painters. They moved Goethe to compose a brief elegiac essay on their themes and, especially, on their artist, a man whose works "satisfy all the demands that the senses can make of works of art."[15]

Goethe says that one should look at Ruisdael "as a thinking artist, even as a poet." The three paintings he saw in Dresden on this, his fourth visit to the gallery, offer, he insists, irrefutable evidence of Ruisdael's achievement in this regard. The theme of all three, according to Goethe, is time and its inevitable passage. The first picture, *The Waterfall*, is about the successive flow of genera-

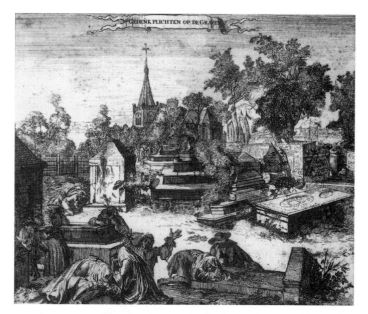

FIGURE 25. Romeyn de Hooghe, *Mourning on the Graves* (etching), Gemeentearchief Amsterdam.

tions, represented by the flowing stream and the variety of edifices—some in ruins, some newly built—in the landscape. The second work, *The Convent*, with its abandoned, decomposing abbey surrounded by thriving nature, "represents the past in the present . . . by visibly uniting the living and the dead."

The third painting, by contrast, "is entirely devoted to the past, without allowing any rights to the life of the present." The tombs depicted, as well as the building in the background, are, Goethe notes, in a dilapidated state and overrun by the surrounding flora. Even the living figures in the work, clustered as they are around a grave, indicate that "the past can leave us nothing but mortality." All of this decay, however, is "conveyed with great tact and artistic taste." Important elements are sensed, not seen; ideas are suggested, not shown. Along with the other two works, it reveals how the artist, "in the purity of his feeling and in the clarity of his thought, shows himself to be a poet, achieves a perfect symbolism, and at once delights, teaches, refreshes and revitalizes us by the

wholeness of his inner and outward feelings." Goethe says that
these are the true functions of Art, and that they find their supreme
manifestation in the three paintings in the Dresden gallery.
"Whoever is fortunate enough to see the originals will be deeply
struck by how far art can and should go."

The painting that Goethe called *The Cemetery* was his favorite
of the three canvases. He owned a copy done in sepia, as well as
prints of Blooteling's engravings of Ruisdael's two drawings.
There is no indication that he knew that there was any other ver-
sion of the work, nor that the cemetery portrayed was related to
an actual one. That it was a Jewish cemetery—something that
most owners of Blooteling's prints and the directors of the gallery
were aware of—is not mentioned at all by Goethe in his essay.

<hr />

There were originally three Ouderkerk paintings by Ruisdael.
This is not unusual in his oeuvre. He painted the Castle of Ben-
theim several times, and his views of Haarlem became a minigenre
unto themselves, called *Haarlempjes*. That he would turn more
than once to so evocative a theme as the Jewish cemetery's tomb-
stones set in a highly dramatic landscape is perfectly natural. Only
the Dresden painting, however, has been kept in continuous sight
over the centuries. A "*Jodenkerkhoff* by Ruisdael," substantially
smaller than the two extant canvases, was up for auction in Rotter-
dam in 1855. This is the first and last extant mention of it. Like
the third synagogue painting by de Witte, it is now lost.

The *Jewish Cemetery* that currently hangs in the Detroit Insti-
tute of the Arts is lighter, less dreary than its German sibling. It
vanished sometime after it was catalogued in England in 1835.
Then it was suddenly and inexplicably rediscovered in London in
the 1920s. Before its disappearance, the English painter John
Constable had occasion to comment on it in a lecture on Dutch
and Flemish landscape painting before the British Institution. Al-
though a great admirer of Ruisdael, as should be clear from his
own rustic landscapes, he was less impressed with what he saw
than Goethe was with the Dresden work. The painting, Constable

insists, is a failure. Ruisdael attempted "to tell that which is out-
side the reach of art," and so produced a work whose message (*An
Allegory of the Life of Man* is the title Constable gives it) cannot be
interpreted and understood without a good deal of trouble.[16]

The cemetery paintings represent a step away from Haarlem
realism. Even when a Ruisdael landscape portrays no identifiable
locale or landmark, it maintains a certain realistic pretense, as if to
say that this is what you *would* see were you in front of so ordinary
a scene. The Dresden and Detroit pictures, on the other hand, de-
pict a more wondrous realm.

What the paintings show is not at all what Ouderkerk looks like.
There are not now and were not then any castle or church ruins on
the grounds, or even in the vicinity. St. Urban's Church, which was
still undamaged at the time Ruisdael was painting these works, is
not on the property. There are no hills or rushing streams within
its gates. The Beth Chaim cemetery is level, its tombs arranged on
cleanly laid out grassy plots. The environs outside the burial
grounds and beyond the village are flat fields, not the rocky out-
croppings in the paintings. Ruisdael's fancy has overwhelmed his
mapping impulse; the art of describing has given way to an art of
imagining.

These are not, in fact, paintings of the Portuguese Jewish
cemetery at Ouderkerk. In all likelihood, Ruisdael, after a day or
two of drawing, never even returned to the village. The only re-
semblance to Beth Chaim in the paintings is the tombs. Ruisdael
made up the landscapes in his Haarlem studio. The ruins in the
Dresden painting are based on some sketches and a painting that
Ruisdael made of the remains of the Castle of Egmond aan den
Hoef around the same time. The scene in the Detroit version, on
the other hand, apparently contains what was left of the Ro-
manesque abbey of Egmond Binnen, near Alkmaar.

Once the drawings were done, Ruisdael had everything he
needed from the Sephardic property. He had gone straight to the
oldest part of the cemetery and sat opposite the largest, most rec-
ognizable monuments on the grounds: the tombs of Montalto,
Mendez, Uziel, and Mendes. Now that they were captured on

paper, no more *plein air* excursions would be necessary. All that remained was to put the headstones to good moralizing effect.

Ruisdael's allegorical intent in the paintings is obvious. All the right elements are present: ruins, crumbling graves, dead wood, flowing water, and changing sky. These are symbols of the fragility of this temporary life and the transitory nature of worldly goods. Most seventeenth-century Dutch *vanitas* paintings are still lifes or genre scenes. Ruisdael's brilliance was to create one out of landscape. One need not go so far as one scholar, who suggests that only a "soul that had felt the tragic blows of circumstances, a mind penetrated with fatalism, could feel and illustrate with such sorrow, such concentration, the impermanence of earthly things."[17] There is no reason to think that Ruisdael possessed any such soul. But one cannot ignore the message of ephemerality that is, contrary to Constable, quite easily read off the Detroit painting.

Still, in the midst of so many reminders of death and transience, there is life and hope. Nature replenishes itself. The grounds overflow with lush greenery. New growth sprouts from the decaying timber in the foreground. Even the ruins will soon be covered by the encroaching woods. In the Detroit version, the dark clouds scatter to reveal a sunlit blue sky. Past generations are replaced by living descendants who remember them and come to visit their final resting place.

Then there is the rainbow, faint in Dresden, vivid in Detroit. The sign of God's covenant with Noah never again to destroy humanity and nature, it bears testimony to a divine guarantee of the everlasting persistence of life. Death haunts every creature, but the world itself will go on. So God has sworn.

Is there more? In the Detroit painting, the rainbow leads to the heavens from the heart of the cemetery. Is this a sign that there is something beyond this mundane existence to which we may look forward? Are we being told that the renewal of life involves more than what is visible in the annual rejuvenation of nature and the temporal succession of generations? Might there be a deeper, theological message in the work? After all, the rabbis say that the coming of the *moshiach*, the anointed one from the House of

David, is to be inaugurated by a resurrection of the dead. For Amsterdam's Portuguese Jews—with their fervent, highly personal debates over eternal reward and punishment, rabbinic treatises on immortality and resurrection, and Messiah-inspired enthusiasms—the place to await this triumphal event, as they eagerly did, would be within the gates at Beth Chaim.

Although it is certainly possible that he, like Rembrandt (according to some scholars), harbored millenarian hopes, Ruisdael was probably not anticipating the imminent arrival of the Messiah. If there is a deliberate message of messianic resurrection in *The Jewish Cemetery*, it would most likely have come from a Jewish patron.[18] This sponsor would, I suppose, have been living in Amsterdam, to which the young Ruisdael had not yet relocated. Its provenance dates back only to 1739, so we know nothing about the first owner of the Detroit painting. But note the prominence of the gravestone of Dr. Elias Montalto that gleams in the scarce sunlight. If his son, Isaac, who was living across the street from Rembrandt in No. 1 Breestraat, wanted an accomplished landscape painter to memorialize his father and express his hope for their eventual reunion under the leadership of the next Jewish king, where else would he go but to Haarlem?[19]

Perhaps. Or maybe Jacob van Ruisdael, that most recognizable of Dutch painters, an artist who saw the sublimity in the flat, low-lying land in which he lived, was, once again, simply exploring the dramatic possibilities of a landscape. If so, he unwittingly contributed—like de Witte with his *Synagogue*, de Hooghe with his prints of Amsterdam's Jews at services, and Rembrandt with his paintings and etchings of his neighbors—yet another Dutch icon to the history of Jewish art.

We spent more time at Ouderkerke than we had planned. We had a lot to talk about with the rabbi who supervises the cemetery, and he was very helpful in showing us around despite the rain. By the time we were ready to return to Amsterdam, after nearly two hours looking around the grounds and examining the

records in his office, we were too wet and too cold to run back. One of the congregation's volunteers who assists the rabbi kindly offered to give us a ride to town, since he was heading that way anyway.

On the drive back, he answered many of my questions about Jewish Amsterdam today. The congregation, he said, was in very bad shape. There were around six hundred members, but few made it to services on a regular basis.[20] It was often difficult to get a *minyan* together. And since the death of the old rabbi whom I had seen at the bar mitzvah some years before, there was no Sephardic rabbi in Amsterdam. The congregation made use of a rabbi in London. He came to the Netherlands infrequently, and most of their consultations with him were by phone, fax, or email. Our driver said that he wanted to move to Israel, but his wife did not.

One of the ironies of the Nazi occupation of the Netherlands is that it saved the Ouderkerk cemetery from obsolescence. At the beginning of the twentieth century, the Sephardim anticipated that the grounds would soon be filled. Three hundred years of burials had just about exhausted all the available space. Some way had to be found to make room within the confines of Ouderkerk, since interring members of the community outside of Beth Chaim was unthinkable.

The directors of the cemetery came up with a plan for temporary relief in 1923. Three meters of soil were added to a part of the cemetery dating to the eighteenth century. This, they calculated at the time, would buy them another forty years, although it had the unfortunate consequence that many older graves would now be lost beneath the raised ground. And they knew that by the 1960s a more permanent solution would be needed.

Then the Germans arrived and began their annihilation of Dutch Jewry. The bodies of those murdered by the Nazis were buried with little ceremony and even less dignity. Those who escaped the horrors of the camps fled the Netherlands, most of them never to return.

There is still room today in Beth Chaim.

When Menasseh ben Israel died in November 1657, his body was brought from Middelburg to Amsterdam, and then to Ouderkerk to be laid to rest. Menasseh was buried near his father, Joseph ben Israel (whose gravestone notes that he was the father of the *chacham*), and close to the man whom he succeeded as rabbi of the Beth Israel congregation, Isaac Uziel. His grave, in the central portion of the cemetery, was covered one year later (in keeping with the Jewish tradition of unveiling) with a simple flat stone. On it is written two epitaphs, in Hebrew and Spanish. The Spanish inscription reads: "He is not dead, for he lives in heaven in supreme glory, while on earth his pen has earned him immortal remembrance."

Most of Amsterdam's Jewish community showed up to pay their last respects to this pillar of scholarship and interfaith understanding. The aged Saul Levi Mortera was there, barely three years away from his own death, as was Isaac Aboab da Fonseca, soon to become the congregation's chief rabbi. The members of the *ma'amad* led the procession from the barge on the river through the grounds to the plot. Among the *parnassim* that year was Menasseh's old friend, collaborator, and patron—and popular sitter for Dutch artists—Dr. Ephraim Bueno; an intellectual in his own right, he may have been asked to say a few words for the occasion. Baruch Spinoza, on the other hand, who had been a student of the late rabbi in the community's elementary school, most certainly did not attend. Even if he had wanted to be present to honor the memory of a man whose open mind and wide-ranging intellect may have inspired him as a youth, he would not have been welcome.

Menasseh's many gentile friends, too, would have been present at his funeral. Isaac Vossius, whom Menasseh regarded as his "intimate friend and obedient servant," was almost certainly there, as well as Menasseh's former pupil Gerbrand Anslo and the well-known millenarian Pierre Serrurier (or Serrarius), still awaiting the conversion of the Jews. Perhaps even the House of Orange, mindful of the kind words spoken by Menasseh when Frederick

Hendrik paid his visit to the synagogue fifteen years earlier, sent a representative.

Was Rembrandt there? It would have been an inconvenience for him, to be sure. He had other things on his mind, what with the imminent loss of his house and belongings. His affairs at this time, according to one notary record, "have reached such a low-point that he is in miserable condition."[21] The sale of his remaining possessions was set to take place later in the month, but it was clear that the proceeds would not come close to satisfying his creditors. And then there were works to be finished. There are, not surprisingly, few dated paintings in his oeuvre from 1657: the dark picture of a careworn Apostle Bartholomew, and a portrait of Catrina Hoogsaet, an old Mennonite widower who lived alone with her parrot. There are also relatively few works on paper. It was probably in November, as his own worldly goods were about to be taken away from him, that he worked on an etching of St. Francis praying beneath a tree. The mendicant kneels in the woods before a large crucifix. Perhaps this was a way for Rembrandt to reconcile himself to his impending (and, unlike the saint, involuntary) poverty.

Still, despite his personal collapse, he owed at least this much to his old friend. Who knew that when Menasseh left for England, two years earlier and not long after they had finished working together on the *Piedra Gloriosa*, it would be the last time they would see each other? As sad an event as it was, it would take his mind off his problems for the morning. Thus, among the mourners to make the trip upriver on that November day was, we can surmise, a certain illustrious but financially broken painter from the neighborhood.

Selected Bibliography

Rembrandt

SOURCES AND DOCUMENTS

K. G. Boon, *Rembrandt: The Complete Etchings* (New York: Harry N. Abrams, 1963); J. Bruyn, B. Haak, S. H. Levie, P. J. J. van Thiel, and E. van de Wetering, *A Corpus of Rembrandt Paintings*, vols. 1–3 (The Hague, Boston, and London: Stichting Foundation Rembrandt Research Project, 1982–1989); Ludwig Münz, *Rembrandt's Etchings*, 2 vols., trans. N. Maclaren (London, 1952); Walter L. Strauss and Marjon van der Meulen, with S. A. C. Dudok van Heel and P. J. M. de Baar, *The Rembrandt Documents* (New York: 1979); S. A. C. Dudok van Heel, *The Rembrandt Papers: Documents, Drawings, and Prints* (Amsterdam: Museum Het Rembrandthuis, 1987), "In de kelder van Rembrandt: Bij een nieuw Rembrandt-document," *Kroniek van het Rembrandthuis* 90 (1990): 3–4, and "'Gestommel' in het huis van

Rembrandt van Rijn: Bij twee nieuwe Rembrandt-akten over het opvijze-len van het huis van zijn buurman Daniel Pinto in 1653," *Kroniek van het Rembrandthuis* 91 (1991): 3–13; A. M. Vaz Dias, "Rembrandt in conflict met zijn buurman Daniel Pinto," *Oud Holland* 53 (1936): 33–36.

BIOGRAPHIES AND GENERAL STUDIES

Bob Haak, *Rembrandt* (London: Thames and Hudson, 1969); Simon Schama, *Rembrandt's Eyes* (New York: Knopf, 1999); Gary Schwartz, *Rembrandt: His Life, His Paintings* (New York and London: Viking, 1985); Seymour Slive, *Rembrandt and His Critics 1630–1730* (The Hague: 1953); Christian Tümpel, *Rembrandt* (Antwerp: 1986); Christopher White, *Rembrandt and His World* (London: Thames and Hudson, 1964).

REMBRANDT AND JEWISH THEMES

Franz Landsberger, *Rembrandt, the Jews, and the Bible* (Philadelphia: Jewish Publication Society, 1946); Erwin Panofsky, "Rembrandt und das Juden-tum," *Jahrbuch der Hamburger Kunstsammlungen* 18 (1973): 75–108; and Netty Reiling (Anna Seghors), *Jude und Judentum im Werke Rembrandts* (Leipzig: Reclam, 1983). See also R. H. Fuchs, *Rembrandt in Amsterdam* (Greenwich, CT: New York Graphic Society, 1969), chapter 5: "The Jewish Community, the Bible, and Religion."

For more detailed studies, see Shelley Perlove, "An Irenic Vision of Utopia: Rembrandt's *Triumph of Mordecai* and the New Jerusalem," *Zeitschrift für Kunstgeschichte* 56 (1993): 38–60, and "Awaiting the Messiah: Christians, Jews, and Muslims in the Late Work of Rembrandt," *Bulletin: The University of Michigan Museums of Art and Archaeology* 11 (1994–1996); and Michael Zell, "Encountering Difference: Rembrandt's *Presentation in the Dark Manner*," *Art History* 23 (2000): 496–521, and *Reframing Rembrandt: Jews and the Christian Image in Seventeenth-Century Amsterdam* (Berkeley and Los Angeles: University of California Press, 2002).

The Netherlands in the Seventeenth Century

Pieter Geyl, *The Netherlands in the Seventeenth-Century*, 2 volumes (London: Williams and Norgate, 1961); Jonathan Israel, *The Dutch Republic: Its Rise, Greatness and Fall, 1477–1806* (Oxford: Oxford University Press,

1995); Simon Schama, *The Embarrassment of Riches* (Berkeley and Los An-
geles: University of California Press, 1988).

For a study of neighborhoods and demographics in seventeenth-cen-
tury Amsterdam, see Tirtsah Levie and Henk Zantkuyl, *Wonen in Amster-
dam in de 17de en 18de eeuw* (Amsterdam: Amsterdam Historisch Museum,
1980)

The Jews in the Netherlands

Until recently, studies in English of the history of the Jews in the Nether-
lands, and in Amsterdam in particular, were limited to articles in scholarly
journals. Now, however, there are two excellent books, each approaching
the subject from a different perspective: Miriam Bodian, *Hebrews of the
Portuguese Nation: Conversos and Community in Early Modern Amsterdam*
(Bloomington and Indianapolis: Indiana University Press, 1997); and
Daniel M. Swetschinski, *Reluctant Cosmopolitans: The Portuguese Jews of Sev-
enteenth-Century Amsterdam* (London: The Littman Library, 2001). I have
relied greatly on Bodian's and Swetschinski's research, in these books and
other studies, particularly for details of the social and economic life of
Amsterdam's Jews. An indispensable illustrated history is Moses Gans,
Memorbook: A History of Dutch Jewry from the Renaissance to 1940 (Baarn:
Bosch and Keuning, 1971). See also the collection of essays edited by J. C.
H. Blom, Renate Fuks-Mansfeld, and I. Schöffer, *The History of the Jews in
the Netherlands* (London: The Littman Library, 2001).

Other important studies from which I have benefited are H. Brugmans
and A. Frank, *Geschiedenis der Joden in Nederland* (Amsterdam: 1940); R. G.
Fuks-Mansfield, *De Sefardim in Amsterdam tot 1795* (Hilversum: Verloren,
1989); Arend H. Huussen Jr., "The Legal Position of Sephardi Jews in
Holland, circa 1600," in *Dutch Jewish History*, volume 3 (Assen: Van Gor-
cum, 1993); Jonathan Israel, "The Economic Contribution of Dutch
Sephardic Jews to Holland's Golden Age, 1595–1713," *Tijdschrift voor
Geschiedenis* 19 (1983): 505–535; Yosef Kaplan, "The Portuguese Jews in
Amsterdam: From Forced Conversion to a Return to Judaism," *Studia
Rosenthaliana* 15 (1981): 37–51, *From Christianity to Judaism: The Story of
Isaac Orobio de Castro* (Oxford: Oxford University Press, 1989), and *Les
Nouveaux-Juifs d'Amsterdam* (Paris: Editions Chandeigne, 1999); Renée

Kistemaker and Tirtsah Levie, eds., *Exodo: Portugezen in Amsterdam, 1600–1800* (Amsterdam: Amsterdam Historisch Museum, 1987); and Henri Méchoulan, *Être juif à Amsterdam au temps de Spinoza* (Paris: Albin Michel, 1981).

For a study of the multifaceted relationship between the Dutch and the Jews in the seventeenth century, and especially the interest of the former in the latter, see Aaron Katchen, *Christian Hebraists and Dutch Rabbis* (Cambridge: Harvard University Press, 1984).

Notes

Chapter 1

1. *The Rembrandt Documents,* 1653/9.

2. Ibid., 1654/3.

3. Ibid., 1654/8.

4. For a mapping of Rembrandt's gentile neighbors, artistic and other, see Christopher Brown, Jan Kelch, and Pieter van Thiel, *Rembrandt: The Master and His Workshop: The Paintings* (New Haven: Yale University Press, 1991), pp. 58–59.

5. Shelley Perlove has pointed out to me that there is some evidence to believe that the house was certainly affordable for Rembrandt when he bought it, and that it was only later, unforeseen events that contributed to his undoing.

6. On Rembrandt's Jewish neighbors, see A. M. Vaz Dias, "Wie Waren Rembrandt's Joodsche Buren?" *De Vrijdagavond:* October 10, 1930: 22–26, and October 17, 1930: 40–45.

7. Simon Schama, "A Different Jerusalem: The Jews in Rembrandt's Amsterdam," in Ruth E. Levine and Susan W. Morgenstein, *Jews in the Age of Rembrandt* (Rockville, MD: The Judaic Museum of the Jewish Community Center of Greater Washington, 1981), pp. 3–18 (p. 5).

8. Jacob Meijer, "Hugo Grotius' Remonstrantie," *Jewish Social Studies* 17 (1955): 91–104 (92).

9. *De Veritate Religione*, book 1, section 1.

10. For example, all the Jews in Barcelona had to wear a yellow badge (by express order of Queen Maria in 1397), as did all Jews in German lands in the mid–sixteenth century.

11. Solo Baron, "John Calvin and the Jews," *Harry Austryn Wolfson Jubilee Volume* (Jerusalem: American Academy for Jewish Research, 1965), vol. 1: 141–164 (152).

12. Meijer, "Hugo Grotius' Remonstrantie," pp. 97–98.

13. Archives of the Portuguese Jewish Community (Amsterdam Municipal Archives) 334, no. 19, fol. 72. On the use of cherem in Amsterdam, see Yosef Kaplan, "The Social Functions of the Herem in the Portuguese Community of Amsterdam in the Seventeenth Century," *Dutch Jewish History* 1 (1984): 111–155.

14. Hermanus Noordkerk, *Handvesten ofte privilegien . . . der stad Amstelredam*, 2 vols. (Amsterdam, 1748), vol. 2, p. 472.

15. Jacques Basnage, *Histoire des Juifs depuis Jesus-Christ jusqu'à présent*, 9 vols. (The Hague: Henri Scheuleur, 1716), vol. 9, p. 989.

16. On Haarlem's original regulation of its Jewish community, see M. Wolff, *Geschiedenis der Joden ter Haarlem*, 2 vols. (Haarlem, 1917), vol. 1, pp. 7–8, 11–12, 56–63.

17. This is from a memorandum written in 1670 by Zodok Perelsheim, a member of the Ashkenazic community, on the occasion of the building of that community's "Great Synagogue"; see Gans, *Memorbook*, p. 25.

18. This story is first told by Daniel Levi de Barrios (1635–1701), poet-historian of the community, in his *Triumpho del govierno popular* (Amsterdam, ca. 1683–1684).

19. This tale first appears in a work by Moses Halevi's grandson, Uri ben Aaron Halevi, *Narraçao da vinda dos Judeos espanhoes a Amsterdam*, printed sometime around 1674.

20. *Histoire des Juifs*, vol. 9, p. 989.

21. See the documents in S. A. C. Dudok van Heel, "In de kelder van Rembrandt."

22. *The Rembrandt Documents*, 1653/7.

23. See the inventory in Schwartz, *Rembrandt: His Life, His Paintings*, pp. 288–291.

24. Ibid., pp. 288–290.

Chapter 2

On Jews, Judaism, and art, see Kalman Bland, *The Artless Jew* (Princeton: Princeton University Press, 2000); Richard Cohen, *Jewish Icons: Art and Society in Modern Europe* (Berkeley and Los Angeles: University of California Press, 1998); Joseph Guttman, *No Graven Images: Studies in Art and the Hebrew Bible* (New York: Ktav, 1971); Elliott Horowitz, "Visages du Judaisme," *Annales histoire, sciences sociales* 49 (1994): 1065–1090; Vivian Mann, ed., *Jewish Texts on the Visual Arts* (Cambridge: Cambridge University Press, 2000); and Rachel Wischnitzer, *From Dura to Rembrandt: Studies in the History of Art* (Jerusalem: Center for Jewish Art, 1990). Also useful are the essays in the catalogue by Susan W. Morgenstein and Ruth E. Levine, *The Jews in the Age of Rembrandt* (Rockville, MD: The Judaic Museum of the Jewish Community Center of Greater Washington, 1981).

Ruth Mellinkoff's *Outcasts: Signs of Otherness in Northern European Art of the Late Middle Ages*, 2 volumes (Berkeley and Los Angeles: University of California Press, 1993), is an extraordinarily rich study of the representation of Jews (among others) in medieval Western art, as is Sarah Lipton's *Images of Intolerance: The Representation of Jews and Judaism in the Bible Moralisée* (Berkeley and Los Angeles: University of California Press, 1999); and Eric Zafran's *Iconography of Anti-Semitism* (Ph.D. diss., New York University, 1973).

For a discussion of Jews and art in seventeenth-century Holland, see especially Shana L. Stuart, *The Portuguese Jewish Community in Seventeenth Century Amsterdam: Images of Commemoration and Documentation* (Ph.D.

diss., University of Kansas, 1992). Stuart's study examines, among other works, de Hooghe's prints, Rembrandt's etchings for Menasseh ben Israel, and the paintings by Emanuel de Witte and Jacob van Ruisdael that I discuss in chapters 4 and 5. On Dutch Sephardic collecting of Bible paintings, see Gabriel Pastoor, "Bijbelse historiestukken in particular bezit," in Christian Tümpel et al., *Het Oude Testament in de Schilderkunst van de Gouden Eeuw* (exhibition catalogue, Amsterdam: Joodsche Historisch Museum, 1991–1992), pp. 122–133 (see especially pp. 124–125). The essays in this catalogue survey a variety of issues raised by Old Testament themes in seventeenth-century Dutch painting.

On Romeyn de Hooghe, see William Wilson, *The Art of Romeyn de Hooghe* (Ph.D. diss., Harvard University, 1974).

On the popularity of the Esther story in late-sixteenth- and seventeenth-century Dutch culture (Jewish and gentile) and especially among Dutch painters, see Madlyn Kahr, *The Book of Esther in Seventeenth-Century Dutch Art* (M.A. thesis, New York University, 1966); Shelley Perlove, "An Irenic Vision of Utopia: Rembrandt's *Triumph of Mordecai* and the New Jerusalem"; Simon Schama, *The Embarrassment of Riches*; and H. van de Waal, "Rembrandt and the Feast of Purim," *Oud Holland* 84 (1969): 199–223.

1. *The Rembrandt Documents*, 1654/4.
2. H. W. Janson, *History of Art* (Englewood Cliffs, NJ: Prentice-Hall, 1974), p. 426.
3. Landsberger, *Rembrandt, the Jews and the Bible*, pp. 26, 37.
4. Eduard Kolloff, "Rembrandt's Leben und Werke, nach neuen Actenstücken und Gesichtspunkten geschildert," *Raumer's Historisches Taschenbuch* 5 (1854): 401–582. On Kolloff's romanticizing Rembrandt and the Jews, see Michael Zell, "Eduard Kolloff and the Historiographic Romance of Rembrandt and the Jews," *Simiolus* 28 (2000–2001): 181–197.
5. Nonetheless, as Michael Zell notes, within his oeuvre "Rembrandt's output of Old Testament paintings was comparatively small—only about thirty-two are known"; *Reframing Rembrandt*, 161.
6. Gans, *Memorbook*, pp. 70–71.
7. Michael Zell traces the genesis of this legend in "Edward Kolloff and the Historiographic Romance of Rembrandt and the Jews."

8. Gérard de Lairesse, *Het groot schilderboeck* (Amsterdam, 1707), vol. 1, p. 324; Schama, *Rembrandt's Eyes*, p. 694.

9. Landsberger, *Rembrandt, the Jews and the Bible*, ix.

10. Perlove, "An Irenic Vision of Utopia." See also "Awaiting the Messiah: Christians, Jews, and Muslims in the Late Work of Rembrandt."

11. Zell argues that Rembrandt was willing to use a Jewish setting to emphasize the Protestant theme of the antithesis of Jewish Law and Christian Gospel and the completion of the former in the latter. He points to the print *Presentation of Christ in the Temple, in the Dark Manner* (dated around 1654), which he insists reflects the "characteristically Protestant emphasis on the opposition between Mosaic Law and Christ's Gospel of justification through faith alone," especially in the contrast between the Jewish (Temple) setting and the highlighted action. However, the print also thereby, he claims, conveys a philo-Semitic conversionist message: that the Law of Moses has been renewed by the Gospel of Christ, and the Jews should accept this fact; see "Encountering Difference" and *Reframing Rembrandt*.

12. *Rembrandt: His Life, His Paintings*, pp. 175, 284.

13. See Babylonian Talmud, Bava Batra, 14a-b. Christopher Brown, meanwhile, believes that Rembrandt's depiction of Moses holding the tablets over his head may have been influenced by his firsthand experience in a synagogue: "Rembrandt may well have attended a Jewish religious service where he would have seen the scroll of the Torah, after the reading, being raised up with the words 'And this is the Law which Moses set before the children of Israel . . .' This action could have suggested Moses's pose to him" (*Rembrandt: The Master and His Workshop*, vol. 1: Paintings, p. 274).

14. See W. Stechnow, "Jacob Blessing the Sons of Joseph, from Early Christian Times to Rembrandt," *Gazette des Beaux-Arts* 85 (1943): 207. Shelley Perlove sees the influence of this rabbinic text (to which Rembrandt may have been led, she believes, by Rabbi Menasseh ben Israel or Rabbi Isaac Aboab) in another painting as well; see her article "Templus Christianum: Rembrandt's 'Jeremiah Lamenting the Destruction of Jerusalem,'" *Gazette des Beaux-Arts* 126 (1995): 159–170.

15. Denis McIntosh McHenry, "Rembrandt's *Faust in His Study* Reconsidered: A Record of Jewish Patronage and Mysticism in Mid-Seven-

teenth-Century Amsterdam," *Yale University Art Gallery Bulletin* 8 (1989): 9–19.

16. I am grateful to Michael Zell for suggesting that I follow this distinction.

17. Schwartz, *Rembrandt: His Life, His Paintings*, p. 315.

18. Gans, *Memorbook*, p. 62.

19. *Catalogue raisonné de toutes les pieces qui forment l'oeuvre de Rembrandt* (Paris, 1751), no. 122. For discussion of this etching, see Ludwig Münz, "Rembrandt's 'Synagogue' and Some Problems of Nomenclature," *Journal of the Warburg Institute* 3 (1939–40): 119–126; and Franz Landsberger, "Rembrandt's Synagogue," *Historia Judaica* 6 (1944): 69–77.

20. In Clement de Jonge's 1679 list of Rembrandt's copper plates; thanks to Michael Zell for pointing this out to me.

21. Gans, *Memorbook*, p. 113.

22. See William H. Wilson, "'The Circumcision': A Drawing by Romeyn de Hooghe," *Master Drawings* 13 (1975): 250–258.

23. See *Encyclopedia Judaica* (New York: Macmillan, 1971), vol. 4, pp. 62–69.

24. Joshua Trachtenberg, *The Devil and the Jews* (New Haven: Yale University Press, 1961), p. 228, n. 26.

25. For example, see Sarah Lipton's important study, *Images of Intolerance*, of the extensive representation of Jews and Jewish traditions in the early-thirteenth-century Bible made for the king of France.

26. This point is made by Michael Zell with respect to the Temple setting in the print *Presentation of Christ in the Temple, in the Dark Manner*; see "Encountering Difference."

27. As Michael Zell has shown in *Reframing Rembrandt*.

28. "A Different Jerusalem: The Jews in Rembrandt's Amsterdam," in Morgenstein and Levine, eds., *The Jews in the Age of Rembrandt*, p. 3.

29. Svetlana Alpers, *The Art of Describing: Dutch Art in the Seventeenth-Century* (Chicago: University of Chicago Press, 1983).

30. A broader discussion of the transformation of the visual image of the Jew "from symbolism to realism" can be found in chapter 1 of Richard I. Cohen, *Jewish Icons*.

31. The date of the work (1637) and the corresponding age it attributes to its sitter (44) do not match up with Menasseh's age in that year (33).

32. Schwartz, *Rembrandt: His Life, His Paintings*, p. 284.
33. Wilson, "The Circumcision," p. 253.
34. The identification is a suggestion by Wilson (ibid., p. 256).
35. Avodah Zarah 3:1.
36. *Mishneh Torah*, Avodat Kokhavim veChukkoteihem, 3:10–11.
37. *Shulchan Arukh*, Yoreh Deah, 141:1.
38. Vivian B. Mann, ed., *Jewish Texts on the Visual Arts*, pp. 25–28.
39. Landsberger, *Rembrandt, the Jews and the Bible*, p. 39.
40. *Les Délices de Holland* (Leiden: Pierre Didier, 1662), p. 25.
41. Ad van der Woude, "The Volume and Value of Paintings in Holland at the Time of the Dutch Republic," in David Freedberg and Jan de Vries, eds., *Art in History, History in Art: Studies in Seventeenth-Century Dutch Culture* (Santa Monica: Getty Center, 1991), 285–329.
42. H. P. Salomon, *Saul Levi Mortera: Tratado de Verdade da lei Moise* (Coimbra, 1988), lxi, n. 19.
43. Katchen, *Christian Hebraists and Dutch Rabbis*, p. 122.
44. Schama, *Rembrandt's Eyes*, pp. 465–466.
45. On the other hand, paintings were often bought as commodities and for speculation.
46. *The Rembrandt Documents*, 1637/7.
47. I am immensely grateful to Mirjam Alexander-Knotter for her generosity in sharing with me the results of research that she, Bert van de Roemer, May Meurs, Saskia van de Bosch, and Yuri van de Linden did at the University of Amsterdam under the direction of Jaap van Veen.
48. Swetschinski, *Reluctant Cosmopolitans*, p. 308.
49. We do not know to what degree Jewish art collecting in Amsterdam was the product of direct order. Most of it was probably done on the open market; see Pastoor, "Bijbelse Historiestukken in Particular Bezit," 125.
50. Van der Woude, "The Volume and Value of Paintings."
51. Yosef Kaplan, "For Whom Did Emanuel de Witte Paint His Three Pictures of the Sephardic Synagogue in Amsterdam?" *Studia Rosenthaliana* 32 (1998): 133–154 (152).
52. According to Rembrandt scholars Christian Tümpel and Albert Blankert; see Blankert, ed., *Gods, Saints and Heroes: Dutch Painting in the Age of Rembrandt* (Washington, DC: National Gallery of Art; De-

troit: Detroit Institute of Arts; Amsterdam: Rijsksmuseum, 1981), p. 54, n. 29.

53. Swetschinski, *Reluctant Cosmopolitans*, 308–309.

54. Gemeentearchief Amsterdam, Notarial Archives, Weeskamer inventory no. 974, no. 68, 1 December 1648; Gemeentearchief Amsterdam, Notarial Archives, inventory no. 2251, notary A. Lock, fol. 505–512, 26 March 1654. See Pastoor, "Bijbelse Historiestukken in Particular Bezit," 125.

55. For a rich study of Dutch Hebraism in the seventeenth century, see Katchen, *Christian Hebraists and Dutch Rabbis*.

56. Ibid., p. 38.

57. Ibid., p. 39.

58. On Coch's conversionist attitude toward the Jews, see ibid., pp. 65–75.

59. Ibid., p. 34.

60. Meijer, "Hugo Grotius' Remonstrantie," p. 95.

61. Ibid.

62. Cornelis Pieterszoon Hooft, *Nederlandsche Historien* (Amsterdam, 1642), p. 390.

63. Johannes de Saef, *De Croon der Schuttery van de beroemde Coopstadt Amstelredam* (Amsterdam, 1628), p. 3.

64. *Passcha ofte De Verlossinge Israels uit Egypten* (1612), quoted in Schama, *The Embarrassment of Riches*, p. 105.

65. Katchen, *Christian Hebraists and Dutch Rabbis*, p. 23.

66. Pieter Geyl, *The Netherlands in the Seventeenth Century*, vol. 2, p. 22.

67. Madlyn Kahr, "Rembrandt's Esther: A Painting and an Etching Newly Interpreted and Dated," *Oud Holland* 81 (1966): 228–240.

68. Blankert, *Gods, Saints and Heroes*, p. 22.

Chapter 3

On the life and times of Menasseh ben Israel, see Yosef Kaplan, Henri Méchoulan, and Richard Popkin, eds., *Menasseh ben Israel and His World* (Leiden: E. J. Brill, 1989); and Cecil Roth, *A Life of Menasseh ben Israel: Rabbi, Printer, Diplomat* (Philadelphia: Jewish Publication Society, 1934).

On Menasseh's influence upon and collaborative relationship with Rembrandt, see Reiner Hausherr, "Zur Menetekel-Inschrift auf Rem-

brandts Belsazaarbild," *Oud Holland* 78 (1963): 142–149; Shelley Perlove, "An Irenic Vision of Utopia: Rembrandt's *Triumph of Mordecai* and the New Jerusalem," and "Awaiting the Messiah: Christians, Jews, and Muslims in the Late Work of Rembrandt"; Shana Stuart, *The Portuguese Jewish Community in Seventeenth-Century Amsterdam: Images of Commemoration and Documentation;* S. A. C. Dudok van Heel, "Rembrandt en Menasseh ben Israel," *Kroniek van het Rembrandthuis* 93 (1994): 22–29; H. van de Waal, "Rembrandt's Etchings for Menasseh ben Israel's *Piedra Gloriosa,*" in *Steps Toward Rembrandt: Collected Articles 1937–1972* (Amsterdam: North Holland, 1974), pp. 113–132; and Michael Zell, "Encountering Difference: Rembrandt's *Presentation in the Dark Manner.*" By far the deepest study of Rembrandt's relationship with Menasseh, and especially the influence that Menasseh's messianism and the conversionist philosemitism of his gentile friends may have had on Rembrandt's art, is Zell's book, *Reframing Rembrandt.*

On Hebrew in early modern Netherlandish and Dutch art, and especially in Rembrandt's works, see Mirjam Alexander-Knotter, "An Ingenious Device: Rembrandt's Use of Hebrew Inscriptions," *Studia Rosenthaliana* 33 (1999): 131–159; "Rembrandt als Joodsch Schilder," *De Vrijdagavond,* January 1925, 38–41; Mellinkoff, *Outcasts,* 97–108; C. Hofstede de Groot, "Kende Rembrandt Hebreeuwsch?" *Oud Holland* (1901): 89–90; and Shalom Sabar, "Hebrew Inscriptions in Rembrandt's Art" (Hebrew), in M. Weyl and R. Weiss-Blok, eds., *Rembrandt's Holland* (Jerusalem, 1993), pp. 169–190.

1. Roth, *The Life of Menasseh ben Israel,* p. 27.
2. See E. N. Adler, "A Letter of Menasseh ben Israel," *Jewish Quarterly Review* 16 (1904): 562–572.
3. Roth, *The Life of Menasseh ben Israel,* p. 53.
4. C. S. M. Rademaker, *Gerardus Joannes Vossius, 1577–1649* (Zwolle: W. E. J. Tjeenk Willink, 1967), p. 213, n. 490.
5. Roth, *The Life of Menasseh ben Israel,* p. 147.
6. Ibid.
7. Preface to *Sefer Elim* (Amsterdam, 1628–1629).
8. In his personal commonplace book, *Huetiana,* §89.
9. Henri Méchoulan and Gérard Nahon, eds., *Hope of Israel* (Oxford: Oxford University Press, 1987), p. 108.

10. *Mishneh Torah*, Hilchot Teshuvah, IX.2.

11. "To His Highness the Lord Protector of the Commonwealth of England, Scotland, Ireland, The Humble Addresses of Menasseh ben Israel, a Divine, and Doctor of Physick, in behalfe of the Jewish Nation" (London, 1655), §1.

12. For a study of this debate (as well as a transcription of its texts), see Alexander Altmann, "Eternality of Punishment: A Theological Controversy Within the Amsterdam Rabbinate in the Thirties of the Seventeenth Century," *Proceedings of the American Academy for Jewish Research* 40 (1972): 1–88.

13. I. S. Revah, "La Religion d'Uriel da Costa, marrane de Porto," *Revue de l'histoire des religions* 161 (1962): 44–76 (62).

14. The print is no. 258 in Gersaint's catalogue (p. 195).

15. For recent contributions to the debate, see S. A. C. Dudok van Heel, "Rembrandt en Menasseh ben Israel"; F. J. Dubiez, "Rembrandt en de rabbijn—maar welke?" *Vrij Nederland*, April 25, 1992, p. 6; H. P. Salomon, "Nogmaals Rembrandt en de rabbijn—maar welke?" *Vrij Nederland*, July 25, 1992, p. 6; and A. K. Offenberg, "Nogmaals Rembrandt en de rabbijn—rabbijn?" *Vrij Nederland*, August 15, 1992, p. 6.

16. See J. S. da Silva Rosa, "Heeft Rembrandt het portrat van Chagam Saul Levi Morteyra geschilderd?" *De Vrijdagavond* 3 (1926): 23–26.

17. Sanhedrin 22a.

18. Song of Songs Rabbah III.4.ii.

19. The connection with the formulation in Menasseh's text was made by Haussherr, "Zur Menetekel-Inschrift auf Rembrandts Balsazarbild." The suggestion that Menasseh advised Rembrandt on this was first made by J. Dyserinck, "Eene Hebreeuwsche inscriptie op eene schilderij van Rembrandt," *De Nederlandsche spectator* (1904): 160–161. See also Tümpel, *Rembrandt*, 141–144.

20. In the dedication to the 1642 Latin edition.

21. Zell (*Reframing Rembrandt*) and Perlove ("Awaiting the Messiah") argue that this is the case in the 1650s.

22. An x-ray photograph reveals that the correct final nun was originally painted at the end of *upharsin* (where there is now what looks like a zayin); see Zell, *Reframing Rembrandt*, p. 61.

23. Reading this etching in such a Jewish kabbalistic context was first suggested by McHenry, "Rembrandt's *Faust in His Study* Reconsidered."

24. Compare McHenry, "Rembrandt's *Faust in His Study* Reconsidered" with Perlove, who argues against a Jewish patron in "Awaiting the Messiah."

25. See Perlove, "Awaiting the Messiah," 93.

26. Ibid., 95.

27. Michael Zell insists that "Rembrandt's encounter with Menasseh [was] a central episode in the artist's career which both complicates and deepens our understanding of his religious art as well as his approach to narrative representation"; see "Encountering Difference: Rembrandt's Presentation in the Dark Manner," 496. He suggests, in particular, that Menasseh's messianism and desire to bring about a reconciliation between Jews and Christians bears a strong relationship to the content of Rembrandt's art, such as the etching *Presentation of Christ in the Temple, in the Dark Manner*.

28. See the works by Perlove and Zell cited above.

29. Perlove has argued that Menasseh, along with perhaps Rabbi Aboab, was also a source of information on rabbinic texts such as *Pesikta Rabbati*; see "Templus Christianum: Rembrandt's 'Jeremiah Lamenting the Destruction of Jerusalem.'"

30. This is how Zell sees it in *Reframing Rembrandt*.

31. See Stuart, *The Portuguese Jewish Community in Seventeenth-Century Amsterdam*, p. 226.

32. This is the suggestion made by Ludwig Münz, *Rembrandt's Etchings*, vol. 2, no. 183 (p. 89).

33. Roth, *The Life of Menasseh ben Israel*, 271.

Chapter 4

Presently, the only full-scale study of de Witte's life and work is Ilse Manke, *Emanuel de Witte* (Amsterdam: Menno Hertzberger, 1963). On the tradition of architectural painting in the Netherlands in the seventeenth century, see Walter Liedtke, *Architectural Painting in Delft: Gerard Houckgeest, Hendrick van Vliet, Emanuel de Witte*, in the series Aetas Aurea: Mono-

graphs on Dutch and Flemish Painting 3 (1982); Rob Ruurs, *Saenredam: The Art of Perspective* (Amsterdam: Oculi, 1987); Gary Schwartz and Marten Jan Bok, *Pieter Saenredam: The Painter and His Time* (New York: Abbeville Press, 1989); and the catalogue *Perspectives: Saenredam and the Architectural Painters of the Seventeenth-Century* (Rotterdam: Museum Boymans-Van Beuningen, 1991).

On de Witte's paintings of the Esnoga, see Yosef Kaplan, "For Whom Did Emanuel de Witte Paint His Three Pictures of the Sephardic Synagogue in Amsterdam?" *Studia Rosenthaliana* 32 (1998): 133–154. This essay also discusses gentile visitors to the synagogue, as does his article *"Gente Politica:* The Portuguese Jews of Amsterdam vis-à-vis Dutch Society," in Chaya Brasz and Yosef Kaplan, eds., *Dutch Jews as Perceived by Themselves and by Others* (Leiden: Brill, 2001), pp. 21–40.

On de Hooghe's etchings of the synagogue, see the discussion in Stuart, *The Portuguese Jewish Community in Seventeenth-Century Amsterdam: Images of Commemoration and Documentation.*

1. Leo and Rena Fuks, "The Inauguration of the Portuguese Synagogue of Amsterdam, Netherlands, in 1675," *Arquivos do Centro Cultural Português* 14 (1979): 489–507.

2. Archives of the Portuguese Jewish Community (Amsterdam Municipal Archives) 334, no. 19, fol. 622 (3 Kislev 5431).

3. Fuks, "The Inauguration," p. 502.

4. Rachel Wischnitzer, *The Architecture of the European Synagogue* (Philadelphia: Jewish Publication Society, 1964), p. 83.

5. The Hebrew text is no longer extant, but a Portuguese version is found in the community's Book of Ordinances (*Livro dos Acordos de Naçao e Ascamot*), Archives of the Portuguese Jewish Community (Amsterdam Municipal Archives), 334, no. 19, fol. 408.

6. F. van Zesen, *Beschreibung der Stadt Amsterdam* (Amsterdam, 1664), p. 272.

7. I am grateful to Shelley Perlove for this point.

8. E. S. de Beer, ed., *The Diary of John Evelyn*, 2 vols. (Oxford: Oxford University Press, 1955), vol. 2, p. 42.

9. E. Hawkins, ed., *Travels in Holland, the United Provinces, England, Scotland and Ireland, 1634–35* (London: The Chetham Society, 1844), pp. 60–61.

10. Archives of the Portuguese Jewish Community (Amsterdam Municipal Archives) 334, no. 19, fol. 161.

11. Ibid., fol. 161 (26 Elul 5400).

12. Meijer, "Hugo Grotius' *Remonstrantie*," p. 99.

13. *Vindiciae Judaeorum* (London, 1656), p. 31.

14. Wischnitzer, *The Architecture of the European Synagogue*, p. 83.

15. William Montague, *The Delights of Holland, or a Three Months Travel about that and the other Provinces with Observations and Reflections on their Trade, Wealth, Strength, Beauty, Policy, etc.* (London, 1696), p. 146.

16. Maximilian Misson, *A New Voyage to Italy, with Curious Observations on Several Other Countries, as Germany, Switzerland, Savoy, Geneva, Flanders, and Holland* (London, 1661), vol. 1, p. 25; quoted in Kaplan, "For Whom Did Emanuel de Witte Paint His Three Pictures of the Sephardic Synagogue in Amsterdam?" p. 143.

17. Gans, *Memorbook*, p. 55.

18. *Gratulação de Menasseh ben Israel em nome da sua nação ao celsissimo Principe de Orange* (Amsterdam, 1642), p. 7.

19. Swetschinski, *Reluctant Cosmopolitans*, p. 208.

20. A. Churchill, ed., *A Collection of Voyages and Travels* (London, 1732), vol. 6, pp. 405–406.

21. Swetschinski, *Reluctant Cosmopolitans*, p. 210.

22. "For Whom Did Emanuel de Witte Paint His Three Pictures of the Sephardic Synagogue in Amsterdam?" pp. 150–153.

23. Yosef Kaplan first suggested to me this way of looking at the painting.

24. On dogs in seventeenth-century Dutch art, see Schama, *The Embarrassment of Riches*, pp. 545–549; and the various discussions in *Perspectives: Saenredam and the Architectural Painters of the Seventeenth-Century*.

25. See Cohen, *Jewish Icons*, p. 24.

26. On the contrast between Ecclesia and Synagoga, see Mellinkoff, *Outcasts*, pp. 48–51, 64–65, 217–220.

Chapter 5

On Ruisdael's life and works, see Seymour Slive and H. R. Hoetink, *Jacob van Ruisdael* (New York: Asheville Press, 1981); and Seymour Slive, *Jacob*

van Ruisdael: A Complete Catalogue of His Paintings, Drawings, and Etchings (New Haven: Yale University Press, 2001).

On the paintings and drawings of the Jewish cemetery, see Jacob Rosenberg, "The Jewish Cemetery by Jacob van Ruisdael," *Art in America* 14 (1926): 37–46; Ernst Schleyer, "The Iconography of Jacob van Ruisdael's Cemetery," *Bulletin of the Detroit Institute of the Arts* 55 (1977): 133–146; Slive and Hoetink, *Jacob van Ruisdael*, pp. 67–77 and 192–197; Peter Sutton, *Masters of Seventeenth-Century Dutch Landscape* (Philadelphia: University of Pennsylvania Press, 1987), pp. 452–455; E. John Walford, *Jacob van Ruisdael* (New Haven: Yale University Press, 1991), pp. 97–102; and Jacob Zwarts, "Het motief van Jacob van Ruisdael's Jodenkerkhof," *Oudheidkundig Jaarboek* 8 (1928): 232–249.

On the Jewish cemetery at Ouderkerk, see Rochelle Weinstein, "Sepulchral Monuments of the Jews in Amsterdam in the Seventeenth- and Eighteenth-Centuries" (Ph.D. diss., New York University, 1979). Wilhelmina Chr. Pieterse, ed., *Livro de Bet Haim do Kahal Kados de Bet Yahacob* (Assen: Van Gorcum, 1970), contains a history of the cemetery and burial records.

1. Stuart, *The Portuguese Jewish Community in Seventeenth-Century Amsterdam: Images of Commemoration and Documentation*, p. 279.
2. Carl Gebhardt, ed., *Die Schriften des Uriel da Costa* (Amsterdam: Curis Societatis Spinozanae, 1922), pp. 154–155.
3. Uriel da Costa, *Examination of Pharisaic Traditions*, trans. and ed. H. P. Salomon and I. S. D. Sassoon (Leiden: Brill, 1993), p. 343.
4. Salomon and Sassoon, introduction to da Costa, *Examination of Pharisaic Traditions*, p. 15.
5. From da Costa's autobiography, *Exemplar humanae vitae*, in *Examination of Pharisaic Traditions*, p. 558.
6. Gershom Scholem, *Sabbatai Sevi: The Mystical Messiah* (Princeton: Princeton University Press, 1973), p. 125.
7. Ibid., p. 519.
8. Ibid.
9. Ibid., pp. 529–530.
10. Ibid., p. 523.
11. Ibid., p. 520.

12. Ibid.

13. Both phrases come from Svetlana Alpers, *The Art of Describing*.

14. The identification of the tombs was first made by David Henriques de Castro, *Keur van Grafsteenen op de Nederlands-Portugeesche-Israëlitische Begraafplaats te Ouderkerk aan den Amstel* (Leiden, 1883).

15. "Ruisdael the Poet" (3 May 1816), in John Gage, ed., *Goethe on Art* (Berkeley and Los Angeles: University of California Press, 1980), pp. 211–215.

16. R. B. Beckett, ed., *John Constable's Discourses* (London/Ipswitch: Suffolk Records Society, 1970), p. 64.

17. Rosenberg, "The Jewish Cemetery by Jacob Ruisdael," p. 42.

18. See Stuart, *The Portuguese Jewish Community in Seventeenth-Century Amsterdam*, pp. 301–315.

19. Schleyer, in "The Iconography of Jacob van Ruisdael's Cemetery" (p. 138), first suggested Montalto's family as the patron for the painting. However, Michael Zell has argued that, far from being commissioned by a Jewish patron or even being for a Jewish market, Ruisdael's cemetery paintings, through the *vanitas* theme and the juxtaposition of the elaborate Jewish gravestones and the Catholic ruins on the site, are a commentary on the Jewish show of pride. "Van Ruisdael was drawn to the oldest and most lavishly exotic tombs of Bet Haim as embodiments—and confirmations—of Jewish otherness" (*Reframing Rembrandt*, pp. 34–37).

20. This is a lower number than even just after the war, when approximately eight hundred Sephardim lived in Amsterdam (compared to a prewar population exceeding four thousand).

21. *The Rembrandt Documents*, 1657/3.

Index

Italicized numbers indicate illustration